WIFREDO LAM
IMAGINING NEW WORLDS

EDITED BY ELIZABETH T. GOIZUETA
MCMULLEN MUSEUM OF ART, BOSTON COLLEGE

This publication is issued in conjunction with the exhibition *Wifredo Lam: Imagining New Worlds* at the McMullen Museum of Art, Boston College (August 30–December 14, 2014) and at the High Museum of Art, Atlanta (February 14–May 24, 2015). Organized by the McMullen Museum, *Imagining New Worlds* has been curated by Elizabeth T. Goizueta and underwritten by Boston College and the Patrons of the McMullen Museum.

Library of Congress Control Number: 2014931464
ISBN: 978-1-892850-23-2

Distributed by the University of Chicago Press
Printed in the United States of America
© 2014 McMullen Museum of Art, Boston College, Chestnut Hill, MA 02467
Wifredo Lam © 2014 Artists Rights Society (ARS), New York/ADAGP, Paris

Designer: John McCoy
Copyeditor: Kate Shugert

Front: *À la fin de la nuit*, 1969, plate 55
Back: *Reflets d'eau*, 1957, plate 51

Lam's paintings in this catalogue appear with the titles, dates, and assigned numbers from *Wifredo Lam: Catalogue Raisonné of the Painted Work; Volume 1, 1923–1960*, ed. Lou Laurin-Lam (Lausanne: Sylvio Acatos, 1996) and *Volume 2, 1961–1982*, ed. Lou Laurin-Lam and Eskil Lam (Lausanne: ACATOS, 2002). Numbers of drawings correspond to those in the SDO Wifredo Lam archives. The graphic works correspond to both the forthcoming *Wifredo Lam: Catalogue Raisonné; Prints Estampes Grafica* 版画, ed. Eskil Lam and Dominique Tonneau-Ryckelynck (Paris: Éditions Hervé Chopin) and *Wifredo Lam: Oeuvre gravé et lithographié; Catalogue raisonné*, ed. Dominique Tonneau-Ryckelynck, exh. cat. (Gravelines: Musée de Gravelines, 1993).

Works in the exhibition are reproduced courtesy of their lenders with additional photography by Mariano Costa Peuser (plates 9, 30, 42, 44) and Sid Hoeltzell (plates 10, 16, 37).

PEGGY SIMONS MEMORIAL PUBLICATIONS FUND

Contents

PREFACE

Nancy Netzer
Director, McMullen Museum of Art

IN 2004 THE MCMULLEN MUSEUM mounted its first exhibition devoted to the work of a Latin American artist, *Matta: Making the Invisible Visible*. Curated by Elizabeth T. Goizueta, a faculty member who teaches Hispanic studies at Boston College, the exhibition broke new ground in its interdisciplinary approach to this highly significant artist of the twentieth century. During the successful run of that exhibition, Goizueta and I focused on Wifredo Lam as another artist from the same era with Latin American roots whose paintings and works on paper would benefit from a similar reexamination. Goizueta began by contacting Eskil Lam, the artist's son and president of the SDO Wifredo Lam, and his chief archivist Dorota Dolega. Both embraced the project with enthusiasm, offering support and help with documentation and obtaining loans from private collections. Goizueta then met with Moraima Clavijo Colom and Roberto Cobas Amate, former director and curator of Cuban avant-garde art, respectively, at the Museo Nacional de Bellas Artes in Havana, who agreed to aid with research. She continued with great success to pursue outstanding loans representative of the artist's major periods from US, Latin American, and European collectors and museums.

The next step was to gather a group of scholars, specialized in the art, literature, and religion of the twentieth century in the places where Lam resided: Cuba, Spain, France, and Italy. We thank Claude Cernuschi, Roberto Cobas Amate, Elizabeth T. Goizueta, Roberto S. Goizueta, and Lowery Stokes Sims for their contributions to the project. Each has asked new questions of the works on display and has written an essay for this volume that illuminates a different aspect of Lam's vast artistic production.

The greatest debt of gratitude is owed to Elizabeth T. Goizueta who has had Wifredo Lam as a constant companion for the past ten years. She has been indefatigable in tracking down his paintings, trawling through archives, connecting his works to modern literature, obtaining loans, and editing this volume. The artist and the Museum could not have been served better or by a more knowledgeable, dedicated, inspirational, and cheerful collaborator. Special thanks also are due our colleagues at the High Museum in Atlanta, the exhibition's second venue. Director Michael Shapiro, David Brenneman, J. English Cook, Julia Forbes, Frances Francis, Becky Parker, Leslie Petsoff, Ruth Richardson, Michael Rooks, Amy Simon, and Jim Waters have been most helpful, adding a healthy dose of humor to the planning at every turn.

We also extend appreciation to lenders, advisors, and photographers without whom this project could not have been realized: Tanya Capriles de Brillembourg; Ramón and Nercys Cernuda, Sergio Cernuda, and Linda Aragón (Cernuda Arte); Virgilio Garza and Jessica Katz (Christie's); Ella Fontanals-Cisneros and Diego Machado (CIFO Foundation); Mariano Costa Peuser; María R. Estorino and Natalie Baur (Cuban Heritage Collection, University of Miami); Madeline Dieppa; Bridgette Farrell; Marta Gutiérrez (Forma Fine Arts); Thessa Herold (Galerie Thessa Herold); Jorge Domínguez (Harvard University); Herman Leyba and Alexandra Gauthier-Pre (Ideobox Artspace); Consuelo Isaacson; Israel Moleiro Sarracino (Latin Art Core Gallery); Douglas and Ann Logan; Martha Richardson (Martha Richardson Fine Art, Boston); John W. Smith, Tara Emsley, and Maureen O'Brien (Museum of Art, Rhode Island School of Design); Madeleine Grynsztejn and Leah Singsank (Museum of Contemporary Art, Chicago); Gary Tinterow, Mari Carmen Ramírez, and Margaret Williams (Museum of Fine Arts, Houston);

1

Glenn Lowry and Hope Cullinan (Museum of Modern Art, New York); María Graciela and Luis Alfonso Oberto; Bill O'Connor; Emilio M. and Silvia M. Ortiz; Jesús J. and Beatriz Melian Peña; María Carlota Pérez; Thomas Collins, René Morales, and Naomi Patterson (Pérez Art Museum Miami); Isaac and Betty Rudman; Jason and Sonia Silverman; Axel Stein (Sotheby's); Antonio de la Guardia (Tresart Gallery); Julianne Simpson (US Department of State); and numerous anonymous lenders.

To bring this project to fruition required the dedication of a strong team of professionals at Boston College. The Museum's assistant director, Diana Larsen, designed the exhibition with great sensitivity to show off the works of each of Lam's periods to best advantage. In designing this book and the exhibition's signage, assistant director John McCoy has captured the imaginative spirit of the artist's work. Our publications and exhibitions manager, Kate Shugert, organized loans, oversaw the publication of this volume, and copyedited its texts and those on the walls of the exhibition with extraordinary discernment. She was aided by student interns Francesca Falzone, Vivian Carrasco, and Keith Lebel. Anastos Chiavaras and Rose Breen arranged insurance and Nora Field provided valuable advice on contracts. Adeane Bregman assembled essential bibliography, and James Husson, Catherine Concannon, Mary Lou Crane, Patricia Kelleher, and Beth McDermott aided with funding.

Such a complex project could not have been attempted were it not for the generosity of the administration of Boston College and the McMullen family. We are grateful especially to Jacqueline McMullen; Boston College President William P. Leahy, SJ; Chancellor J. Donald Monan, SJ; Provost David Quigley; former provosts Cutberto Garza and Joseph Quinn; Associate Provost of Faculties Patricia DeLeeuw; Dean of Arts and Sciences Gregory Kalscheur, SJ; and Director of the Institute for Liberal Arts Mary Crane. Major support was provided by the Patrons of the McMullen Museum, chaired by C. Michael Daley. This volume has been underwritten in part by the publications fund in memory of our former Museum docent Peggy Simons, who always reveled in imagining the new worlds envisioned by artists.

WIFREDO LAM'S POETIC IMAGINATION AND THE SPANISH BAROQUE

Elizabeth T. Goizueta

"Memorizing rule books indicates a poverty of imagination." —Miguel de Unamuno[1]

MORE THAN EVER, WIFREDO LAM (1902–82) is today recognized as an international visionary in the artistic world. Born in Cuba during the same year that the island gained its independence from Spain, Lam already foreshadowed his later entanglements in the major political, literary, and artistic movements that came to define the twentieth century. As a result, Lam defies facile categorization, though he is often appropriated by primitivists, Latin Americanists, magical realists, surrealists, modernists, and postmodernists. Lam is both all and none of these. A contemporary consideration of Lam requires an expansion of preconceptions, boundaries, and frontiers and must be grounded in multiple contexts.

Wifredo Lam was born in Cuba to a Chinese father and a mother of African and Spanish descent; as such, he was rooted in four continents. While he spent significant time in three countries—Spain, France, and Cuba—this essay is particularly interested in examining the Spanish connections to surrealism, both literary and artistic, during Lam's Spanish period from 1923–38. In light of Lam's strong association with Spain's avant-garde movement and its direct influence on his artistic development, this essay will trace the Spanish surrealist roots of Lam's style, whose subsequent evolution is reflected in later, better known works (e.g., *La Jungla*, 1942–43 [43.12], *Le Présent éternel*, 1944 [fig. 6]). In order to understand the complete Lam canon, it is necessary to view his evolutionary trajectory through the retrospective lens of the academic and avantgarde influences prevalent in Spanish literature and art of that period. In an interview at the end of his life with Antonio Núñez Jiménez, a Cuban academic, art critic, and writer, Lam reflected that "outside of Cuba, Spain has been the most direct fountain of information. To both I owe my most significant accomplishments."[2] Heretofore, studies of Lam's oeuvre have assumed that France and Cuba were the countries that most profoundly influenced his work. Spain, for the most part, has been ignored.[3] Without discounting the contributions that France and Cuba made to his artistic development, scholarship on Lam cannot be considered adequate or complete unless this major lacuna is addressed; that is, unless scholars undertake serious research into the Spanish artistic and literary contributions to Lam's style as well as to the study of his earliest paintings. These paintings evidence the first promptings of the artistic vision for which he is internationally known today.

Leaving Cuba at the impressionable age of twenty-one to pursue an academic scholarship in Madrid, Lam found himself under the tutelage of F. Álvarez de Sotomayor, director of the Museo Nacional del Prado. It was through traditional painting that the young Lam was able to supplement his meager scholarship monies and eventually scrape together a still less-than-sufficient income. *Plaza de Segovia, Madrid*, 1923 (plate 1); *Bodegón, II*, 1927 (plate 4); and *Untitled*, 1931 (plate 8) are all paintings that reflect classic academic themes, especially in architecture and portraiture. However, Lam quickly grew bored with academic painting and found relief in the Prado studying the works of Renaissance painters Hieronymus Bosch and Brueghel the Elder, Spanish baroque painters El Greco, José Ribera, Francisco de Zurburán, and Diego Velázquez, as well as Spanish Enlightenment painter Francisco Goya.[4] Álvarez de Sotomayor was mentor to many young artists, including a radical painter named Salvador Dalí, who was at the forefront of the nascent surrealist movement. In the fervor of this Spanish avant-garde milieu, Lam befriended artists and writers alike who subsequently introduced the young

painter to the aesthetic novelties sweeping across Europe. Specific to Spain and independent from Europe, the literary group known as the *Generación del 27* (Generation of 1927) developed its own distinct current of surrealism, drawing directly on inspiration from Spain's hallowed baroque poets. This baroque approach, rooted in complexity, multiplicity, and changeability, influenced what would culminate in Lam's characteristic hybrid style.[5] For Lam, the events in his life would create the impetus for his quest for identity and, ultimately, his own independence from imposed artistic strictures toward a transcultural poetry of forms and symbols.

Returning to his native land in 1941 due to the outbreak of the Second World War, Lam found his European sojourn of eighteen years abruptly terminated. His surrealist proclivities, nurtured for fifteen years in Spain and three years in France, were regarded with disinterest among the Cuban avant-garde painters upon his return.[6] In the first half of the twentieth century, Cuba had produced its own vibrant, internationally recognized avant-garde movement. It now looked upon this native son as an outsider. Repatriation would force Lam to reassess his own artistic vision as he found himself ensnared in an aesthetic struggle between surrealism (represented by European modernism) and the philosophical exploration and dissemination of the concept of magical realism (represented by Latin America).[7] These two prominent twentieth-century artistic currents, the former waning and the latter waxing, held sway over Lam's imagination for many decades. Lam would turn to the poets and their movements in an attempt to clarify his positioning between these two seemingly contradictory currents. Ultimately, they would fail to define him. Nevertheless, it was their nexus that created the seedbed for Lam's unique style, arresting in its originality and poetic in its application.

Much as André Breton and the surrealists were defining the "marvelous" as an aesthetic category in the *Manifesto of Surrealism* of 1924, Franz Roh was the first to coin the term "magic realism" a year later.[8] Magical realism re-emerged again in the early forties, this time in Latin America. Undoubtedly, magical realism's most important Latin American theorist and proponent was the pre-

eminent Cuban writer Alejo Carpentier, who was also a scholar of Latin American art and history. In the prologue to his 1949 novel on the eighteenth-century Haitian revolution, *El reino de este mundo* (*The Kindgom of This World*) Carpentier expounded on his concept of *lo real maravilloso*, otherwise known and used almost interchangeably as "the marvelous American reality" or "magical realism."[9] According to Carpentier, magical realism presupposed faith and, unlike Roh's interpretation, was not viewed in a strictly phenomenological sense, devoid of transcendental and religious impulses.[10] Carpentier developed the theory that the history and landscape of Latin America appeared so extreme to outsiders that it was viewed as purely fantastic or even magical.[11] A former participant in the French surrealist movement, Carpentier eventually eschewed surrealism as false and contrived. Like a zealous convert, he promoted magical realism as the true embodiment of the fantastic. For him, magical realism offered a natural and unforced understanding steeped in a Latin American reality. Indeed, in Latin America, magical realism's broader appeal, and one that was actively debated when Lam returned to Cuba in 1941, was that it posed the question of the position of the "New World" in the context of universal history.[12] At the crux of the debate was identity. Paradoxically, the more Carpentier and other Latin American writers tried to separate themselves from Europe, the more dependent they became on a European mode of expression to claim their new consciousness. Specifically these visionaries turned to the baroque style, rich in hybridization, adopting and reconfiguring it to fit the new Latin American artistic vision. Hybridization was key to Lam's nascent signature iconography of the forties: it provided the bridge between surrealism and magical realism. Both leaders of their respective movements, Breton (surrealism) and Carpentier (magical realism) claimed singular interpretations of this putative New World order. A personal and professional friend of both writers (figs. 1–2), Lam found himself caught in the middle of this aesthetic struggle. Ironically, commonality could be found in the movements' Iberian baroque roots. Perhaps the syncretic character and style of the Spanish avant-garde poets provided Lam with the raw material for an artistic resolution of this dilemma. To fully understand the baroque elements in Lam's work, and,

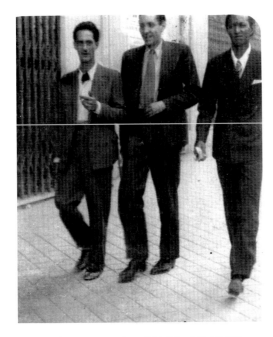

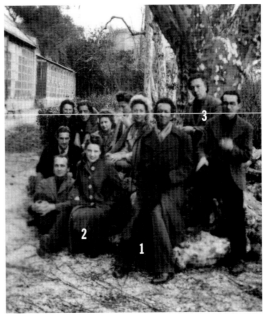

1. Carlos Enríquez, Alejo Carpentier, and Wifredo Lam in Madrid, 1933.

2. Wifredo Lam (1) with Helena Holzer (2), André Breton (3), and friends in Marseilles, 1941.

indeed, Lam himself, requires a re-examination of these movements, their histories, and their implications.

Surrealism and the Spanish Avant-Garde

The surrealist movement was initiated in France by poets and writers Louis Aragon, Philippe Soupault, Paul Éluard, Robert Desnos, and, principally, André Breton. A formalization of the movement came with the publication of Breton's first *Manifesto of Surrealism* in 1924. Largely evolving from the other aesthetic movements at the beginning of the twentieth century (i.e., cubism, futurism, and specifically dadaism), surrealism developed, in part, as a reaction to the moral, social, and political upheavals brought to bear on society by the turn of the century. Not least among them were the inhumanity and barbarism exhibited during the First World War. For many European intellectuals, the devastation of that war revealed the violent underside of modern rationalism and left them in search of an alternative worldview. Surrealism grounded itself on the novel premise that the rational and the logical must be disavowed in favor of the irrational and the illogical. It radicalized the norms of society by basing its precepts on the findings and theories of psychoanalyst Sigmund Freud, which posited that the forces of the mind's inner repressed regions (unconscious) could exert force on the repressing (conscious) regions.[13] Internal functions of the mind no longer had to submit to the external control of reason. Indeed, Breton's manifesto made clear that a parallel dream "reality" was desired: the dream world should be valued above and beyond the waking world. The untarnished internal processes made manifest in imagination, chance, and spontaneity constituted a superior reality, an absolute reality, a "surreality." Indeed, Breton defined surrealism as "psychic automatism in its pure state, by which one proposes to express—verbally, by means of the written word, or in any other manner—the actual functioning of thought. Dictated by thought, in the absence of any control exercised by reason, exempt from any aesthetic or moral concern."[14]

The emphases on automatic thought and language are inextricably linked. For the surrealists, especially poets and writers, the medium of language, spoken or written, was the manifestation of thought. The poets poured forth a continuous flow of monologues and word games in their quest for surrealist truth. As the movement expanded, it came to include three principal expressions: surrealist language exemplified by "automatic writing"; surrealist image exemplified by arbitrariness "to the highest degree";[15] and surrealist action exemplified in non-conformism. With the

Second Manifesto of Surrealism of 1929, Breton laid claim to an even more radical theory: complete sabotage against the ideas of family, country, and religion. The *Second Manifesto* espoused that moral virtues should be subjected to a total revolt. Calling upon the spirit of literary anarchists Arthur Rimbaud and the Uruguayan-born French writer Isidore Ducasse, writing under the pseudonym Comte de Lautréamont, Breton demanded unconditional adherence. He chastised those surrealist artists who sought approval or monetary gain. The approval of the public, according to Breton, "was to be avoided like the plague" and "the public must be kept panting in expectation at the gate by a system of challenges and provocations."[16] This strategy proved acceptable as long as these challenges and provocations were not directed at Breton. He alone defined the tenets of the movement. Stating in the *Second Manifesto* that he believed in the absolute virtue of anything that takes place, spontaneously or not, in the sense of non-acceptance, Breton clearly contradicted the theories he laid out in the first *Manifesto*, where he championed spontaneity and chance at all costs.[17] Clever enough to anticipate contradictions or inconsistencies in his intellectual argument, Breton bypassed such obstacles by asserting that there was no such thing as a contradiction in surrealism.[18] His unrelenting and arbitrary judgments against those who challenged him resulted in denouncements and defections, proliferating at the time of the *Second Manifesto*.[19]

As surrealism developed in France, the Generación del 27 was growing in cultural significance in Spain. Between the years of 1923 and 1927 a group of poets with a desire to experience and work with avant-garde poetry and art began to form literary circles. Their first formal meeting took place in Seville in 1927 to mark the tercentenary of the death of the seventeenth-century baroque poet Luis de Góngora. The dramatic choice of Góngora as the Generación del 27 group's emblematic mentor also may have signaled a deep-seated desire to reconnect with a glorious epoch in Spain's past, the Golden Age, in which Spain's baroque artists and writers were at the apex of their creative activity. Góngora, considered one of the most intellectually challenging yet sensually oriented poets of the baroque period, was adopted as the symbol for the new literary activity. The clever play of Góngora's verses and his extravagant elaboration of style appealed to the group's heightened search for absurdity and innovation. The poetry of Góngora would substitute, for example, *formidable de la tierra bostezo* ("formidable earth yawn") for *cueva* ("cave") and *infame turba de nocturnas aves* ("an awful mob of nocturnal birds") for the bats that inhabit it.[20]

This stylistic elaboration, too, was an element revered in the visual arts. To understand the baroque in a traditional sense within the visual arts, the Swiss art historian Heinrich Wölfflin draws the distinction between the Renaissance and the baroque in the following manner: "The baroque uses the same system of forms, but in place of the perfect, the completed, gives the restless, the becoming, in place of the limited, the conceivable, gives the limitless, the colossal. The ideal of beautiful proportion vanishes; interest concentrates not on being, but on happening. The masses, heavy and thickset, come into movement."[21] In his book, *The Spanish Avant-Garde*, Derek Harris elaborates on the significance of this baroque identification in literature:

> The raising up of a poet of the highest baroque as a symbol and model of what was coming to be called now the "new literature" is a clear indication of the syncretic character of innovative literature in Spain and not as arbitrary as it might seem. The baroque conceit, of which Góngora was a supreme master, has a lot in common with the imagery of the cubist avant-garde. Neo-gongoresque imagery proliferated in the 1920s: radiators became nightingales because they made singing noises in the night; electric light became a princess imprisoned in the crystal castle of the light bulb.[22]

This next generation of Spanish writers, impatient for a new expression, eschewed traditional devices and absorbed many of the literary currents sweeping across Europe. It is essential to note that the amalgamation of those European currents developed alongside the specifically Iberian literary influences driving the intelligentsia of the day. Harris observes, "Just as the Chilean poet [Vicente Huidobro] wrote in French and sought to integrate himself into the cubist-oriented group of writers in the French capital, so Spanish avantgardists took off the peg the literary and

artistic isms fashioned for the most part beside the Seine. But in Spain writers and artists also frequently felt the need to assert an individual identity apart from the dominating pressures from Paris."[23] The collective Spanish identity, limited by borders, both linguistic and geographic, allowed for concentrated experimentation in nationalistic literary movements. In the ferment of Spanish avant-garde activity, major precursors to surrealism, such as Ramon Gómez de la Serna, contributed to an aesthetic climate through the use of incongruous imagery, later mined by the Generación del 27. This anti-traditional approach did not meet with immediate success: it took over ten years for Spain's avant-garde movement to receive the recognition the other European aesthetic movements found. It took a leading proponent of this new art to pave the way toward acceptance.

Dehumanization of Art

Directly challenging the traditional writing style that had held sway at the beginning of the century, the writers known as the *Generación del 14* centered on the dominant figure of philosopher José Ortega y Gasset and the magazine he founded in 1923, *Revista de Occidente*.[24] The importance of Ortega y Gasset and his magazine cannot be overstated. Ortega y Gasset's education in Germany lent his magazine a decidedly pro-European orientation and his publication was widely read and fiercely debated first in Spain and subsequently in Latin America.[25] It was through Ortega y Gasset's editorial policies and translations that the Spanish-speaking world was able to connect to the European intelligentsia.[26] The latest philosophical, aesthetic, and scientific advances translated into Spanish brought these intellectual topics to the forefront of the Spanish consciousness. Due to Ortega y Gasset's academic training and subsequent profound exploration of German philosophers, he became familiar with the writings of the great philosophers of the day, such as Georg Wilhelm Friedrich Hegel, Oswald Spengler, and Leo Frobenius. Ortega y Gasset's predilection was for Spengler and his doctrine on culture, *The Decline of the West*, 1923.[27] Spengler offered a view of universal history in which there is no fixed center and where Europe is simply one more culture. According to literary scholar Roberto González Echevarría, Spengler's cyclic conception of the history of cultures kindled

the hope that if Europe was in decline, Latin America must be then in an earlier, more promising stage of its own independent evolution. This popularized idea had some significant corollaries to artistic activity.[28] Key to that endeavor was Ortega y Gasset's enthusiastic treatise on the European avant-garde, entitled *Dehumanization of Art*, 1925. No doubt influenced by Spengler's posited theories of culture in which the Western world no longer occupied a privileged place, Ortega y Gasset argued that the essential characteristic of the new art, whether in music, theater, literature, or the visual arts, was its tendency to dehumanize. The new artist, instead of trying to approximate reality, expressly set out to attack it, deforming and breaking apart its human essence. Ortega y Gasset reasoned that such a break with familiarity necessitated not only an initial unpopularity but also a groundswell in rejection.[29] The solution, he felt, was to teach the masses to understand this novel art. Through a philosophical approach, Ortega y Gasset attempted to provide a justification for the new art, together with a conception of culture that denied ethnocentrism, especially with respect to European populism.[30] The decline of Europe and, specifically, imperial Spain, played itself out in literary circles between the Generations of 1898 and 1927.

The Spanish Poets: Between the Generations 1898 and 1927

As art critic Catherine David contends, "it is important to place Lam in the context of Spain at the end of the century, between the Generations of 1898 and 1927. All that was and all that was to be: The lost empire."[31] With the traumatic loss of the colonies in 1898, the last being Cuba, Spain's writers and philosophers reflected deeply on that lost empire and Spain's relevance in the world. These writers were known as the *Generación del 1898* and included Miguel de Unamuno, the foremost intellectual of the day. Unamuno's own personal anguish over the state of his soul was used to express metaphorically the national angst and soul-searching reflective of that period. Politically, his writings rejected a move toward a European model or a modernization of Spain.[32] Creatively, however, his writing displayed novel, experimental elements, and this innovation may have even lent encouragement to the new, burgeoning

Spanish avant-garde movement and its many literary pro-liferations that erupted between 1909 and 1927.

Lam's experience in Spain transpired on the heels of this pervasive Iberian identity crisis. More important, however, was Lam's familiarity with the two figureheads that bookended those generations: Unamuno, the spiritual representative of the Generación del 98 and Ortega y Gasset, the intellectual powerhouse of the Generación del 27. Catherine David notes that, while in Madrid, Lam met Miguel de Unamuno, Ortega y Gasset, as well as Federico García Lorca.[33] According to art scholar Ámparo Lopez Redondo, between Lam's arrival in 1923 and 1932, he met with writers from the Generación del 98 such as Spanish novelist and literary critic José Augusto Trinidad Martínez Ruiz, better known by his pseudonym Azorín, and Ramón del Valle-Inclán.[34] Núñez Jiménez affirms that "while seated in the cafés of Madrid, Lam met frequently with Azorín, Valle-Inclán and Miguel Angel Asturias as well as other writers."[35] Theirs was a quest for defining the true essence of Spain. Reaching back for inspiration from those satirical poets of the baroque age, they found solidarity in the shared despair over the crumbling national state. Reaching forward toward regeneration, they experimented with bold innovations, maintaining the baroque construct. The legacy of the Generación del 98 is one of probing, of questioning, and of exploring, manifested in writings that displayed a free play of ideas and forms.[36] Their influence continued to be felt during the first decades of the twentieth century, inspiring the next generation of Spanish writers and poets. Catherine David emphasizes the impact of the Generación del 98, noting that: "In the literary scene the final echoes of the Generation of '98 still muffled the voices of the poets of '27."[37]

Of particular impact on Lam from the Generación del 98 was Miguel de Unamuno. Rector at the University of Salamanca, Unamuno had a profound influence on Lam during the Spanish writer's frequent visits to Madrid. Lam remembered feeling a sense of admiration for this great intellectual, especially when Unamuno was removed from his university position in 1924 under the dictatorship of Miguel Primo de Rivera. Forced into banishment in Fuenteventura, Canary Islands, Unamuno escaped and fled to

France, where he spent one year in Paris. When Primo de Rivera's dictatorship fell in 1930, Unamuno was reinstated as rector of the University of Salamanca. Wifredo Lam reflected on his great admiration for this man and the inspiration he drew not only from his personal story but also from his works:

> That man seemed to be prepared to liberate great battles; always combative and, of course, …he knew how to defend the purest essence of what is Spanish, above all in those moments that were really difficult for him: his exile to the small island of Fuenteventura. At times I think that, like in me, it was in exile where his feelings for the sea became nostalgia. That is why his poems in *De Fuenteventura a Paris* are very close to my heart. When I least expect it, I feel as though those verses assault me…I have carefully gone over his works *Vida de Don Quijote y Sancho*, *Del sentimiento trágico de la vida*, *Paisajes*, *La agonía del cristianismo* and that extraordinary book that is *De mi país*. What a prolific writer![38]

Lam's familiarity with the writers Miguel de Unamuno and José Ortega y Gasset is summed up in the following reflection in which Lam clearly grasps the polarity of their individual interpretations on the Iberian peninsula's geographic and philosophical positioning in the modern world: "[Unamuno] swore that the Pyrénées separated Europe from Africa; that the Spaniards were African and that Spain was part of Africa. That is how he thought: The opposite [could be said] for Ortega y Gasset who fought for the westernization of Spain."[39] The inward thrust of the Generación del 98 was replaced by the outward thrust of the Generación del 27, which led directly to surrealism. The bridge between the avant-garde and surrealism was constructed precisely by the Generación del 27. Harris explains, "The Generation of 1927 absorbed the frenetic of the avant-garde into their continuation of symbolism based on the idea of pure poetry borrowed from Paul Valéry; poetry that eschewed any emotional, ideological, moral aims. Thus they maintained the elitism of the avant-garde while abandoning the agitprop attitudes that sought to change the world."[40]

Lam, a contemporary of that generation, studied and lived within this artistic milieu. According to Núñez Jiménez, "Lam attended the Ciudad Universitaria de Madrid, the academic world in which Buñuel, Dalí, Lorca and other Spanish cultural greats were formed. Ortega y Gasset practiced his teaching profession here."[41] Additionally caught up in this avant-garde fervor were young intellectuals from Latin America studying in Madrid. Lam's friendships with Cuban writer Alejo Carpentier (fig. 1) and, later, with the poet Nicolás Guillén, were framed within those turbulent years in Madrid. These friendships would last a lifetime.[42] For all three, the bridge between avant-garde Spain and surrealism would eventually extend back to Cuba.

Surrealism in Spain

In the meantime, surrealism arrived in Spain with trumpets blaring. Undoubtedly, Spain produced many of the greatest surrealists: in painting, Salvador Dalí, Joan Miró, Remedios Varo, and, arguably, Pablo Picasso; in film, Luis Buñuel; in poetry, many from the Generación del 27, Vicente Aleixandre, José María Hinojosa, Luis Cernuda, Rafael Alberti, and Federico García Lorca, whose works after 1926 display distinct surrealist tendencies. Surrealism swept through Europe and arrived in Spain, reaching Barcelona first, and, subsequently, Madrid. It took hold in Spain in a most spirited fashion, assuming a decidedly different hue partly due to a certain affinity with Spanish culture. Perhaps the most emblematic Spanish surrealist poet, Rafael Alberti, explained it in this way: "Spanish tradition exalted the illogical, the subconscious, the monstrously sexual, the dream and the absurd."[43] Indeed, Dalí opens his lecture "Phenomenological Aspects of the Paranoiac-Critical Method" at the Sorbonne on December 17, 1955 with this declaration: "France is the most intelligent country in the world, the most rational country in the world. Whereas I, Salvador Dalí, come from Spain, which is the most irrational and the most mystical country in the world."[44]

Dalí's statement reflects the contradictions inherent in the Spanish reaction. The rebellious individualism characteristic of Spain manifested itself in a receptivity to surrealism as well as a paradoxical reticence to adopt the French import. From the beginning, French surrealism received bad press in Spain, but, interestingly enough, for the first time since the eighteenth century, Spain demonstrated itself to be receptive without the traditional lag.[45] Lorca scholar Marie Laffranque affirmed that, "Surrealism in Spain linked the antirealist and the anticonformist poetic, neo-baroque inspiration that was never abandoned. It culminated around 1924 in the homage to Góngora and the neo-gongorism poetry."[46]

Spanish surrealist literary critic Robert Havard also identifies the particular distinctiveness of Spanish surrealism with its baroque origins, but refines it even further, observing that a "context saturated in religion" imbued it with its own particular ethos. He states:

> The distinctiveness of surrealism in Spain was directly related to its indigenous cultural roots (such as Goya, Quevedo and Góngora) and formative milieu (the receptivity of avant-garde precursors) as well as a context saturated in religion. While religion in the surrealist movement was rejected in the form of morals and the banishment of Freudian super-ego controls, it paradoxically ran consistent with surrealist precepts in both the negative, in that it often produced neuroses through repression, as well as the positive, through an imagery rich in biblical references reflected through characteristic patterns of articulation.[47]

This tendency to implement recurring religious imagery as a literary device resonated in the poetry of Rafael Alberti's *Sobre los ángeles* (*Concerning the Angels*) as well as that of Federico García Lorca in his *Poeta en Nueva York* (*Poet in New York*), and *Crucifixión*. So ingrained was religious iconography in Spanish surrealism, that it commonly appeared in allegorical metaphors. According to Derek Harris, "the young poets of the Generation of 1927 produced some of the most intense, lacerated, rehumanised poetry of their time like Rafael Alberti's *Concerning the Angels* and Lorca's *Poet in New York*."[48]

Lam was familiar with these two poets of the Generación del 27,[49] though it would be a stretch to claim they explicitly influenced his oeuvre. Nonetheless, iconographic and philosophical correlations among their works are clearly

noticeable, which emerged through the artists' direct participation in the surrealist movement. In Alberti's collection, *Concerning the Angels*, published in the summer of 1929, the poetry reflected a growing sense of alienation, not only personal but generational. Alberti adopted a messianic voice in this collection: the commonality between the prophets and the surrealists was the desire to let the source speak freely. According to the surrealists, inspiration should be born from internal sources, often reflected in the poet-seer's utterances, thus bearing comparison to psychic automatism. Subsequently, imagery was discussed, internalized and interpreted, according to the artist/poet. Take Lam's painting *Casas Colgadas, III*, 1927 (plate 5). Curvy, personified forms replace the impersonal, linear, architectural renderings exemplified in *Plaza de Segovia, Madrid*, 1923 (plate 1). Houses stacked vertically seem to peer out through black windows, suggesting vacuous eyes confronting the viewer. The curvilinear forms in the painting recall Wölfflin's baroque description: "The baroque uses the same system of forms, but in place of the perfect, the completed, gives the restless." The restless gives way to alienation, reflected in the somber tones and the darker cast of the scene. Rafael Alberti deftly captures the same mood in the poem, "El cuerpo deshabitado" ("The Uninhabited Body"):

> Dawn.
> The light, dead on the corners,
> and in the houses.
> Neither men nor women
> were there anymore
>
> "Get out."
>
> My body remained empty,
> a black sack at the window.
>
> It left.
>
> It left, circling the streets.
> My body went out with nobody in it.[50]

In another painting from that period, *Composición, I*, 1930 (plate 6), we see in the foreground a sensual, erotic female (the heavy application of makeup could possibly identify her as a prostitute) whose presence commands full atten-

tion. Behind her and dwarfed in size, stand two men in sailor suits, one whose back is to the viewer while the other faces forward. The latter raises his hands to cry out into the void. Behind them, stairs dissolve into an abstract, geometrical path, which leads to a bridge where a lone figure emerges. In the background, a full moon casts a glow over water, shedding its light on a mysterious, oneiric scene.

In the same poem, "The Uninhabited Body," Alberti incorporates similar imagery:

> You. I. (Moon.) By the pool
> Green arms and shadows
> tightened about your waist.
>
> I remember. I don't remember.
> Ah yes. A suit of clothes went by
> uninhabited, hollow,
> slaked lime between the trees.
> I followed…Two voices
> told me it was no one. […]
>
> Alone, on the world's sharp edge,
> immobile now, cast in plaster.
> He's not a man,
> he's a wet, black void
> in which nothing is visible.
>
> A cry.
> Nothing!
>
> A void, without an echo.[51]

Continuing this same theme of alienation, or perhaps inspired by it,[52] Lorca wrote a collection of poems entitled *Poeta en Nueva York* during his visits to New York, Vermont, and Cuba from June 1929 to March 1930.[53] Much in the same way that Alberti's poetry lends itself to the iconographic surrealist imagery found in Lam's *Composición, I*, so, too, do Lorca's poems find similar resolution in *Composición, II*, 1931 (plate 7). In this painting, a general sense of despair and resignation pervades the canvas. An amputated leg in the background tramples unsuspecting persons underfoot. People flee with hands raised high in distress. A rooftop shows a man decapitating another, head clutched in one hand, knife in the other, while red blood runs down the side of a dark, foreboding building.

In the foreground, we see a cluster of women, no longer objectified as sexual but now revealed as sacred, depicted as mothers. The religious iconography of the Virgin Mary and the infant Jesus is juxtaposed against somber, eerily ghostlike faces. The women reveal deep circles around closed eyes that peer out of blank faces. The child's face, egg-shaped and white, reveals a similar blankness, against which a gray pallor encroaches. These are the faces of deep resignation; they are joyless and passive, perhaps faces that grapple with death, which might refer to Lam losing his wife and son to tuberculosis in that same year. In one of Lorca's poems, "Vuelta de Paseo" ("After a Walk"), the poet expressed the degradation of nature and the experience of human torment in New York, which perhaps functioned as an extended metaphor for the poet's tormented self. Lorca's reference to the loss of limbs or to mutilated nature works both emotionally and intellectually, depicting an utter lack of joy.

> Cut down by the sky.
> Between shapes moving toward the serpent
> and crystal-craving shapes,
> I'll let my hair grow.
>
> With the amputated tree that doesn't sing
> and the child with the blank face of an egg.[54]

In this collection, Lorca narrated a spiritual voyage based on a sense of increasing oppression in the alien metropolis. While in New York to learn English at Columbia, Lorca gave a lecture in which he mentioned his poem "Danza de la muerte" ("Dance of Death"). He noted that he had imagined "the typical African mask, death which is truly dead, without angels or 'Resurrexit'; death totally alien to the spirit, barbarous and primitive as the United States, a country which has never fought, and never will fight, for heaven."[55] In that poem, Lorca writes:

> *The mask. Look how the mask*
> *comes from Africa to New York.* [...]
>
> While the Chinaman wept on the roof
> without finding the naked body of his wife,
> and the bank director examined the manometer
> that measures the cruel silence of money,
> the mask arrived on Wall Street.[56]

And in another poem, "El rey de Harlem" (The King of Harlem"), Lorca describes:

> Blood flows, and will flow
> on rooftops everywhere
> and burn the blond women's chlorophyll,
> and groan at the foot of the beds near the wash-
> stands' insomnia
> and burst into aurora of tobacco and low yel-
> low.[57]

Lam's strong association with Spanish luminaries and the avant-garde movement, grounded in religious precepts and iconography, would have had a direct impact on his surrealist artistic development. Indeed, the anthropologist and Cuban-African specialist, Fernando Ortiz stated:

> The painting of Lam has religion and magic but it is still indistinguishable between them. Religion and magic consumed, as in the primal distance of the human recesses, when concepts or concrete figures of the forces of mystery had not even yet been formed. It is sacramental magic, even better, it is mystalogical or apocalyptical, because it attempts to reveal to us the powers of the Great Mystery that coexist with us, invisible and magnificent.[58]

While Lam was never explicitly religious, his exposure to Santería in Cuba along with his exposure to Catholicism in Spain, and his cultural access to those religious symbols, made for a transmutation in his imagery consistent with the precepts of Spanish surrealism. As evidence of this symbolic religious dexterity, Nuñez Jiménez observed, "From the magic world of Sagua, Lam shifted to the religious world of Spain."[59]

Spanish Civil War

Lam's extensive familiarity with contemporary literature and writers was reflective of a soul in search of communion. Through his participation in the modern movements Lam was able to address personal, moral, and aesthetic questions driving the concerns of a foreigner in a strange land. He appears also to find solidarity with the writings of a disoriented society. Arriving from Cuba with no fam-

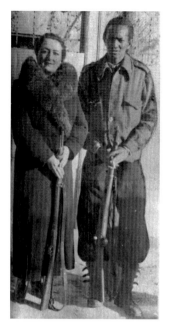

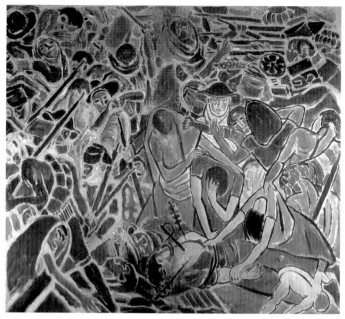

3. Balbina Barrera and Wifredo Lam in Barcelona, 1936.

4. Wifredo Lam, *La Guerra civil [Guerre civile espagnole]*, 1937 [37.16]. Gouache on paper, 211 x 236 cm, private collection.

ily in Spain, Lam was thrown into a particularly turbulent social and political environment. The literary movements in Spain reflected a reaction to the turbulence, manifested in the avant-garde tendencies to which Lam was so profoundly drawn. Rebellion was in keeping with the political movements of that time. While maintaining a fragile neutrality during the First World War, Spain was, nonetheless, subject to the internal turmoil of the twenties in which the Republicans, champions of an independent, anti-dynastic government, found sympathy with syndicalists and socialist sympathizers. Fearing this increasingly strong opposition, King Alfonso XIII aligned himself with the army and, on September 23, 1923, Miguel Primo de Rivera, backed by both the king and the army, staged a military coup d'etat, suspending all constitutional rights. The political upheavals of the twenties continued with a period of military dictatorship under Primo de Rivera, in which the intellectuals were targeted, forcing their exodus. Intellectual centers, such as the *Ateneo* in Madrid, were shut down.[60] The dictatorship ended in 1930, when the king convinced Primo de Rivera to resign. However, in the elections of 1931, King Alfonso XIII was unable to stem the tide of support for the Republicans, and he and his family fled the country two days after the Second Spanish Republic was declared on April 14, 1931.

Despite Republican optimism, 1931 marked a year of personal tragedy for Lam: he lost both his wife, Eva Piriz and, days after, his infant son, Wilfredo Lam, to tuberculosis.[61] As Lam recounted to Max-Pol Fouchet, "My grief deprived me of all enthusiasm for life, even of the strength to go on living. I had to overcome my feelings, but it was hard."[62] Despite the personal hardships, Lam exhibited his work in the *Círculo Artístico* of Leon in 1932.[63] That same year, distressed by the dire poverty he encountered in Spain, Lam declared his support for the Republican party. As if to mirror Lam's own personal upheaval, national peace and prosperity remained elusive for the new Republic. The coalitions that had formed alliances with the Republicans (i.e., socialists, communists, syndicalists) and the Nationalists (i.e., army, church, state, monarchists) found themselves at odds with each other. A tenuous balance was supported only for a time. In 1936, the Spanish Civil War erupted. Lam enlisted in the service of the Republicans: first producing propaganda materials and posters and eventually participating in the siege of Madrid, which began in 1937.[64]

Severely depressed, Lam turned to his compatriots and companions for support, among whom was a Republican by the name of Balbina Barrera de García de Castro (fig. 3). Balbina Barrera, married and with several children,

initiated a friendship with Lam that would later lead to an intense liaison. Her voluptuous figure appears in many paintings of the period, indicating great complicity in their relationship. Her care and love during those turbulent war years would provide Lam with the healing forces needed to sustain his painting. During that period, Lam began to explore Matisse's influences in some of his own works such as *La Ventana, I*, 1935 (plate 10); along with a double-sided painting, *Untitled*, 1937 (plates 11–12), and *[Retrato de la Sra. García de Castro, II]* (Balbina Barrera), 1937 (plate 13).[65]

By 1937, Lam's work began to display a phase of experimentation, as he gradually introduced geometrical imagery as is evidenced by the paintings *Untitled* (plate 12); *Untitled*, 1937 [37.32]; and his extraordinary *La Guerra civil* (fig. 4). This startling innovation, supported by the avant-garde currents, marked a shift in Lam's painterly lexicon present in his Spanish period up to that point. It was in Spain, not France, where Lam was first exposed to African art at the Museo Arqueológico Nacional in Madrid and he wrote of the lasting impression of viewing those sculptures.[66] In 1936, a traveling show of works by Pablo Picasso came to Spain and it was in Madrid that Lam first viewed this artist's work. Lam reported having felt an immediate affinity for Picasso and his painting, which he described as "exaltation."[67] Undoubtedly, the apex of Lam's production during the Spanish period is his masterpiece *La Guerra civil*, Lam's personal homage to the Republicans' tragic attempt to defeat General Franco's Nationalist forces. Like Picasso's *Guernica*, 1937, painted after Franco invited German and Italian forces to bomb the northern Spanish Basque town of Guernica, Lam paints his own heart-wrenching commentary on the vagaries of war.[68] Both masterpieces were painted for the Spanish Pavilion of the World Fair in Paris in 1937. After working in the Ministry of Propaganda during the Spanish Civil War, Lam was hospitalized outside of Barcelona with symptoms of overwork and malnutrition.[69] While convalescing, Lam designed sets for a theater production at the hospital. A fellow patient, the sculptor Manuel (Manolo) Hugué, discovered Lam's work and enthusiastically provided a letter of introduction to his fellow Spaniard, Pablo Picasso, now living in Paris. In 1938, Lam left Spain and the war

for a new, promising future in a country as yet untouched by war. He was thirty-five.

Surrealism in France

At Picasso and Lam's first formal meeting, Picasso is known to have famously quipped, "you remind me of someone that I knew many years ago…me."[70] Of their relationship, Lam described the influence that Picasso had on his work stating:

> I had done my own paintings in a synthetic style, in an attempt to simplify my forms, before discovering his [Picasso's]. Our plastic interpretations simply coincided. I already know the Spanish temperament, for I had lived it, suffered it, in the country itself. Rather than an influence, we might call it a *pervasion of the spirit*. There was no question of imitation, but Picasso may easily have been present in my spirit, for nothing in him was alien or strange to me.[71]

Indeed, in a recent interview with Eskil Lam, the artist's son and president of the SDO Wifredo Lam, Mr. Lam reflected on the life-long relationship between these two great artists and suggested that the greatest effect that Picasso had on his father was to "empower" Lam's work.[72] Geometrical shapes superimposed onto African mask-like two-dimensional faces surface in the works of *Le Repos du modèle [Nu]*, 1938 (plate 14); *Mère et enfant, II*, 1939 (plate 17); *Femme*, 1939 (plate 18); and *Untitled*, c. 1940 (plate 20). Picasso's tacit approval allowed Wifredo Lam the freedom to develop his own style and propelled him forward with confidence into the world of the French surrealists. His involvement with André Breton and the other surrealists created an equally strong thematic development in his work. Helena Holzer, a German scientist whom Lam had met briefly in Barcelona in 1938, also became a source of inspiration for Lam's work when they reconnected in Paris,[73] eventually marrying in 1944 in Havana. It was in the Château de Bel-Air in Marseilles (fig. 2), at the last surrealist gathering before the outbreak of the Second World War (with Max Ernst, Peggy Guggenheim, André Breton, Victor Brauner, Óscar Domínguez, among others), that the fusion of the surrealist elements and the African

13

motifs came to fruition in the sketchbooks of Lam (plates 22–27).[74] These drawings were the basis of illustrations for André Breton's poem *Fata Morgana*.[75] These inchoate themes would form the seedbed for the style that would be cultivated in what is considered Lam's most important period, his return to Cuba.

Crosscurrents of Surrealism and Magical Realism

Desperately anxious to leave France, especially after Helena Holzer had been briefly interned in a camp in Oloron, France, Lam and Holzer found their chance.[76] Along with various surrealist compatriots, they set sail on the *Capitaine Paul Lemerle* bound for Martinique in 1941. André Breton, his wife Jacqueline, and their daughter Aube; ethnologist Claude Lévi-Strauss; writer Victor Serge, as well as over three hundred other intellectuals, accompanied them. Amidst the misery of the four-week travail, as Lévi-Strauss reveals in his book *Tristes Tropiques*, "Throughout this interminable voyage, we passed the time discussing the relationship between aesthetic beauty and absolute originality."[77] Many surrealists intended to continue on to diaspora surrealist hubs, principally the United States or Mexico, but Lam was to return home to Cuba.[78] Serendipitously, in April the *Capitaine Paul Lemerle* stopped over in Fort-de-France, the capital city of Martinique. On a walk to the store to buy his daughter a ribbon, Breton discovered a copy of a review published in Martinique under the title *Tropiques*. Its surrealist content astounded him. Two men, the intellectual René Ménil and the poet Aimé Césaire, had founded the review. Their purpose in publishing the review was to provide a response to the pro-Nazi Vichy government whose censorious and racist policies had worsened an already difficult postcolonial climate for blacks in Martinique.[79] Like many from Latin America and the Caribbean who had continued their education in Europe, Césaire spent time in Paris from 1932 to 1939. Not surprisingly, he had been exposed to the surrealist movement, in which he found the personal and countercultural aesthetics that would frame the groundwork for his involvement in the Négritude movement.[80] This involvement was summed up in his lyrical but forceful epic poem, *Cahier d'un retour au pays natal,* first published in a Parisian journal in 1939. In

1943, Lam conceived the illustrations for a Spanish translation, *Retorno de un país natal,* by Lydia Cabrera. The poem was a call to action for the Négritude movement, demanding a complete severance from colonialism. The ethnic validation garnered through the denial of European centrism would eventually allow Lam and others (like Césaire) to wager on the independence of Latin American culture. This wager set the stage for Lam's subsequent positioning of himself between surrealism and magic realism. The meeting of Césaire and Lam, ironically both on returns to their native lands, must have resonated deeply within each. Their collaborations lasted over their lifetimes; so, too, their friendship (fig. 5).

Four months after setting sail from Marseilles, Lam finally set foot on Cuban soil once more.[81] Eighteen years had transpired and Lam had changed, having lived to the fullest both tragedies and fortunes. As a black man in Spain, Lam confessed to never having experienced racism, nor to being perceived as inferior due to his colonial heritage. In an interview with Núñez Jiménez, Lam recounted: "I could confirm that [in Spain] there was no racial discrimination against the blacks. [...] Never was I humiliated because of my color. Never."[82] This treatment, so emphatically relayed, must have seemed incongruent in this novel, yet familiar, postcolonial climate. Lam is quoted in an interview with Max-Pol Fouchet as stating: "If you want to know my first impression when I returned to Havana, it was one of terrible sadness. The whole colonial drama of my youth seemed to be reborn in me."[83]

To witness first hand the degradation of the blacks, especially on an island whose tourist industry lent itself to a certain caricature of the black man and woman, warranted critique. The sad condition of the black man, no longer yoked to the indignity of slavery yet chained to inferiority, forced Lam to reflect on the plight of the black man and woman. His weapon of both acknowledgment and denunciation would become his paintbrush. Lam would join poets Aimé Césaire and Nicolás Guillén in their struggle for universal acceptance and human dignity. As Lam stated in his oft quoted "manifesto":

> Poetry in Cuba then was either political and
> committed, like that of Nicolás Guillén, and a

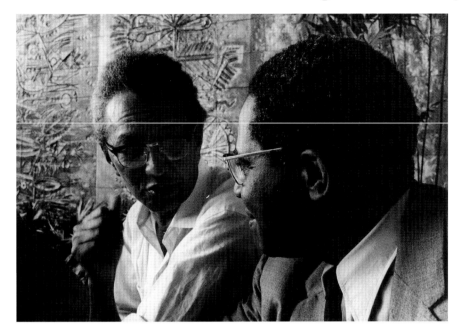

5. Wifredo Lam and Aimé Césaire at the Congrès Culturel in Havana, 1968.

few others, or else written for the tourists. The latter I rejected, for it had nothing to do with an exploited people, with a society that crushed and humiliated its slaves. No, I decided that my painting would never be the equivalent of that pseudo-Cuban music for nightclubs. I refused to paint cha-cha-cha. I wanted with all my heart to paint the drama of my country, but by thoroughly expressing the Negro spirit, the beauty of the plastic art of the blacks. In this way I could act as a Trojan horse that would spew forth hallucinating figures with the power to surprise, to disturb the dreams of the exploiters. I knew I was running the risk of not being understood either by the man on the street or by the others. But a true picture has the power to set the imagination to work, even if it takes time.[84]

Here Lam speaks with the passion of the poets. His integration into the European poetic movements, breeding grounds for manifestos, had proven valuable: theories on his artistic style began to coalesce in this colonial context. His painterly lexicon would harness the imagination of surrealism and wed it to the new consciousness of magical realism. Lam noted that his "return caused a great stimu-

lation of my imagination…the exteriorization of my world has always responded to the presence of factors that emanated from our history, from its geography, tropical fruits and black culture. […] Latin America is an unreal world to the rational mind whose form of thinking is founded on very different historical grounds from our own."[85] The marvelous American reality, simply stated, fused the rational with the irrational, the acceptable with the unacceptable, the corporeal with the mystical. Drawing on a direct link between the works of Lam and the baroque influence on hybridization, Alejo Carpentier states: "All the magic, the imponderable, the mystery of our environment, reveals itself in his [Lam's] recent works with an impressive force. There is a certain baroque style in these exuberant compositions, gravitating around a solid central axis. The figures are metamorphosed."[86] Hybridization had found its platform; Lam was its new poet.

His voice resonated deeply in his new environs. Lam's first full year in Cuba heralds a whole new direction in his painting as is evidenced in *La Réunion*, 1942 (plate 28) and *Anamu*, 1942 (plate 29). These works demonstrate how Lam's surrealist roots evolved to culminate in his characteristic hybrid style, foremost among the paintings being *La Jungla*, 1942–43. Alejo Carpentier identified Lam's particular hybridization as marking a new direction in painting,

15

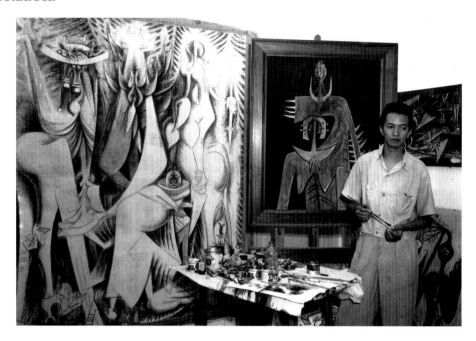

6. Wifredo Lam with *Le Présent éternel*, 1944 [44.04] (l) and *Le Sorcier de l'océan*, 1947 [47.45] (r) in his Havana studio, 1947.

stating: "This monumental painting…constitutes a transcendental contribution to the new world of the American painting. There is creation in function of the environment. Reality and the dream world become confused. Poetry and painting become one. There is an atmosphere of myths and of color, thoroughly original. There exists a world unto its own."[87] *La Jungla* is widely regarded as one of the quintessential masterpieces of that rich decade, along with *Le Présent éternel*, 1944 (fig. 6). Close examination of these two masterpieces lends itself to various political and social interpretations, more metaphorical than literal. Indeed, Lam pointed out that the title of *La Jungla* "has nothing to do with the real countryside of Cuba, where there is no jungle but woods, hills and open country and the background of the picture is a sugar cane plantation."[88] Lam provided a description of the latter painting: "the figure on the left is a…whore. […] From her heart comes…an animal's paw… she evokes cross-breeding, the degradation of the race. The figure on the right has a knife, the instrument of integrity, but he makes no use of it, he does not fight. He suggests the indecision of the mulatto, who does not know where to go or what to do."[89] In a personal interview, Lam told Max-Pol Fouchet "from childhood there had been something in me that was leading to [*La Jungla*]. […] My idea was to represent the spirit of the Negroes in the situation in which they were then."[90] But, according to Fouchet, overt political protest was never to be Lam's style; he would rather use "poetry to show the reality of acceptance and protest."[91] This poetry is evidenced in many of Lam's greatest known works from that decade such as *Le Sombre Malembo, Dieu du carrefour*, 1943 (plate 30); *Oya*, 1944 (plate 36); and *Au défaut du jour*, 1945 (plate 37).

Inspired by his trip to Haiti in 1946, elements of voodoo, Santería (a religion that combines elements of African Yoruba religion and Roman Catholicism), and other forms of syncretism are reflected in many of his works over the duration of the Cuban period, ending, along with his marriage to Holzer, in 1951.[92] One such work is *L'Action*, 1946 (plate 40), painted for an exhibition that same year in Haiti. Another recurrent motif is the horse-headed woman also commonly referred to as *femme-cheval* or *mujer-caballo* and exemplified in the work by the same name, *Femme-Cheval*, 1948 (plate 45). According to scholar and art critic Julia Herzberg, the horse-headed woman is a hybrid whose human, horse, and vegetal features combine to suggest a spiritual union between the devotee and the deity.[93] By the late 1940s, this signature leitmotif was recognizable with her horned appendages, which gradually become ears and her elongated face with its prominent muzzle.[94] These motifs would be reworked throughout Lam's practice to

symbolize different meanings during the evolution of his work. The Cuban writer and art critic Gerardo Mosquera avers: "There is no precise symbolism in Lam. […] His references to Afro-Cuban religious-cultural complexes are very indirect." Mosquera goes on to opine, "Lam was only trying to transmit, through the topological medium of modern art, a cosmic vision conditioned by the living African factors in his culture of origin and a general mystical sense that emanates from it."[95] Representing a new understanding of Wifredo Lam as a global artist, Lam's unique aesthetic is here seen as expressing multiracial and multicultural aspects of his heritage and experience.

Lam and the Poets

Living and working in Cuba and Europe in the fifties, and spending long stretches of time in the United States, Lam eventually settled in France and Italy. In this final period, Lam's style evolved from a lexicon of hybridity—reflected in a revolution of ideas and forms—in the forties, to a more abstract reading in the fifties, as evidenced in *Untitled*, 1958 (plate 52) and *Près des Îles Vierges*, 1959 (plate 53). In 1957, his son Stephane-Manuel is born. In 1960, Lam married his third wife, Lou Laurin. With Lou Laurin-Lam, Wifredo had three sons, Eskil, Timour, and Jonas. During his later period, extending over the sixties and seventies, we see the culmination of Lam's personal iconography in the works of *Grande Composition*, 1960 (plate 54); *À la fin de la nuit*, 1969 (plate 55); *Les Abalochas dansent pour Dhambala, dieu de l'unité*, 1970 [70.72]. These works are some of Lam's strongest paintings, in which he was able to demonstrate a metamorphosis of imagery that came to define his signature painting style.

Nurturing his painting throughout the decades was Lam's constant interest in graphic work, inspired by the poets. Indeed, Lam is quoted as saying "I have never created my pictures in terms of a symbolic tradition, but always on the basis of a poetic excitation. I believe in Poetry. For me it is the great conquest of mankind."[96] Early exposure to poets and writers Rafael Alberti, Federico García Lorca, Alejo Carpentier, and later collaborations with André Breton and Aimé Césaire set precedents for a series of portfolios throughout the decades. These resulted in outstanding contributions to the twentieth-century poetic canon. In

1947 Lam created his first lithograph to accompany the catalogue *Le Surréalisme en 1947*, on the occasion of the inauguration of the *Exposition internationale du Surréalisme* at the Galerie Maeght.[97] That same year, Lam made another lithograph, *Quetzal*, at the request of Robert Altmann, art director of Brunidor Editions in New York. This work, together with the works of a group of world-recognized artists (Roberto Matta, Yves Tanguy, Max Ernst, William Hayter, Kurt Seligmann, and Joan Miró), was commissioned for a portfolio prefaced by Nicolas Calas.[98] According to art critic Roberto Cobas Amate, "these initial engravings paved the way for a prolific graphic work that [paralleled] his performance as a draftsman. […] The prints made in the forties and fifties contain elements of Lam's iconography which appeared for the first time in notes and sketches and were later transposed to his painting."[99] Urged to try his hand at lithographs by Asger Jorn, a Danish artist who lived in the seaside Italian village of Albisola Mare, Lam created a series of eight color lithographs in 1958. Soon, Lam discovered a new direction as an artist, experimenting with original techniques in his graphic works. Surrounded by an active community of artists in Albisola Mare, Lam purchased a home in the seaside community in the early sixties. There, Lam honed his skills for sculpture, lithography, ceramics, and etchings. In all media he was considered a master; in etchings, Lam had truly found his passion. Principal to that endeavor was Lam's collaboration with Milan printer Giorgio Upiglio, who was able to create, through experimentation, the conditions necessary to allow for a flourishing of Lam's particular technique (fig. 7).[100] In the sixties and the seventies, Lam would embark on a final burst of creativity, collaborating on a series of projects in which he provided illustrations to poetic and literary texts.

Lam's collaborations with the poets and writers of the day led to some of his most exquisite artistic renderings. In 1966 alone, Lam produced three tremendously important graphic works: a series of nine engravings which accompany the text *L'antichambre de la nature* by Alain Jouffroy, a nostalgic poem on the first encounter between Jouffroy and Breton in Bretagne; five etchings and aquatints for the text of *Le théâtre et les dieux*, by the surrealist Antonin Artaud; and fourteen delicate engravings for the poem *Apostroph' Apocalypse* by Gherasim Luca, the latter published on

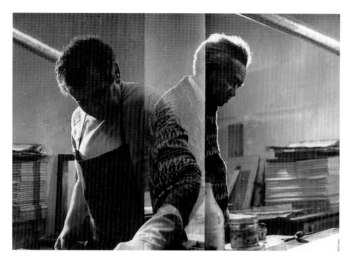

7. Giorgio Upiglio and Wifredo Lam in Upiglio's workshop, Milan, c. 1975.

8. Wifredo Lam, untitled lithograph from *El último viaje del buque fantasma*, 1976 [354/7608].

January 1, 1967. In 1969 Lam produced a striking group of nine etchings (plates 56–64). Upon seeing them in Lam's studio ten years later, Aimé Césaire felt inspired to write a series of accompanying poems, fulfilling both Césaire and Lam's long-shared wish to collaborate on an artistic project. *Annonciation*, a title conceived of by Lam, included an epigraph by Lam in honor of his godmother Mantonica Wilson, ten poems by Césaire, and seven of the 1969 etchings.[101]

Finally, among Lam's many collaborations in the seventies, Lam conceived of a series of twelve lithographs to accompany the short story *El último viaje del buque fantasma* by Gabriel García Márquez (fig. 8). According to Cobas Amate, this was "undoubtedly one of his most esteemed works as an engraver, since he succeeded in creating a rich artistic invention that integrates and enriches the exuberant imaginative display of the marvelous American reality, characteristic of the literature of the Colombian writer."[102] This marvelous reality, rooted in the exuberance of the baroque, the supernatural, and the syncretic provided the essence for Lam's paintbrush to soar to new heights providing an eloquence all his own.

In an interview in Cuba in the late 1970s Lam said: "I would have liked to have been a writer because I think the word is the most eloquent element that exists. But I don't think I have the gift of words. Nevertheless, painting can be as eloquent."[103]

Max-Pol Fouchet perhaps sums up Lam's identity in the most profound way: "Wifredo Lam was a painter and, to no less a degree, a poet of forms and images."[104] Elaborating on that metaphor, Ortega y Gasset would no doubt agree that Lam's work exemplifies the poetic imagination. He states: "The humans' lot is to live their lives, the poets' to invent what is non-existent. The poets enhance the world by adding to reality, which is given, the continents of their imagination. [...] Art has no right to exist if, content to reproduce reality, it uselessly duplicates it. Its mission is to conjure up imaginary worlds."[105]

This, then, is Lam for our time: poetic visionary imagining new worlds.

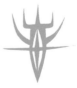

I would like to thank all those who have helped me in writing this essay, especially Roberto S. Goizueta and Claude Cernuschi for their insightful recommendations and invaluable editorial suggestions. I am also deeply grateful to the McMullen staff: to director Nancy Netzer for her unwavering support of Latin American art and for believing in this exhibition, despite the obstacles, from the beginning; to assistant director Diana Larsen for the stunning installation; to assistant director John McCoy for his creative inspiration and implementation of all design elements; and to publications and exhibitions manager Kate Shugert for her tireless persistence in organizing complex loans and for her keen editorial skills. I would also like to thank Moraima Clavijo Colom, former director, and Roberto Cobas Amate, curator of Cuban avant-garde art, at the Museo Nacional de Bellas Artes in Havana for their steadfast support of the project over the years and for providing access to Wifredo Lam's works in the museum. My sincere appreciation goes to Eskil Lam for kindly sharing with me his recollections and impressions of his father, Wifredo Lam, and for his continued support and collaboration. Dorota Dolega at the SDO Wifredo Lam also provided valuable research and archival assistance for which I am most appreciative.

I am grateful to Provost David Quigley and the College of Arts and Sciences for providing two summer research grants (2011 and 2012), in partnership with the Office of International Programs, to conduct research at the SDO Wifredo Lam archives in Paris.

Finally, I would like to dedicate this essay to my father, William J. Thompson, sculptor, who introduced me to the beauty of art and to my mother, Claire E. Thompson, author, who introduced me to the beauty of literature. As Wifredo Lam might say, the deepest debt of gratitude is owed to all artists and poets.

1 "Pobreza imaginativa es aprenderse códigos de memoria." Miguel de Unamuno, *Contra esto y aquello* (Madrid: Renacimiento, 1912), 50. Also in Alejo Carpentier, *El reino de este mundo* (Distrito Federal: Compañia General de Ediciones, 1967), 9. Unless otherwise noted, all translations are my own.

2 Antonio Núñez Jiménez, *Wifredo Lam* (Havana: Letras Cubanas, 1982), 87.

3 José Manuel Noceda, ed., *Wifredo Lam: La cosecha de un brujo* (Havana: Letras Cubanas, 2002), 17–18.

4 Núñez Jiménez, *Wifredo Lam*, 86–87.

5 Mary Ann Caws, *The Surrealist Look: An Erotics of Encounter* (Cambridge: MIT Press), 1.

6 See Roberto Cobas Amate, "Wifredo Lam: The Ascending Spiral" in this volume for an examination of Lam's struggle to reintegrate himself into Cuba's cultural milieu.

7 Roberto González Echevarría, *Alejo Carpentier: The Pilgrim at Home* (Ithaca: Cornell University Press, 1977), 121–29.

8 Roh's book was read avidly in Latin America in a translation disseminated by José Ortega y Gasset's *Revista de Occidente* (ibid., 115).

9 For a complete discussion on *lo real maravilloso* and the distinction between the terms "magical realism" and the "marvelous American reality," see ibid., 106–29.

10 Ibid., 115.

11 Carpentier, *El reino de este mundo*, 7–17.

12 González Echevarría, *Alejo Carpentier*, 39, 60, 100.

13 Sigmund Freud, *The Ego and the Id*, trans. Joan Riviere (New York: W. W. Norton, 1989), 18–19.

14 André Breton, *Manifestoes of Surrealism*, trans. Richard Seaver and Helen R. Lane (Ann Arbor: University of Michigan Press, 1972), 26.

15 Ibid., 37, 38.

16 Ibid., 177.

17 Ibid., 125.

18 Ibid.

19 Ibid., 130.

20 Javier Gonzales Rovira, introduction to *Soledades y otros poemas* by Luis de Góngora y Argote (Madrid: Santillana Ediciones Generales, 2005), 10. Góngora's cave and bat analogies would not have been lost on Lam: he populated his works with bat figures throughout his life. Indeed, in interviews, Lam expounded on the definitive impression of his first encounter with a bat at age five, making it the subject of a whole section of a poem-biography, presaging later echoes of that moment. Max-Pol Fouchet, *Wifredo Lam*, trans. Kenneth Lyons (Barcelona: Ediciones Polígrafa, 1986), 15.

21 Heinrich Wölfflin, *Principles of Art History: The Problem of the Development of Style in Later Art* (Cambridge: MIT Press, 1999), 10.

22 Derek Harris, ed., *The Spanish Avant-Garde* (Manchester: Manchester University Press, 1995), 9.

23 Ibid., 1.

24 González Echevarría, *Alejo Carpentier*, 52.

25 In an interview Nicolás Guillén answered the question "what books were you reading when you wrote *Sóngoro Cosongo* [1931]?" He responded, "Laugh if you want! A book that had nothing to do with my position then: Ortega y Gasset, who was much in vogue then." "Conversación con Nicolás Guillén," *Casa de las Américas* 73 (July–Aug. 1972): 129.

26 González Echevarría, *Alejo Carpentier*, 53.

27 González Echevarría notes that Spengler's *The Decline of the West* appeared in Manuel García Morente's masterful translation (done with the assistance of Ortega y Gasset himself) in 1923 (ibid., 55).

28 Ibid., 56.

29 José Ortega y Gasset, *La deshumanización del arte y otros ensayos de estética* (Madrid: Revista de Occidente, 1991), 11–52.

30 José Ortega y Gasset in González Echevarría, *Alejo Carpentier*, 53.

31 Catherine David, "La invención del nuevo mundo: Dibujos 1914–1942," in *Wifredo Lam: Obras sobre papel*, exh. cat. (Barcelona: Fundación "La Caixa," 1993), 56.

32 Harris, *Spanish Avant-Garde*, 10.

33 David, "La invención del nuevo mundo," 56. Lam was at the very least familiar with Federico García Lorca's work as he states: "I was able to prove that in Spain there was no racial discrimination against blacks although there was against the gypsies, as one can appreciate in some of the poems of García Lorca." Núñez Jiménez, *Wifredo Lam*, 85.

34 Amparo López Redondo, *Wifredo Lam en Cuenca, 1925–1927* (Cuenca: Gráficas Cuenca, 1985), 10.

35 Núñez Jiménez, *Wifredo Lam*, 96.

36 Beatrice P. Patt and Martin Nozick, *The Generation of 1898 and After* (New York: Harper and Row, 1960), 5.

37 David, "La invención del nuevo mundo," 56.

38 Núñez Jiménez, *Wifredo Lam*, 97.

39 Ibid., 98.

40 Harris, *Spanish Avant-Garde*, 10.

41 Núñez Jiménez, *Wifredo Lam*, 88.

42 Ibid., 98.

43 Rafael Alberti, "La poesia popular en la lirica española contemporanea," in *Prosas encontradas: 1924–1942*, 2nd ed., ed. Robert Marrast (Madrid: Ayuso, 1973), 127–28. Also quoted in Victor García de la Concha, ed., *El Surrealismo* (Madrid: Taurus Ediciones, 1982), 15.

44 Salvador Dalí quoted in Robert Havard, *The Crucified Mind: Rafael Alberti and the Surrealist Ethos in Spain* (London: Tamesis, 2001), 232.

45 Harris, *Spanish Avant-Garde*, 5

46 Marie Laffranque in García de la Concha, *El Surrealismo*, 11.

47 Robert Havard, *A Companion to Spanish Surrealism* (Rochester: Boyell and Brewer, 2004), 5.

Elizabeth T. Goizueta

48 Harris, *Spanish Avant-Garde*, 10.

49 David, "La invención del nuevo mundo," 56.

50 Rafael Alberti, *Concerning the Angels*, trans. Christopher Sawyer-Lauçanno (San Francisco: City Lights Books, 1995), 15.

51 Ibid., 19, 21.

52 Given the close friendship between the two poets, Lorca may have even taken a copy of Alberti's new book with him on a trip to New York (ibid., ix).

53 Christopher Maurer, ed., *Federico García Lorca: Selected Verse* (New York: Farrar Straus Giroux, 1998), 317.

54 Ibid., 203.

55 Ibid., 318.

56 Ibid., 211, 213.

57 Ibid., 207. These pairings are simply meant to suggest commonalities in the surrealist lexicon.

58 Fernando Ortiz, *Visiones sobre Lam* (Havana: Fundación Fernando Ortiz, 2002), 8.

59 Núñez Jiménez, *Wifredo Lam*, 83.

60 Patt and Nozick, *Generation of 1898*, 2.

61 Fouchet, *Wifredo Lam*, 19.

62 Ibid.

63 Ibid., 20.

64 Lowery Stokes Sims, *Wifredo Lam and the International Avant-Garde, 1923–1982* (Austin: University of Texas Press, 2002), 18.

65 María Lluisa Borrás, "Lam y el surrealismo: 1929–1934," in Noceda, *La cosecha de un brujo*, 61.

66 Daniel Maximin, *Césaire & Lam: Insolites batisseurs* (Paris: HC Éditions, 2011), 93.

67 Fouchet, *Wifredo Lam*, 37.

68 Like Picasso, Lam was invited to "do a painting on the theme of war." Sims, *International Avant-Garde*, 23.

69 Max-Pol Fouchet, "El acontecimiento español," in Noceda, *La cosecha de un brujo*, 45.

70 Núñez Jiménez, *Wifredo Lam*, 139.

71 Fouchet, *Wifredo Lam*, 23.

72 Interview with Eskil Lam conducted by Elizabeth T. Goizueta, summer 2011.

73 Helena Benitez, *Wifredo and Helena: My Life with Wifredo Lam, 1939–1950* (Lausanne: Sylvio Acatos, 1999), 19.

74 Helena Benitez, *Wifredo Lam: Interlude Marseille* (Copenhagen: Edition Bløndal, 1993), 21.

75 Lowery Stokes Sims, "From Concept to Style: Lam and His Geography of the Marvelous," in *Wifredo Lam: Catalogue Raisonné of the Painted Work; Volume I, 1923–1960*, ed. Lou Laurin-Lam (Lausanne: Sylvio Acatos, 1996), 119.

76 Benitez, *Wifredo and Helena*, 28.

77 Claude Lévi-Strauss in Fouchet, *Wifredo Lam*, 28.

78 Fouchet, *Wifredo Lam*, 28.

79 Annette Smith in Aimé Césaire, *Notebook of a Return to the Native Land*, ed. and trans. Clayton Eshleman and Annette Smith (Middletown: Wesleyan University Press, 2001), viii.

80 Ibid.

81 Benitez, *Wifredo and Helena*, 53–58.

82 Núñez Jiménez, *Wifredo Lam*, 85.

83 Fouchet, *Wifredo Lam*, 30.

84 Ibid., 30–31.

85 Sims, "From Concept to Style," 120.

86 Alejo Carpentier, "El amor brujo: Reflexiones acerca de la pintura de Wifredo Lam," in Noceda, *La cosecha de un brujo*, 191.

87 Ibid., 192.

88 Sims, *International Avant-Garde*, 64.

89 Ibid., 57.

90 Max-Pol Fouchet in Sims, *International Avant-Garde*, 63.

91 Fouchet, *Wifredo Lam*, 32.

92 See Cobas Amate, "The Ascending Spiral" for more on Lam's first Cuban period.

93 Julia P. Herzberg, "Rereading Lam," in *Santería Aesthetics in Contemporary Latin American Art*, ed. Arturo Lindsay (Washington, DC: Smithsonian Institution Press, 1996), 151.

94 Sims, "From Concept to Style," 120.

95 Gerardo Mosquera in Sims, *International Avant-Garde*, 64.

96 Fouchet, *Wifredo Lam*, 34.

97 Lowery Stokes Sims, "The Graphic Work of Wifredo Lam: Drawing into Painting," in this volume.

98 Sims, "From Concept to Style," 132.

99 Roberto Cobas Amate, "Wifredo Lam: From Myths to Poetry," *Bellas Artes* 1 (2012): 22.

100 Dominique Tonneau-Ryckelynck, ed., *Wifredo Lam: Oeuvre gravé et lithographié; Catalogue raisonné*, exh. cat. (Gravelines: Musée de Gravelines, 1993), 29–33. See also Sims in this volume for Upiglio and Lam's improvised graphic techniques.

101 Two of the etchings (plates 56 and 58) were first published in a 2000 edition of *Annonciation*, being too large for the original publication. Very few of the 1982 *Annonciation* were signed due to Lam's death on September 11, 1982, with the remaining sets certified by his estate with stamped signatures. Césaire's ten poems appeared again in his *Moi, Laminaire* published in November 1982. Eskil Lam and Dominique Tonneau-Ryckelynck, eds., *Wifredo Lam: Catalogue Raisonné; Prints Estampes Grafica 版画* (Paris: Éditions Hervé Chopin, forthcoming).

102 Cobas Amate, "From Myths to Poetry," 22.

103 Sims, *International Avant-Garde*, 69.

104 Fouchet, *Wifredo Lam*, 7.

105 Ortega y Gasset, *La deshumanización del arte*, 29, 45.

THE GRAPHIC WORK OF WIFREDO LAM: DRAWING INTO PAINTING

Lowery Stokes Sims

IF WIFREDO LAM'S LATE PAINTINGS HAVE generally been less enthusiastically received by critics and art historians than have his early paintings, it is probably because they seem more simplistic in character. The rich textures and complex interplay between the background vegetation and the figural, masked elements in the foreground that we see in his signature work of the 1940s and 1950s are no longer evident by the 1960s and 1970s. Lam continues to draw endless variations on his repertoire of motifs—the horse-headed woman (*femme-cheval*), the diamond-shaped rhomboid heads of deities, the upturned cup-shaped heads of the orisha Elegguá, and the sugarcane intersected by knife-like scythes and florid tobacco leaves. But these variations become increasingly grotesque, and fanciful creatures of Lam's imagination are literally drawn in black on top of washes of color.

These developments in Lam's painting are due in large part to his graphic work, which he began to pursue in earnest in the 1960s. His use of techniques such as etching and aquatint account for the elegant, linear character of some of the work, while lithography accounts for the more urgently abrupt linear character in other work. Lam's painting had always had a definite linear character, emphasizing the outline and decorative embellishment of form. It is that deft draftsmanship that has led the French critic Jacques Leenhardt to position Lam along with Giacometti as a catalyst for the restoration of the status of drawing in painting in the post-World War II era.[1]

It was not until the 1940s, however, after Lam had been a professional artist for more than twenty years, that he first experimented with any graphic medium. Sequestered in his native Cuba, where he had fled from Paris at the outbreak of the war, he created what is perhaps his first graphic work:

a color lithograph produced for the catalogue of the 1947 *Exposition internationale du Surréalisme* organized by André Breton and Marcel Duchamp at the Galerie Maeght in Paris.[2] That same year he produced a lithograph, *Quetzal*, for the first Brunidor *Portfolio*, published by Robert Altmann in New York (fig. 1). Over the course of the war, Lam maintained a tenuous connection with the New York art scene through the intervention of Breton, who introduced his work to Pierre Matisse. Matisse, in turn, exhibited Lam's work regularly in the early 1940s, although Lam did not visit New York until 1946, largely because of restrictions on Chinese immigration to the United States (Lam's father was Chinese).

In the early 1950s, Lam worked with the legendary printmaker and studio printer Stanley Hayter at his Atelier 17 Studio in Paris.[3] During this period, Lam also completed four lithographs for René Char's *Le rempart de brindilles*, 1953, the first of many collaborations with contemporary poets and writers. While some of these prints exhibit the sparse draftsmanship and more schematic, compartmentalized organization of the paintings, others intimate at newer tendencies. In a series of lithographs done for an issue of the portfolio *Derrière le miroir*, 1953, which was devoted to his work, Lam explored more fully the fragmented anatomies seen in his 1950 painting *Le Rumeur de la terre* [50.53]. These appear in the company of more specifically abstract, geometric forms—specifically diamonds—painted as flat, unarticulated shapes. The representations of dense groves of sugarcane and tobacco leaves (Cuba's twin agricultural products) seen in the 1940s begin to appear also in more truncated, schematic stalks and knife/machete forms.

By the late 1950s and early 1960s, Lam was willing to experiment with other ways to convey images. Some proj-

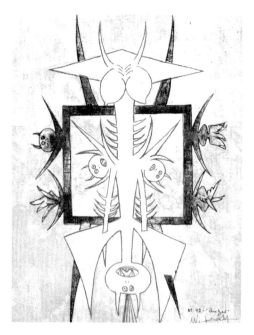

1. Wifredo Lam, *Quetzal, Portfolio Number 1* (New York: Brunidor Editions, 1947), plate 3 [003/4701].

2. Giorgio Upiglio and Wifredo Lam at Grafica Uno, c. 1964.

ects show a more gestural splattering and splotching of the printing ink to similar effect of that seen in a group of paintings collectively entitled *La Brousse* which Lam painted in 1958 (plate 52) as a response to abstract expressionism and *l'art informal.* This is particularly evident in a 1958 untitled suite of eight color lithographs executed in Albisola Mare, Italy, at the instigation of Lam's close colleague, Danish artist Asger Jorn, a founder of the CoBrA group. In the 1961 etching suite *Images,* Lam explores the potential of "accidental" splatterings, stains, blobs, and smears on the surface of the prints, sometimes creating a moiré pattern. At times the splotched color edges create effects that mimic scorching into the papers. His characteristic imagery of rounded and triangular heads, spiked vegetation, and so forth fades into the rich textural mix of newsprint, brown ink, and relief print.

By the late 1960s, Lam was more preoccupied with his graphic work than with his paintings, although he worked with various editors and printers, such as Mathieu in Zurich and Studio Grafik in Stockholm.

Lam's most prolific and sympathetic collaboration, however, was with Giorgio Upiglio (fig. 2). Lam produced some of the most memorable images of his late career at Upiglio's studio Grafica Uno in Milan. The two men first met in the

early 1960s and worked together until Lam's death in 1982. During this period, Lam was living year-round in Albisola Mare, an ancient town on the northwestern coast of Italy known for its ceramic works, and traveling to Milan to work at Upiglio's studio for ten days to two weeks at a time.[4] By all accounts, Upiglio was a solicitous and nurturing resource for Lam. As Stanley Hayter noted, Lam could be very demanding about his printmaking, often refusing to make impressions of compositions that he did not feel were successful in their design.[5] Upiglio would improvise on familiar graphic techniques to satisfy Lam and to make the printmaking process as fulfilling as possible for him. Since drawing was an essential part of the graphic process for Lam, a way had to be found to allow him to achieve the fluid lyrical quality that lent Lam's graphic work its special quality. In the medium of lithography, Lam had an advantage, as this technique complemented that of drawing. However the technique of etching posed a particular challenge since the copper plate offered resistance to the burnisher used to cut in the design. Upiglio therefore devised a solution to allow Lam to draw into bitumen powder spread on a copper plate. Lam supported his arm above the surface of the powdered plate by means of a wooden "bridge." When the drawing was complete, the copper plate was heated from beneath, and when it cooled the design was fixed into the bitumen.

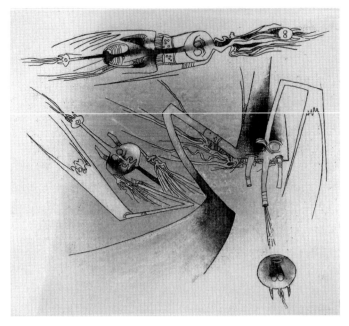

3. Wifredo Lam, untitled lithograph from *Apostroph' Apocalypse* (Milan: Grafica Uno, 1967) [181/6621]. 4. Wifredo Lam, *Oiseau du possible, XXᵉ Siècle* 52 (1979) [343/7514].

The plate would then be set into the acid bath to cut the design into the plate.[6]

The spectacular results can be seen in Lam's 1967 collaboration with the Romanian poet Gherasim Luca, *Apostroph' Apocalypse* (fig. 3). The ease with which Lam's lines traverse, reverse, and cut through space suggests a movement that emanates from the arm as opposed to the wrist. As a result, these images demonstrate a particular subtlety in the modulation and ease of the lines and the tints. Their haunting, ethereal quality is unparalleled in Lam's work, and the cast of earthly and unearthly apparitions is more varied than elsewhere. This is in stark contrast to the condition of the femme-chevals in his paintings (plate 45), which seem to sulk under the weight of the various head accoutrements and extra anatomical parts.

In the suite *Visible, Invisible*, 1971, Lam creates complex hybrid forms by gathering and overlapping separate motifs on the plate, as well as by linear play. The subtle gradations of color within the forms demonstrate Lam's ability to control the hues so that the fading out of the color follows the outline of the form until it gently interfaces with the color of the background sheet. The familiar forms of the femme-cheval are seen in improbable contortions that at times are stretched out as if being pulled by some mysterious

force. This invention, and the openness and airborne disposition of the forms and figures in this graphic suite, seems to justify the description of Lam's creatures by the Chinese critic Xing Xiao Sheng. Writing in 1991, Sheng noted that these beings seem to "traverse time faster than space and have access to the Beyond."[7]

The decorative flourishes of Lam's late lithographic work, interestingly, are suggestive more of the florid ceremonial diagrams used in rituals of the Afro-Cuban secret society known as the *Abakua*. This is particularly evident in the 1976 lithographs created to accompany Gabriel García Márquez's poem *El último viaje del buque fantasma* and in the work *Oiseau du possible*, 1975, one of two lithographs created for *XXᵉ Siècle* magazine (fig. 4). The embellishment of the interstices between the forms, the exuberant curlicues, and overlapping triangular elements all recall the drawings traced on the floor that summon the orisha Elegguá to visit the faithful gathered to celebrate their presence in the world.

Lam brought all of the characteristics described here to bear on his *Annonciation* series (plates 56–64). Originally created in 1969, Aimé Césaire wrote ten poems inspired by the prints in 1979. Seven of the etchings were finally published alongside the poems in 1982 as *Annonciation*, the poems also appearing in Césaire's *Moi, Laminaire*, 1982.[8]

23

Here, Lam reunites one by one all the characters that have marched in and out of his work for more than forty years. Within the intermediate hues are suspended figures that in Lam's work have represented entities that go back and forth between the physical and ethereal realms, between the foreground and the background. There is also the girl with the long hair, first seen in the drawings for Breton's poem *Fata Morgana* in 1941; the femme-cheval; the winged apparitions that refer to Lam's childhood encounter with a bat; the horned creatures that synthesize the Christian cherub and the Afro-Cuban orisha Elegguá; the knives, bowls, masks, and on and on. Abstract, realistic, horrific, and engaging, these are the "living memories" that Césaire evokes in "Passages," one of the poems for this etching suite.[9]

From photographs of drawings in the archives of the artist's estate, it is evident that Lam had been involved with these images since 1969, when he first began to work on the plates at Grafica Uno. What is astonishing is how prescient the images are in view of how trenchantly, crowded with multiple references, they seem to sum up Lam's career. The images were printed in a single color or tonalities—in this case rich, dark brown that ranges in nuance from green to orange. Lam allows the main elements in the compositions to stand in stark contrast—they are the color of the paper—to the tenebrous background. He thus exploits negative space by presenting an inversion of the usual manner in which figure-ground spatial relationships are defined.

Once we understand the importance the graphic medium held for Lam at the end of his career, we can better understand the character of his painting effort. It would seem that Lam was faced with a quandary: how to feed the public's seemingly insatiable appetite for his paintings while indulging his passionate pursuits in various graphic media. If we look at Lam's graphic work and painting as a continuum and ponder his virtual abandonment of the latter for the former in his late career, we can see that Lam found that accommodation. In the process, he created some of the most memorable images of his oeuvre.

This exhibition has given me the opportunity to rework and publish this essay for the first time. It has been adapted from my manuscript, *Wifredo Lam and the International Avant-Garde, 1923–1982* (Austin: University of Texas Press, 2002). The first version of this discussion was published in my "Rethinking the Destiny of Line in Painting: The Later Work of Wifredo Lam," in *Wifredo Lam: A Retrospective of Works on Paper*, ed. Elizabeth Ferrer, Diane Garvey Nesin, and Daniel Jussim, exh. cat. (New York: Americas Society, 1992), 47–55.

1 Jacques Leenhardt, "Wifredo Lam," in *Gravures de Wifredo Lam*, ed. Xing Xiao Sheng and Jacques Leenhardt, exh. cat. (Beijing: Central Institute of Fine Arts, 1991), 18–21.

2 Robert Altmann, letter to the author, Paris, March 1993; see also Dominique Tonneau-Ryckelynck, ed., *Wifredo Lam: Oeuvre gravé et lithographié; Catalogue raisonné*, exh. cat. (Gravelines: Musée de Gravelines, 1993), 42.

3 Stanley Hayter, interview with the author, New York City, September 1989.

4 Giorgio Upiglio in discussion with the author, Milan, October 1989.

5 Hayter, interview.

6 Upiglio, discussion.

7 Xing Xiao Sheng, "Merveilles et Demons de Wifredo Lam," in Sheng and Leenhardt, *Gravures de Wifredo Lam*, 10.

8 Eskil Lam and Dominique Tonneau-Ryckelynck, eds., *Wifredo Lam: Catalogue Raisonné; Prints Estampes Grafica* 版画 (Paris: Éditions Hervé Chopin, forthcoming). See also Elizabeth T. Goizueta, "Wifredo Lam's Poetic Imagination and the Spanish Baroque," 17–18, 20n101 for more on the *Annonciation*.

9 See Aimé Césaire, *Moi, Laminaire* (Paris: Éditions du Seuil, 1982), 82.

THE ART OF WIFREDO LAM AND THE ANTHROPOLOGY OF LUCIEN LÉVY-BRUHL AND CLAUDE LÉVI-STRAUSS

Claude Cernuschi

Lam and the Colonial Legacy

FOR ANY ADVOCATE OF POSTCOLONIAL theory, or anyone enticed by topics that transgress the canonical orbit of Western culture, the paintings of Wifredo Lam offer, at least at first sight, an ideal object of investigation. Born in Cuba, the last Spanish colony—and one of the few nations still officially labeled a "Sponsor of Terrorism" by the US State Department—Lam sprang from unusual ethnic and cultural origins: his father was Chinese and his mother of African and Spanish descent. Though singular, this diverse heritage does reflect a certain *cubanía* ("Cubanness"), since Europeans, Africans, and Asians mixed (in varying degrees) with what was left of the island's indigenous population. Hybridity, not surprisingly, is considered emblematic of Cuban culture.[1] "The real history of Cuba," according to anthropologist Fernando Ortiz, "is the history of its intermeshed transculturations."[2] By its very scope, then, investigating Lam against the intellectual backdrop of postcolonial theory gives space to these alternative voices; in Kinshasha Holman Conwill's words, it moves Third World artists "from the margins of the art world to its center stage."[3]

First in Cuba, and then in Spain, Lam was originally trained in the rigorous academic tradition of Western art—as many of his early portraits attest (plate 8). By 1946, however, he largely disavowed this heritage and moved down a postcolonial path. Writing from Cannes to his second wife, Helena Holzer, he states:

> My personality, whether I would want it or not, is not European…I feel phony here, as some exotic thing (branded, if you like) as some Negro or Oceanic statue from the Pacific, from wherever, but whose transplanted existence here becomes sterile, a museum curiosity…everyday I feel more and more distant from this culture and from its way of understanding humanity… the destiny of these African pieces in Europe is the symbol of a people swept aside by a conquering civilization that indoctrinates the whole world with…its false spirituality. […] Yesterday, it was black skin that was sold; today it is its spirit, its dreams, that are exploited, like objects of curiosity, because primitive peoples are reduced to the condition of slaves, of criminals, because today's world is Western and white. […] These [non-Western] peoples have already lost their dreams because these dreams have been removed from their mindset. Their works are dead in museums and private collections that no one can see, disseminated throughout the world and what is more, denied all research and analytical effort bearing on the values they represent for human history.[4]

Lam's biography retraces circumstances in which an individual of non-Western heritage leaves his birthplace to study in Western Europe, where he cannot help but internalize the values of the dominant culture and ignore (even feel shame toward[5]) his own. Just as he acquires the skills necessary to practice this "foreign" tradition, something intervenes. He rediscovers his origins and realizes that the very devices he strove so hard to master actually stifle his identity. Per chance, he reencounters the African art he had seen during childhood and grasps its broader implications: more specifically, how its insertion in European museums and private collections contributes to, or even exacerbates, its physical and cultural deracination. Referencing non-Western art in his own work thus accompanies

a personal journey of self-discovery, an acknowledgment of the intrinsic value of alternative traditions, of the cultures from which they emerged, and a revitalization of his own art as an act of resistance, an act that undermines the way Western culture appropriates non-Western art for its own purposes. "My painting," Lam affirmed, "is an act of decolonization."[6]

Though correct in its general outlines, this scenario sounds progressively more clichéd upon every retelling. More often than not, situations are far muddier than they appear at first sight. Lam's return to Cuba in 1941, for example, is rightly considered indispensable to the development of his mature style; but it remains unclear whether Lam would even have returned to his birthplace—after an eighteen-year absence—were it not for the eruption of World War II. Holzer remembered how "bitter" Lam was "about the brusque interruption of his career in Paris…he never failed to mention the superficiality and materialistic attitude of life in Havana."[7] Far from reconnecting with his native land, and escaping an artificial, Western culture that was not his, Lam felt disoriented. "I had left everything behind me in Paris,"[8] he recalled, fitting uneasily in an art world and social framework from which, after so long a time, he had grown estranged. Not surprisingly, he returned to Europe at the end of the war. Lam, Holzer recollects, "was impatient to go back to Paris. He felt that Cuba was not a place where an artist could survive intellectually or financially."[9] He did visit the island occasionally, professed support for the Castrist revolution, but far from made Cuba his permanent residence.

Lam's characterization as a "Cuban" artist is thus a tricky proposition. So is his description of his art as "an act of decolonialization." Though not employed in a literal sense, this term suggests that the broader implications of his art were political, and that these closely align, as indicated above, with postcolonial criticism. Lam's concerns, Curtis L. Carter writes, were "with societal issues such as race, gender, and politics, which are at the forefront of contemporary social activism in the United States."[10] Admittedly, the major aims of postcolonial theory are to evaluate the effects of colonialism on colonizer and colonized alike, to subject the justification and implementation of Western exploitation of non-Western peoples to rigorous critique, and to expand the canonization of art and literature to give greater voice to those long marginalized. Lam's work fits with this agenda hand and glove.

But again, the situation is not so simple. Lam rediscovered his links to Cuban culture as much through friendships with white, European-trained anthropologists, as by re-igniting early, adolescent experiences. His situation, it seems, always remained ambivalent. In Europe, he was a legitimate exponent of an untainted, non-Western culture; in Cuba, tainted by the very Western tradition in which he was trained; in Europe, a genuine product of an "exotic" land, an individual unspoiled by the corruption and hyper sophistication endemic to the West; in Cuba, a suspicious foreigner,[11] or, as Holzer remembers, "an outsider and a snob."[12]

To complicate matters further, though Lam was cited above as criticizing the collections of non-Western art in European museums and private collections, he was himself an avid collector of non-Western art from the 1940s onward, and even proudly posed in photos before the numerous pieces he amassed from various cultures and geographical locations (fig. 1). (Unfortunately, the majority turned out to be forgeries,[13] if, by "forgeries," one means modern pieces made for the tourist trade with the express purpose of looking old.)

Since Lam's life and work intersect multiple cultures and traditions, his son, Eskil, called his father "unclassifiable," an artist "who knew both to return to his origins so much the better to sever himself from them; reconcile primitivism and modernity. […] Are these not the traits of an artist who sought to invent a universal language?"[14] Any claims to invent a "universal language," whether made by colonizer or colonized, should, of course, be met with extreme caution. Not simply because a "universal language" is a contradiction in terms (given that language is arbitrary and conventional), but because such an assertion also contravenes attempts to recognize the autonomy and distinctiveness of indigenous cultures. A similar tension can be seen in the words of Carlos Franqui, who wrote that Lam's work "reflects a national will to anti-colonialism. It has a substantial intellectual basis and a vigorous plastic

1. Wifredo Lam in Albisola among his Oceanic and African sculptures, c. 1972.

expression that is both genuinely American and universal."[15] But this statement is clearly divided against itself: one can no more be universal *and* American than colonial *and* anti-colonial at the same time.

Though not to be accepted uncritically, Mr. Lam's remarks —that his father reconciled "primitivism and modernity" and invented "a universal language"—suggest that Lam's solution to these dilemmas was to embrace an aesthetic of hybridity, a recurring theme in postcolonial discourse, and, as we have already seen, a term aptly descriptive of the Cuban context. The majority of scholars, in fact, have seen Lam through precisely this lens. For Lowery Stokes Sims, Lam's signature work betrays "a unique synthesis of European modernist vocabularies—specifically cubism (with its engagement of African forms) and surrealism (with its engagement of nonempirical phenomena)—and African religious motifs and symbols which had survived in Cuba."[16] For Kinshasha Holman Conwill, Lam likewise "synthesized the lessons of Cubism and Surrealism with the complex beliefs and practices of Afro-Cubanism that he learned from his mother and godmother and from the philosophy of his Chinese-born father to create a style, iconography, and vision that are all his own."[17] And for Robert Linsley, Lam's work is "an alchemical mixture of Third World liberation, surrealism and Negritude. The

active ingredients are the ideas of Breton and the surrealists and of Aimé Césaire, the first poet of Negritude."[18]

But hybridity is more than an aesthetic attempt at synthesis. Against the set of questions mentioned above, its political implications are far ranging. If procreation only occurs among the same biological species, conflating different aesthetic idioms insinuates, if only symbolically, that they all exist on equal footing. When Jason Edward Kaufman described Lam as a "potent symbol of the intermixing of cultures that will flower in our increasingly 'multicultural' civilization,"[19] he obviously saw such a development in a positive light. As did Gerardo Mosquera when he interpreted Lam's work as reflecting a "de-centralized international culture."[20] But when he explained the purpose of his art, Lam made more pointed claims. With respect to his most significant work, *The Jungle* of 1942–43 [43.12], he declared:

> Some people say that this is the first work
> painted as an actual representation of the Third
> World (*el Tercer Mundo*). Certainly, at that time,
> I spoke here in Cuba with other artists about
> the importance of bringing the Black presence
> into art, but they did not seem to understand
> me. They thought that I was merely speaking

to them about painting a little black person with a basket of fruit on his head. Yet I was not referring to this but rather to something much more profound.[21]

With this remark, Lam articulates his view that the conventions of academic art—whether Cuban or European—inadequately expressed Third World conditions, especially the conditions for peoples of color. By the same token, he refused to dismiss his academic training as a waste of time. "I did succeed in becoming a polemical representative of the Third World within European culture," he continues, because "I was able to speak in a language that turned out to be a lucid one. If a young untrained Black person had come along painting these things, the Europeans would almost certainly have paid no attention to him, because he did not have the skills or instruments to transpose those contents. Yet, I could do it, because I had studied European art very deeply."[22]

This statement invites the unexpected conclusion that, as dedicated as Lam was to an aesthetic of hybridity, his intended audience was primarily Western, and that, for this reason, mastering the European artistic tradition was an obligatory rite of passage—both for the kind of academic training it offered and for subverting that same training in the form of modernist experimentation. Indeed, although Lam explained the figure holding scissors on the right of *The Jungle* as signifying the need for Cubans "to sever" themselves "from the culture of colonialism,"[23] the visual language he employed to make that point is as much European as Cuban or African. "Of course," he conceded, "this work also has much to do with European art in its formal values. I realized my painting with all the discipline in art characteristic of the sixteenth century and above all of major French paintings, especially those of Cézanne and Matisse. I employed Cézanne's pictorial conquests in this painting, a painting also tied to Africa in terms of its poetry, as well as to Western culture and to Cuba. The painting is a synthesis, because I have worked in both directions."[24] This avowal corroborates Sims's view that "Lam's peculiar allegiance to European modernism and his determination to establish his place in that context cannot be overlooked or ignored…these postulations make it clear that a simple

deconstruction of Eurocentrist art history is not an adequate means to reconstruct Lam's artistic identity on the twentieth-century world stage."[25]

If Western artists could appropriate non-Western forms, then, for Lam, it was perfectly acceptable for non-Western artists to appropriate Western ones, if only to criticize the very culture that produced them, or to conflate them with indigenous styles and thematic material. If a clearer implementation of the program of hybridity exists, it would be difficult to find. But to characterize Lam's work as hybridity for its own sake would be to miss the point. Lam adapts European modernism to an anti-European agenda, and references *and celebrates* African art in the process. "Africa has not only been dispossessed of many of its people," Lam added, "but also of its historical consciousness. It irritated me that in Paris African masks and idols were sold like jewelry. In *La Jungla* and in other works I have tried to relocate Black cultural objects in terms of their own landscape and in relation to their own world. My painting is an act of decolonization [*un acto de descolonización*] not in a physical sense, but in a mental one. In Africa they consider me to be the best painter from that continent, despite the fact that I have seldom visited there."[26] To express the black experience authentically, and create art that would counter the legacy of colonialism, it was not enough for Lam to master European academic practices and prevent his works from being dismissed in Western circles. It was also necessary for him to counteract the way African masks had been misappropriated and commodified in Europe. For this purpose, his art had, in effect, to be relocated in its appropriate—Cuban—setting. "In this way," he declared, "I could act as a Trojan horse that would spew forth hallucinating figures with the power to surprise, to disturb the dream of the exploiters. I knew that I was running the risk of not being understood by the man in the street or by the others."[27]

This lack of clarity was perhaps exacerbated by his attempt to reflect the Afro-Cuban experience through an idiosyncratic mix of Cuban, European, and African traditions. All the same, if some of Lam's champions praise his images because they "disrupt," "challenge," "disempower," or "liberate the subject from the oppressive construct of race,"[28]

it is not always easy to see this practice in operation. It is ironic, for example, that Lam's work should be construed as relocating African art to its appropriate setting when he himself seldom visited the continent, and then only late in life. If Lam's aesthetics "relocate" African art to its "appropriate" context, that context is not African as much as Afro-Cuban—a domain, admittedly, in which he fits more snugly than in the purely "Cuban" one, but one that cannot be automatically labeled "appropriate" either. It is no less ironic that Lam's embrace of formal solutions particular to non-Western art, and, more specifically, to African art, was triggered by none other than Pablo Picasso, whom he unfairly omitted to mention in favor of Cézanne and Matisse in the interview mentioned above. Who knows, perhaps Picasso was a descendant of Spanish conquistadors no less than Lam was of African slaves?

Prolegomena: Lam and Western Modernism

But Picasso was a seminal influence. After years of studying and practicing art in Spain, Lam was compelled to leave on account of fighting on the losing side in the Spanish Civil War. Given a letter of introduction to Picasso, Lam fled to France in 1938 where he met and befriended the artist who, more than any other, brought non-Western art to the attention of the European art world. In many ways, "Africa" provided the common ground for both men, the name of the continent left in quotation marks to signal its function as a concept rather than as a literal, geographical location. Upon meeting Lam, for example, Picasso could not help but show him an African sculpture from his own collection. "You should be proud," Picasso exclaimed; "Why?" Lam asked; "Because this was made by an African," Picasso replied, "and you have African blood in you." For Picasso, Lam possessed the very characteristics he (Picasso) hoped to inject in his own art. These were not qualities Lam needed to acquire; these were qualities with which he was "naturally" endowed. The more time he spent with Lam, or so Picasso reasoned, the more these qualities would rub off on him, and the greater legitimacy he could claim for his own work. "I think there's some of my blood in your veins," Picasso went so far as to tell Lam, "you must be a relative of mine, a cousin."[29]

That Lam even asked the question as to why he should be proud of a piece he had no direct role in creating bespeaks the naïveté of someone arriving on the Parisian art scene at the tail end of the Jazz Age. Lam was apparently so ignorant of African art that a dismayed Picasso enlisted Michel Leiris, an ethnographer in charge of the African collections at the Musée de l'Homme, to instruct him in this domain.[30] Lam became so attentive to this form of instruction that Pierre Loeb, after Picasso introduced him to Lam, immediately noticed the latter's heavy debt to African art—intimating, by that remark, that Lam was nothing more than a follower of Picasso. Furious, Picasso shot back: "he has the right, him, he is black!"[31] Fair enough. But if Lam had not met Picasso, his art would not have moved in this direction—at least not at that point (plate 17). "I derived all my confidence in what I was doing," Lam confessed, "from [Picasso's] approval."[32] If Lam discovered "Africa," it was through Picasso's direct tutelage. Lydia Cabrera—one of the anthropologists Lam later befriended upon his return to Cuba, and who was instrumental in helping forge an Afro-Cuban cultural identity on the island—went through a strikingly similar form of awakening: "I discovered Cuba on the banks of the Seine."[33] For better or worse, the West's mediating role proved instrumental.

Today, few would dismiss Lam's work as nothing more than an imitation of Picasso. On the formal and conceptual levels, Lam moved beyond Picasso through his involvement with surrealism, a movement he encountered in Spain even prior to his engagement with African art, and a movement with which Picasso was also loosely associated. In fact, an interest in African art and an interest in surrealism were mutually reinforcing. Among the African pieces Picasso showed Lam from his own collection was an Ivory Coast Goli Glin mask (fig. 2) whose importance, according to Jean Louis Paudrat, was its "composite make-up—antelope horns, schematic human face, crocodile mouth." That this mask delighted the surrealists is hardly surprising given their love of irrational juxtapositions (the mask came from the collection of André Breton, the founder and leader of the movement), but, in Paudrat's view, it also directly contributed to the development of Lam's own hybrid-character: the *femme-cheval*, or horse-woman.[34]

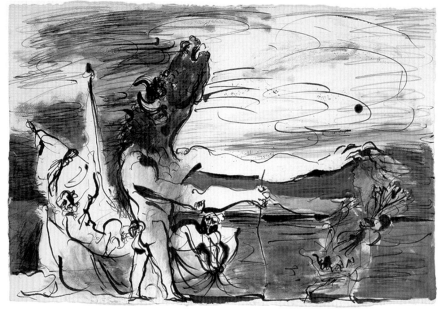

2. Baoulé (Ivory Coast), *Goli Glin mask*, n.d. Wood, 109 cm, private collection; formerly in the collections of André Breton, Pablo Picasso, and Marina Picasso.

3. Pablo Picasso, *Minotaure aveugle conduit par une petite fille*, 1934. Gouache, watercolor, ink, and pencil on paper, 35 x 51 cm, private collection.

Consistent with the surrealists' interest in classical myth, Lam's femme-cheval (plate 45) parallels the Greek mythological character of the Minotaur, who made especially frequent appearances—again—in Picasso's work, betraying remarkable iconographical range and functioning as a surrogate self-portrait for the artist (figs. 3–4). It also bears mentioning that myth played an inordinately important role in psychoanalytic investigations, which, in turn, provided the underlying intellectual rationale for surrealism (in particular, the movement's attempts to enlist art to access and elicit thoughts originating in the unconscious). If only by using terms such as "Oedipal complex" or "Narcissism," Freud clearly betrayed the degree to which he construed classical narratives, not as fictive inventions, but as reflecting basic psychological fixations.

On this model, the surrealists paid close attention to myths, and, given Freud's debt to Darwinian evolutionary theory, to myths where human and animal were conflated in an unnatural way. (In Freud's view, the theory of evolution justified the notion that human beings, having descended from "lower species," were motivated by many of the same instincts and compulsions.) For the iconoclastic surrealists, the Minotaur was no esoteric reference to classical legend. Half-man, half-animal, born of the sexual relations between the Cretan queen Pasiphäe and a bull, the Mino-

taur symbolized those very sexual drives and brutal forces that human beings inherit from the animal kingdom, but repress—just below the surface of normative, civilized behavior—in the recesses of the unconscious mind (fig. 4). That the Minotaur was consigned to a labyrinth, from which Theseus emerged with the help of Ariadne's thread after slaying the beast, could be taken to mean that modern individuals, having denied the reality of their mental condition, urgently need to probe their inner selves and acknowledge these very drives and compulsions as their own. Only through self-knowledge, only by confronting the reality of the human condition, Freud contends, can human beings ever reach some form of mental health and psychic equilibrium. An analysis of myths, such as those of Theseus and Oedipus, advances this self-knowledge; not surprisingly, the surrealists named one of their most important periodicals *Minotaure*.

Lam's endorsement of these notions is deducible from a circa 1943 drawing (fig. 5) depicting an idealized female figure unsuspectingly gazing into a mirror, only to see an animal form stare back at her. As an answer to the Minotaur, the femme-cheval was another human/animal hybrid likely to visualize the darker psychological forces the majority of human beings deny, at least according to Freud, about their very selves. And just as Picasso triggered

30

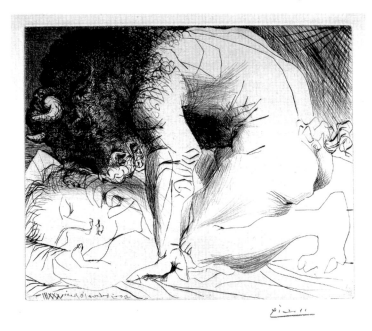

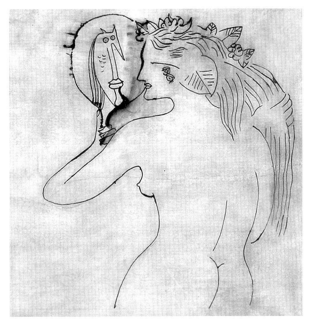

4. Pablo Picasso, *Minotaure caressant une dormeuse*, *Vollard Suite*, plate 93, 1933. Etching, 29.5 x 26.5 cm, private collection.

5. Wifredo Lam, *Untitled*, c. 1943 [D-43.21]. Ink on paper, 18.7 x 18.4 cm, Lowe Art Museum, University of Miami, 91.0295.10.

Lam's sensitivity to African art, the Minotaur incentivized Lam to seek precedents in non-Western art where human and animal were deliberately conflated. The confusion between species, Paudrat suggests, may have been adapted from "the mythopoetic compatibilities of the statuary Lam observed at the Musée de l'Homme" in Paris.[35] Indeed, images such as a Dahomey sculpture of a man-shark (fig. 6), now at the Musée du Quai Branly, could easily have contributed, with modification, to the conceptualization of the femme-cheval, reinforcing the suggestion, not only that human and animal could be liberally assimilated, but that African art and Western surrealism were actually as compatible aesthetically as they were ideologically. The surrealists, as insinuated above, were no less appreciative of non-Western art than Picasso and, to illustrate this appreciation and their contempt for Western rationalism, redrew the map of the world accordingly (fig. 7). André Breton admired Lam's art and ethnicity as much as Picasso and spoke favorably of the "marvelous primitiveness" that Lam "carries within himself—the highest degree of consciousness—assimilating for the task the most clever techniques of European art."[36] Although, by "the most clever techniques of European art," Breton no doubt meant surrealism, it is undeniable that he held things non-Western in the highest esteem. Many surrealist pieces, in fact, such

as Alberto Giacometti's *Spoon Woman* (fig. 8), also owe their juxtaposition of incongruous elements to precedents established in African art (fig. 9).

Though Lam clearly aligned himself with this agenda and, opportunistically, reaped its rewards, he, like many modernists, often disavowed his sources. Inasmuch as he later denied being a "student" of Picasso—wanting, justifiably, to assert his own artistic autonomy—he also denied direct African influences, claiming, instead, that his works were unprompted expressions of primordial aspects of the human psyche—what Carl Jung called the "collective unconscious." "I have spontaneously rediscovered these forms!" Lam insisted, "they have emerged within me as an ancestral memory."[37] Lam greatly admired Jung,[38] an important thinker to mention in this context because, even more than Freud, he stressed the broader interpretive relevance of myth to psychological inquiry. Comparing mythic narratives across cultures and chronological periods, Jung noticed remarkable similarities, similarities for which he coined the term "archetypes," and whose emergence he attributed, not to coincidence or accident, but to the existence of a collective layer of the psyche shared by humanity as a whole.

At a time when Nazi ideology was preaching the supe-

31

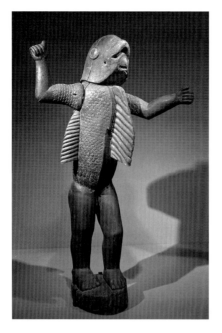

6. Sossa Dede (Dahomey), *Homme-requin*, c. 1890. Wood, 168 x 102 x 92 cm, Musée du Quai Branly, Paris, 71.1893.45.3. 7. André Breton, "Le monde au temps des surréalistes," *Variétés* (June 1929): 26–27.

riority of the Aryan race, Jung's concept of the collective unconscious suggested, in contradistinction, that human beings, regardless of ethnicity or geographical origin, are, at some fundamental level, all the same. Given his opposition to Franco's Fascist forces during the Spanish Civil War, and his own mixed ethnicity, Lam would have quickly grasped the larger political implications of Jungian theory. Jung, moreover, stressed that members of non-Western and pre-industrial cultures, by performing rituals predicated upon magic, and by relating their existence more intimately to the supernatural, had a readier access to the unconscious mind than members of Western cultures, conditioned, as they were, by excessive rationality and logic. Jungian notions, then, proved doubly helpful for Lam. On the one hand, he could claim that his origins counted him among those individuals whose relationship to their unconscious is most active; and, on the other, that the similarities between his work and non-Western forms resulted, not from direct borrowing, but from an obvious, albeit subliminal, reflection of a similar spirit.

As alluring as it sounds, this scenario remains largely unconvincing.[39] Not simply because it sounds patently self-serving, but also because few present-day psychologists or comparative mythologists endorse Jung's postulation. If mythic narratives display similarities across cultures (which is undeniable), it is not because of some largely nebulous, highly subjective notion like the collective unconscious, but—some argue—because narratives spread in lockstep with linguistic forms of communication. If similarities can be traced between French, Latin, Greek, and Sanskrit, similarities can also be traced among mythic narratives; as languages migrated, myths migrated along with them.[40] In some cases, of course, because vast spaces separated the cultures in question, direct influence could not have been a factor. But their myths may still betray striking similarities, the French anthropologist Claude Lévi-Strauss submits, because their narratives betray similar structures. All forms of social life, he argues, "consist of systems of behavior that represent the projection, on the level of conscious and socialized thought, of universal laws that regulate the unconscious activities of the mind."[41] As such, similarities in mythic narratives cannot be attributed to vague and imprecise concepts, but to the human mind's innate ability to organize and categorize material in a similar way: primarily, by means of binary opposition. The narratives may be superficially different, but their plots are structurally analogous. "Instead of reducing the story or myth to a mere narrative," he writes, it is more constructive "to discover the scheme of discontinuous oppositions governing its organization."[42] Binary opposition, Lévi-Strauss

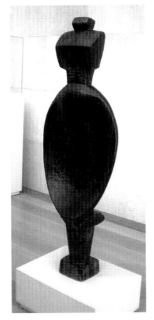 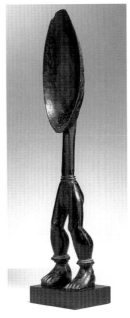

8. Alberto Giacometti, *Spoon Woman*, 1926–27. Bronze, 144.4 x 50.8 x 17.5 cm, private collection.

9. Dan (Ivory Coast/Liberia), *Ladle/spoon*, n.d. Wood, 57.8 cm, location unknown.

claims, is "a universal feature of human thinking, so that we think by pairs of contraries, upwards and downwards, strong and weak, black and white."[43] If only on this basis, scholars may disregard "the concepts of 'archetypes' or a 'collective unconscious.' It is only forms and not contents which can be common."[44]

We will return to some of Lévi-Strauss's notions later in the essay. At this point, we cannot blame Lam for invoking Jung; by doing so, he presents his art as a genuine reflection of unconscious processes rather than as a deliberate imitation of African forms. But to accept such claims to naïveté would mean being naïve oneself. Max-Pol Fouchet is far more persuasive when he writes that separating Lam "from his origins would be as unreasonable as to find in those origins a determinism from which his work could not escape."[45] More reasonably, Fouchet intimates that Lam's work, though grounded in a specific set of historical and cultural conditions, did not prevent him, like many artists, from being an "equal opportunity borrower."

Along these lines, it is no less important to reconnect Lam with his Cuban origins. Even if Lam conceptualized the femme-cheval prior to returning to Cuba, and was already exploring the hybridity that was to mark his mature style, the femme-cheval is intelligible only against the back-drop of Cuban Santería (the worship of *santos*, or saints), an amalgam of African (mostly Yoruba) religious beliefs resulting from the influx of slave populations into the New World. In time, many of these practices fused uneasily with Christianity, partly because slaves converted without relinquishing their traditional religions, or sought means to worship without incurring retribution from their white masters. All in all, Caribbean blacks were far less "Christianized" than, say, their North American counterparts, accounting for a far more active survival of African ancestral belief systems in Cuba, the very context in which Lam was raised. As a youth, he was even inculcated in the basic principles of Santería: "I was attending ceremonies with rites that had come from Dahomey or the Congo."[46] His godmother, Mantonica Wilson, a Santería healer-priestess, imparted her knowledge to Lam in the hope that he would succeed her.

Even if he declined to follow in her footsteps, Lam absorbed a great deal from Wilson's example. In fact, the impact of African culture upon Cuba as a whole cannot be overestimated. According to Fernando Ortiz, a writer and anthropologist Lam befriended in Cuba: "Without blacks, Cuba would not be Cuba."[47] Lydia Cabrera expressed the analogous view that Cuban culture cannot be understood "without knowing the Blacks. Their influence is even

more important now than during the Colonial period. One cannot obtain a deep understanding of Cuban life without confronting the African presence, one that transcends the fact of skin color."[48] Cabrera, it should be said, extensively studied the belief systems of the Afro-Cuban community, as well as supported Lam's work in an art world from which he was almost ostracized. She no doubt learned from Lam as well, given his early experiences as a priest-in-training under his godmother, and he from her, as she assiduously pursued her investigations. The extent of Lam's revelations to Cabrera, though, is impossible to ascertain with any precision, but, in view of their profound friendship and esteem for one another, they must have frequently exchanged ideas while visiting tribal fraternities and observing rites together.[49]

In effect, Santería is not simply another general ingredient in the totality of Lam's intellectual sources; it provides the specific context in which to place the femme-cheval. For her readers unfamiliar with Cuban culture, Cabrera explains the importance of horse symbolism in Afro-Cuban ritual. The expression, "the saint rides someone," she writes, signifies that a "spirit or divinity takes possession of an individual's body and acts as if it were its master… one calls 'horse' or 'head of a saint' the one into whom a saint or orisha has introduced himself…one says 'the saint descends and rides his horse,' he introduces himself into one, and 'the man or woman into whom he has introduced himself is no longer him or herself, he has become the saint.'"[50] Theoretically speaking, those who undergo possession in a ceremonial context are defenseless against the intrusion and lose consciousness and control of their personality. They cannot predict if or when the possessions will unfold, and, during the event, the horse's personality is completely subsumed by that of the saint.

The importance of this theme cannot be over emphasized; according to Lowery Stokes Sims, the femme-cheval represents the "cornerstone of Lam's work."[51] To be sure, Picasso and the surrealists emboldened Lam to valorize the contributions of non-Western art above the traditional academic art he was taught in Cuba and Spain. And although his return to Cuba was disorienting, and the art world on the island far from welcoming, Lam obviously

experienced increasing pride over his national origins, pride that jumpstarted and fueled his artistic experimentation. Given that the femme-cheval, in particular—and Santería symbology, in general—were culturally specific to Cuba, they provided a means of moving beyond Picasso *and* the surrealists, if only on an anthropological level. Lam, after all, conceded feeling empathy with Picasso's painting because of "the African spirit" that he "discovered in it."[52] But Picasso was completely ignorant of the cultural assumptions and religious beliefs of the artists from whom he was borrowing. Lam may have had scant knowledge of African sculpture upon meeting Picasso, but he held a considerable advantage when it came to native Cuban religious practices. Since his understanding of that culture ran deeper, he could draw upon it in a legitimate way—in a way, that is, that could be deemed neither superficial nor exploitative. In this sense, he could rightfully call this culture his own, not an "other" to be appropriated in a self-serving, opportunistic way. Even if his art were ever dismissed as a hybrid of cubism, surrealism, African art, and Afro-Cuban religious beliefs, Lam could justifiably describe that admixture as an authentic reflection of the hybridity of Cuban culture itself.

If the femme-cheval allowed Lam to move beyond Picasso on an anthropological level, it also allowed him to do so on a formal one as well. Lam's morphology—his fusion of human, animal, and vegetal shapes—arguably proves far more radical than anything Picasso and the surrealists had attempted by this time. This is not to deny the inspiration Lam drew from surrealism's more experimental devices such as automatism and the *cadavre exquis*.[53] In fact, he described the emergence of his hybrid forms in a manner that comes right of out of the surrealist playbook: "in an automatic way, as the surrealists would say, this new world began to surface within me. In other words, I had carried all of this in my subconscious, and by allowing myself to produce automatic painting, especially by means of that unexpected drawing whereby one does not know what one is going to paint, this strange world started to flow out of me."[54] Even so, one would be hard pressed to find surrealist works where the merger of human, animal, and vegetal is consistently pushed to such an extreme degree. The very Cuban culture he lamented rejoining after his stint

in Europe thus provided Lam with the very catalyst he needed to craft a novel signature style. He even began to see Cuban culture itself as a form of surrealism: "Here in Cuba there were things that were pure surrealism [*surrealismo puro*]. One example would be Afro-Cuban religious beliefs [Santería]; one can immediately see the poetry that is preserved in this elemental magical state [*estado mágico, primitivo*]."[55] Lam's use of the term "poetry" to refer to Afro-Cuban rituals betrays the importance of surrealism as a literary movement; but it also betrays the ideas of Fernando Ortiz. "The ritual practices of the African religions and magic surviving in Cuba," Ortiz writes, "teach us that the most sacred and intimate expression is simply spoken in traditional and cryptic African language, which can only be heard by the supernatural entity it addresses. It is poetry."[56]

Referencing Santería symbology, then, allowed Lam to remain within surrealism's ideological orbit *and* radically expand its visual language, all the while reflecting his culture of origin in a manner that could only be seen as authentic—or, at least, more authentic than Picasso's or even the surrealists' engagement with the non-Western. Breton, after all, regretted that, as far as non-Western artists were concerned, the surrealists remained "ignorant of their aspirations and have only very partial knowledge of their customs. The inspiration we were able to draw from their art remained ultimately ineffective."[57] In many ways, Breton could have included Picasso in this statement—but not Lam. By celebrating "the physical union of man and the world,"[58] his work, in the words of the Martinican poet Aimé Césaire, reflected the attitude of many Caribbean blacks. This point was also made by Césaire's wife Suzanne, who, like her husband, contributed to the important journal *Tropiques*, a major venue for the Négritude movement, and who described the native Martinican as a "plant-man, and in identifying himself with the plant, his wish is to abandon himself to the rhythms of life."[59] Lam, Césaire, and Breton struck up a close friendship when they met in Martinique, and, in conversation with Julia Herzberg, Holzer confirmed how critical the connection between humanity and nature was to Lam's overall worldview. Lam, she professed, subscribed to a conception of things according to which plants, animals, and divinities have a single

soul, a vital energy. This was not an intellectual approach, in her view, as much as an attitude that pervaded the majority of people in Cuba.[60]

On all these counts—an interest in non-Western art, in the psychological ideas of Jung, and in the mixture of human and animal forms—Lam's work closely aligns with the early phase of the American abstract expressionist movement. *The Jungle*, as is widely known, was shown in 1944 at the Pierre Matisse Gallery in New York, a city Lam visited several times, where he met Arshile Gorky, Roberto Matta, Robert Motherwell, Frederick Kiesler, and Jackson Pollock. Since Lam's work was subsequently exhibited at Pierre Matisse's in 1945, 1948, and 1950, it can be also assumed that the abstract expressionists were familiar with his work, examples of which also appeared in *Tiger's Eye*, a short-lived journal with which New York School artists were closely associated.[61] From the other side, Lam followed the New York art scene through the publications, articles, reviews, and catalogues regularly sent to him by Matisse.[62]

No less than Lam, the abstract expressionists inherited Picasso's and the surrealists' fascination with things non-Western. And just as Breton acknowledged how little European artists knew of the cultural assumptions motivating their African or Oceanic counterparts, the abstract expressionists recognized—but sought to overcome—these limitations. In a radio interview, Adolph Gottlieb declared that: "While modern art got its first impetus through discovering the forms of primitive art, we feel that its true significance lies not merely in formal arrangements, but in the spiritual meaning underlying all archaic works."[63] Hoping to redress modern artists' ineffectiveness in initiating a legitimate dialogue between disparate cultures, the abstract expressionists' attitude closely coincides with Lam's. Upon returning to Cuba, he set the following agenda for himself: "I decided that my painting would never be the equivalent of that pseudo-Cuban music for nightclubs. I refused to paint cha-cha-cha. I wanted with all my heart to paint the drama of my country, but by thoroughly expressing the Negro spirit, the beauty of the plastic art of the blacks."[64] Likewise, Gottlieb declared: "If we profess a kinship to the art of primitive men, it is

because the feelings they expressed have a particular pertinence today. In times of violence, personal predilections for niceties of color and form seem irrelevant. All primitive expression reveals the constant awareness of powerful forces, the immediate presence of terror and fear, a recognition and acceptance of the brutality of the natural world as well as the insecurity of life."[65]

Ironically, the increased popularity of non-Western art in the West eroded Picasso's radical edge (one says "ironically" because he had initiated this very trend). Suspicious of this process, Lam and the abstract expressionists sought to spark a more meaningful, respectful dialogue with non-Western cultures, a dialogue, in other words, that would avoid the trap of trivializing or commercializing the other. Concocting unprecedented, disconcerting mixtures of human and animal forms, it seems, was their weapon of choice. In Mark Rothko's *The Omen of the Eagle* (fig. 10), for example, a work loosely based on Aeschylus, aquiline forms in the center interrupt the continuity of three human bodies (whose heads and feet are discernible at the top and bottom of the piece, respectively). In a drawing Jackson Pollock submitted to his Jungian psychoanalyst in 1939–40 (fig. 11), a central human embryonic form lies under a Picasso-esque double-profiled head, all combined with equine body parts, including no less than three horses' heads—the one at the bottom left terminating into a sharp triangle stabbing a disembodied human face in the mouth.

Like Lam, Pollock was strongly affected by psychoanalytic ideas,[66] and frequently praised non-Western art, though he disavowed, somewhat disingenuously, any intentional appropriation of its formal properties.[67] Again like Lam, Pollock sought to surpass Picasso and surrealism by initiating unprecedented mixtures of human and animal anatomy. As influenced by Picasso as Pollock's drawing undoubtedly is, its radical morphology clearly parallels Lam's experiments in pieces such as *The Jungle*, as well as the more extreme renditions of the femme-cheval, works in which the artist, in Charles Merewether's words, enacts "the moment of woman-becoming-the-horse."[68] Difficult to interpret, Pollock's intermixtures may be read as attempts, no different from Lam's, to give free rein to spontaneity and improvisation. (The drawing mentioned above was submitted to Pollock's Jungian psychoanalyst as a trigger for discussion, a substitute for the act of free association in which the artist, quiet and taciturn, was reluctant to engage.) Yet, in keeping with the abstract expressionist directive to fashion formal solutions that would convey "the spiritual meaning underlying all archaic works,"[69] one wonders to what extent Pollock was, not simply being impulsive and extemporaneous, but consciously visualizing anthropological ideas about the organization and belief systems of non-Western cultures.

Modern Art and Anthropology

Unlike Lam, Pollock was not inculcated in a belief system such as Santería. But this does not mean that he had no knowledge of non-Western art, or remained indifferent, like Picasso, to the way specific objects functioned in their culture of origin. In *The Making of Man*, an anthropological anthology found in Pollock's library, Edward Tylor devotes a chapter to a phenomenon he construes as almost universally present in preindustrial cultures: animism.[70] He defines the concept—similar to anthropomorphism—as the attribution of human characteristics to animals, plants, or inanimate objects. In this regard, animism signals a largely mystical rather than strictly material view of the ambient universe. "The sense of absolute psychical distinction between man and beast," Tylor writes, "so prevalent in the civilized world, is hardly to be found in the lower races."[71] Not only is it common for individuals in non-Western cultures to count animals as their equals, but, he adds, they also believe animals to "have a soul," a soul that "may have inhabited a human being." As a result, any animal "may in fact be their own ancestor or once familiar friend."[72] The predisposition of pre-literate cultures, then, is to integrate, not separate, human and animal; in some cultures, ancestors are even believed to have been hybrid shape-shifters capable of moving from human to animal and vice-versa.[73]

Pollock alluded, albeit generally, to this form of identification in pieces such as *Totem I* and *Totem II* of 1944 and 1945, respectively. A concept frequently employed but rarely defined in Lam scholarship, totemism was also widely mentioned and explained in the anthropological literature Pollock owned.[74] Borrowed from Native North

10. Mark Rothko, *The Omen of the Eagle*, 1942. Oil and graphite on canvas, 65.4 x 45.1 cm, National Gallery of Art, Washington, DC, 1986.43.107.

11. Jackson Pollock, *Untitled*, c. 1939–40. Colored pencil, lead pencil, 35.6 x 27.9 cm, private collection.

Americans, the word "Totem" refers to a form of social organization where clans identify a particular plant or animal and its protector. This is not simply a question of wearing a costume, or of imitating the behavior of animals during select rituals. Each member of the clan worships and identifies with the animal, often to such an extent that injury or death is believed to befall any who harm, consume, or kill their respective totem animal (an act considered so egregious as to be tantamount to auto-cannibalism). The identification, moreover, is all encompassing; no differentiation is made between animal as individual and animal as genus.[75]

If animals are endowed with particular aptitudes (eagles or falcons with flight) some North American tribes will impute additional powers to them (the ability to see and divine everything in their surrounding environment). Believed to reside in sections of the animal's anatomy (feathers, wings, or tail), these powers automatically transfer to shamans who don such garb.[76] So intimate are these connections that shamans allegedly gain insight into, and even influence over, the animals to which they become linked by totemic identification. In the skin of a tiger, wolf, or bear, the shaman *becomes* the tiger, wolf, or bear. There is no need to ask whether he was first human, animal during the ceremony, and then human again afterward; accord-

ing to the mystical laws governing the totemic mindset, human and animal are interchangeable.[77]

Though little is known of Pollock's knowledge of mythology, Peter Busa, an artist friend, recalled that "Jack had a feeling for the transformation that the Northwest Indians have—a bird turns into a man or something,"[78] thus insinuating that his human/animal hybrids were directly inspired from Native American folklore. From the testimony of an informant, the ethnologist Diamond Jenness transcribed a strikingly similar account: "We know what the animals do, what are the needs of the beaver, the bear, the salmon, and other creatures, because long ago men married them and acquired this knowledge from their animal wives. Today, the [missionary] priests say we lie, but we know better. The white man has been only a short time in this country and knows very little about the animals; we have lived here thousands of years and were taught long ago by the animals themselves."[79] The same applies to plants, which would have been of particular interest to Lam since his work amalgamates human and animal to botanical life as well as to each other. This is an important point to make: in societies where subsistence is either partly or completely dependent on cultivating the soil, extraordinary properties and sacred status are assigned to, and ceremonies and agrarian rites are performed to assure the reproduction of,

vegetal life.[80]

The idea that human beings are inextricably connected to the animal kingdom is also central to Santería. If harming one's totem animal is deadly to the perpetrator, the opposite is also true. When animals are sacrificed in Afro-Cuban ceremonies, an "invisible life force (ashê)," Julia Herzberg writes, is believed to pass "from one living creature to another. In that exchange, each creature is strengthened, and the union between the living, the ancestors, and the deities is perpetuated."[81] Lydia Cabrera also emphasized how, for many Afro-Cubans, "Trees and plants are beings endowed with soul, intelligence, and will, no less than all that is born, grows, and lives under the sun, like any other natural manifestation."[82] Animal mascots, she continues, are also dedicated to, and entrusted to protect, an orisha or saint. As a result, they are given special attention and cannot be sacrificed. Orishas are the animals' real masters and severely punish anyone who mistreats them.[83]

Though they may not have recognized the full range of these connotations, Lam and the abstract expressionists, unlike Picasso, sought to translate the general mindset of pre-industrial societies—concepts relating to animism and totemism in particular—by conflating human, animal, and vegetal forms in their work. In perfect alignment with Aimé Césaire's assessment that Lam's work celebrates "the physical union of man and the world,"[84] Robert Motherwell insisted that "one's art is just one's effort to wed oneself to the universe, to unify oneself through union."[85] That being said, the merger between self and world Lam and the abstract expressionists visualized should not necessarily be taken in a purely pantheistic light. More often than not, the results of these conflations, or so these artists hoped, created a disturbing and disconcerting art, one that resisted the kind of commercial commodification to which, say, African art was subject in Western Europe. Lam's own contempt for tourist art is equally emblematic of this attitude, one that echoes the abstract expressionists' broader ambition to evoke "the fear and terror" of human existence. Hoping to dispel any notion of having created an entertaining art, Lam likewise declared: "There is no equivalent for the well-known phrase 'No problem' in my paintings. There are problems in them."[86]

Even so, it must be conceded that, despite seeking to advance a non-commercial, more anthropologically-informed dialogue with non-Western cultures than their predecessors, the abstract expressionists' references to terror and fear are, by all accounts, more of a Western projection than a legitimate engagement. What is more, the abstract expressionists experienced few, if any, direct contacts with non-Western societies. Given his Cuban origins and early training in Santería, Lam could justifiably claim greater authenticity and legitimacy for his own art. But, again, the situation is not so simple. In communication with Julia Herzberg, Holzer insisted that her husband was an atheist,[87] which means that Lam, no less than the abstract expressionists, did not endorse the belief systems he conjured in his work, a proposition that, admittedly, poses a delicate problem for art historical interpretation. Frédéric Keck usefully observes that, by describing a belief in supernatural beings in an intelligible way, a scholar will be unable to describe that belief from the perspective of a believer, since the belief will be distorted as logical forms of explanation are brought to bear.[88] For this reason, Joseph Campbell feels that poets and artists "are better qualified both by temperament and by training to intuit and interpret the sense of a mythological figure than the university trained empiricist."[89]

Lam, of course, did not subject Afro-Cuban beliefs to logical explanatory schemes, but his atheism could not help but insert epistemic distance between the mindset he evoked in his art and his own. "The trouble is," he confessed, "that I'm fifty-percent Cartesian and fifty-percent savage."[90] Jacques Leenhardt is thus rightly skeptical of interpretations that liken Lam's work to cult rituals or ceremonial trances. Whenever a belief system is being transcribed in a modern aesthetic idiom, we are confronted, he writes, with a non-religious employment of religious symbols.[91] Similarly, Charles Merewether observes that, by referencing Afro-Cuban belief systems, Lam transcribed a "sacred world into another sphere of circulation, outside of itself."[92] These are important points to make. It was mentioned earlier that, to offset its commercialization in Europe, Lam sought to relocate African art to its proper setting. But in Lam's work, very few archaeological pieces or religious beliefs are ever transcribed verbatim, and few

compositions repeated with predictable regularity: "Neither illustrator, nor ethnographer, if Lam borrows, he distorts, transforms, and reconfigures."[93] On this account, though Lam had greater familiarity with the symbols he was employing than Picasso or European and American modernists, he was still removing them from their original context and forcing them to serve a completely different function, a function over which he alone had absolute control.

If his lack of faith prevented him from describing a belief system from "the perspective of a believer," it would not have precluded him, as Herzberg proposes, from conjuring the cultural and religious ethos of the Afro-Cuban community in his work out of respect, even reverence.[94] "He might evoke the names of the African gods," Sims interjects, "but he would not risk breaking taboos of secrecy by using sacred symbology in a profane context."[95] According to Fletcher, Lam's evocations of "Afro-Cuban religions arose not from belief (he was agnostic) but from ethnic and racial pride. He considered these sects manifestations of the originality, complexity, and power of the African diaspora, to which he belonged by birth and inclination."[96] These observations are sound. Still, the invocations of "mystery," "mysticism," and "secrecy" often imputed to Lam's work—under the pretext that these qualities represent alternative modes of meaning from those practiced by Western "instrumentality"[97]—may actually reflect forms of Western poetic license more than legitimate Santería practices. Lam, after all, was removing non-Western symbols from their ritualistic origins, and making them serve an aesthetic rather than a religious function, ironically, precisely what Picasso is often—and quite rightly—accused of doing. According to Holzer, Lam never referenced Santería "in an explanatory or narrative way. He detested didacticism. The emblems were merely plastic and poetic elements within the structure of his pictures."[98] Extrapolating from this account, one might advance the proposition that, as far as engaging a dialogue between Western and non-Western art is concerned, the distinction between Lam and Picasso is perhaps more one of degree than one of kind.

Providing, as it were, a critical distance between himself and the Afro-Cuban thematic of his art, Lam's atheism makes it difficult to know how far to push the act of interpretation. If Leenhardt is rightly suspicious of approximating his work to cult rituals or ceremonial trances, Gerardo Mosquera also expresses the view that "no precise symbolism" exists in Lam; any "references to Afro-Cuban religious-cultural complexes are very indirect."[99] Julia Herzberg, for her part, argues for an opposite approach, bemoaning the lack of specificity in art historical readings of Lam's paintings. More than anyone, she has advocated for more intimate connections between Lam's imagery and Afro-Cuban beliefs. There are legitimate points to be made on both sides. But how is an interpreter to navigate between them? How is Lam's imagery to be deciphered?

In Afro-Cuban religion, for instance, Oggun is the god of iron, protector of all professions that require manipulating this or any other metal.[100] One painting (fig. 12) conceivably represents Lam's interpretation of this divinity, the presence of the horseshoe in the piece providing a dead giveaway. If this identification seems self-explanatory, Lam's execution of an almost exact composition entitled *The Mango King* (fig. 13) thwarts any attempt at effective interpretation. Lam rarely repeated compositions verbatim, but, in this case, barring differences in color, the figures in both pieces are nearly identical. How, and against what frame of reference, is this similarity to be construed? On the most obvious level, it belies Lam's previously cited assumption that he worked "in an automatic manner," that his thematic material simply "sprang out" of his unconscious mind. Indeed, the reemergence of the same shapes in exactly the same configurations betrays the extent to which his manner of working was far more calculated than he described, a point he conceded, intriguingly, on another occasion: "I can't do anything without an almost absolute control of my consciousness. When I paint, I am like a combat weapon."[101]

Representing Oggun and the Mango King by one and the same form suggests, not just how calculated Lam's process actually was, but also how tenuous connecting Lam's forms with a particular subject may be. How specific, one may ask, is Lam's assigning of meaning if the same shapes represent both Oggun and the Mango King? *Le Sombre Malembo,*

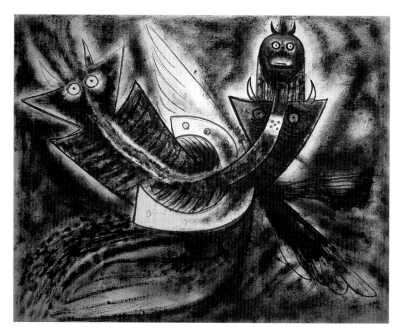

12. Wifredo Lam, *Oggun Ferraille, le dieu du fer [Ogun Arere]*, 1944 [44.33]. Oil on reinforced paper, 74 x 94 cm, private collection.

Dieu du carrefour (plate 30), moreover, references a single deity in its title, yet, disregarding the extra limbs and heads protruding in all directions, the image patently represents no less than two figures.[102] And, despite having singular titles, *Oggun* and *The Mango King* are also multi-figural compositions. The lesson to draw, perhaps, is that *Oggun*, *The Mango King*, or *Le Sombre Malembo* are no more literal visualizations of Santería spirits than *L'Annonciation* of 1944 (plate 32) is a literal visualization of any scene from the New Testament. Not surprisingly, Lam claimed to reject any "specific symbology" or "symbolic tradition" in favor of working "on the basis of poetic excitation."[103] Such eclectic pluralism could allude to the amalgamation of African and Christian beliefs in Cuba; but it also runs afoul of Lam's later comments about his art being "an act of decolonization," a "Trojan horse" to "disturb the dreams of the exploiters." The tension is undeniable: on the one hand, the artist professes a belief in the necessity for art to convey a social message, as well as his confidence in his work's ability to meet this requirement; on the other, the necessity to give free rein to his imagination, irrespective of the audience's expectations.

This tension may be resolved, however, if Lam's allusions to Santería—about which the evidence is too scant to permit firm conclusions—were reconnected to surrealist ideology.

After all, surrealism's radical aesthetics did not imply an abjuration of Breton's political commitments. Anything non-conformist, anything that violated the expectations of the audience, anything that might shock the spectator, would, or so the argument goes, incite a disturbing effect, jolting the public so far from its normal habits of mind that social and political change would ensue. Subscribing to this point of view, Lam could easily have construed the rejection of prescribed iconographical codes as inherently political, if only because his pictures' lack of legibility would frustrate the audience's desire for a clear, transparent mode of communication. We will return to the political implications of Lam's work below; for now, one might also say, regarding *The Mango King,* that the piece came into the possession of Breton, who may even have assigned its unusual title, one whose connection to Lam's own conception may have been marginal at best. Consequently, we cannot determine whether the Mango King refers to an actual monarch, to the fruit's origins in South-East Asia (where the mango is often referred to as the "King of Fruits"), or to both.

No less relevant is Lam's practice, Fouchet recalls, to assign titles to his paintings only after completion.[104] He even allowed Holzer, Breton, or Cabrera to do so, a disposition that—again—intersects with that of the American abstract

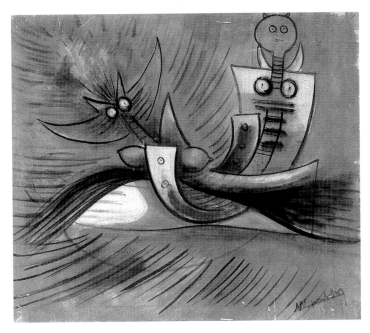

13. Wifredo Lam, *The Mango King [Roi-Mangue]*, 1944 [44.35]. Oil on canvas, 65.5 x 77.5 cm, private collection; formerly in André Breton's collection.

expressionists. "There is always a subject that is uppermost in my mind," William Baziotes explained, "Sometimes I am aware of it. Sometimes not. Often I recognize my subject at completion of the picture."[105] Similarly, Barnett Newman admitted that: "The verbalized title comes after I've finished."[106] And Pollock also conceded that, during the act of painting, he was "not aware of what [he] was doing," only after what he called a "get acquainted period," did he realize what he was "about."[107] Like Lam, Pollock also made a habit of titling paintings after the fact, often with the help of individuals he trusted. And—also like Lam and the surrealists—the abstract expressionists did not view the absence of a pre-ordained iconographic system, or the implementation of improvisational techniques, as politically neutral. "The abstractness of modern art," Robert Motherwell insisted, "has to do with how much an enlightened mind rejects of the contemporary social order. [...] But I think that the art of the School of New York, like a great deal of modern art that is called 'art for art's sake,' has social implications. These might be summarized under the general notion of protest."[108]

Lam and Lévy-Bruhl

Lam and the painters of the New York School obviously shared more artistic and intellectual concerns than have been acknowledged in the scholarly literature thus far. But despite their frequent contacts—e.g., Lam's visits and exhibitions in New York—it is difficult to ascertain the direction in which influences moved. Pollock fused human and animal forms several years prior to Lam's first show at Pierre Matisse in 1942, yet those drawings, kept in his psychoanalyst's files until 1970, remained inaccessible to Lam. If mutual influence must be recognized, its directionality cannot be assessed with any precision; nor can the question whether Lam and the abstract expressionists ever exchanged ideas relating to totemism and animism. One might therefore venture the hypothesis that Lam altered the course of Pollock's work no more than Pollock altered the course of Lam's, most notably, because both used similar sources (Picasso, surrealism, Jung, non-Western art) and moved along parallel thematic and aesthetic trajectories.

One might also venture another hypothesis: that, in their attempts to engage non-Western art with a view to understanding its meanings—although those attempts were not always successful—Lam and the abstract expressionists relied, not simply on aesthetic examples, but also on a set of related ideas articulated in contemporary anthropology. Included in the previously mentioned anthology in Pollock's possession—*The Making of Man*—for example, was an essay, "The Solidarity of the Individual with

His Group," by French philosopher-turned-anthropologist, Lucien Lévy-Bruhl. In this text, Lévy-Bruhl posits that non-Western individuals see human beings, animals, and inanimate objects as participating in a common yet dynamic, mystical continuum.[109] These observations strike a remarkable chord with both Pollock and Lam's proclivity to interlace human and animal forms. Explaining the collective nature of what he (somewhat unceremoniously) calls the "primitive mind," Lévy-Bruhl writes that "The primitive mind tends to confuse the individual and the species…individuality is but relative…only a multiple and transient expression of a single and imperishable essence."[110] In other texts, Lévy-Bruhl stresses that the "member of a tribe, of a totem, of a clan, feels himself mystically unified with his social group, mystically unified with the animal or vegetal species that is his totem."[111]

Collecting detail was not Lévy-Bruhl's ambition, only finding the "governing principles of primitive mentality, and how these principles make their presence felt in institutions and practices."[112] This general approach may be especially useful for our purposes because, as we have seen, Lam's references to Santería were more generic than specific, less about particulars than about wide-ranging principles pertaining to non-Western patterns of thought. Although these principles cut across a variety of religious belief systems, birth and death rituals, mythological narratives, etc., Lévy-Bruhl detects no corresponding analogs in Western society.[113] Contrary to Jung's later idea of the collective unconscious, Lévy-Bruhl dismisses the suggestion that a common "human spirit" perdures in all geographical locations and chronological periods. Totemism and animism are not inevitable manifestations of a common human proclivity, if only because no comparable structures exist in our own culture.[114] The "primitive" tendency to attribute supernatural causes to natural phenomena, Lévy-Bruhl adds, is diametrically opposed to the intellectual curiosity and search for causal explanations emblematic of Western scientific rationalism. In contradistinction, the collective representations and explanatory schemes governing pre-industrial cultures are taken purely on faith.[115] As such, collective social structures will differ from society to society, and, more importantly, from "lower" to "higher" cultures. Any pre-conceived attempt to reduce human mental operations to a single type, regardless of the society studied, or to explain collective representations by consistent or unvarying psychological principles, he claims, must be categorically rejected.[116]

Outlining the basic, common characteristics of "primitive mentality," Lévy-Bruhl classifies the mental activity of "primitives" as undifferentiated, i.e., unable to parse ideas and objects from the feelings or emotions they provoke. Although Westerners can distinguish representations from emotive states,[117] individuals in pre-literate societies acquire their collective social representations under circumstances susceptible to provoke strong emotional reactions (e.g., initiation ceremonies, purification rituals, etc.). In these contexts, no object is devoid of affect and images of objects are deemed as real as objects themselves.[118] Consequently, images are both petitioned and feared, establishing relationships that compel Lévy-Bruhl to call "primitive" mentality "mystical." A mentality is deemed mystical if it is governed by a belief in external forces and influences that, albeit invisible, are considered real.[119]

Under these conditions, perception remains "undifferentiated." No logical operations govern the interpretation of phenomena since no phenomena exist independently of interpretation.[120] Phenomena are not divided according to species, varieties, or classes, but according to the totems to which individuals belong; principles of classification rely not on empirical qualities but on laws of mystical participation.[121] In conclusion, Lévy-Bruhl argues that the mentality of "inferior societies…does not exclusively obey the laws of our logic, nor perhaps to laws that are of a logical nature…primitives apply the principle of causality indiscriminately, and confuse the antecedent with the cause."[122] Simply imagining a link between two separate occurrences is often sufficient to persuade an individual that the link is real; no empirical or causal verification is necessary. What makes the link possible are not logical rules, but "laws of participation," according to which objects, beings, or phenomena can be simultaneously themselves and things other than themselves. For "primitive" mentality, in other words, "the opposition of the one and the many, the same and the other, etc., does not impose the necessity to affirm one of the terms if one denies the other, or inversely."[123]

The many connections between Lam and abstract expressionism, arguably, are explainable against this background. Not simply the general tendency to reference totemism by fusing human, animal, and vegetal in an unprecedented way, but also the set of assumptions more specific to Lam, according to which, say, Oggun and the Mango King may possibly be represented by one and the same figure (figs. 12–13). If the laws of participation escape the constraints of logic—for Lévy-Bruhl "primitive mentality" qualifies as mystical *and pre-logical*—then laws of participation do not abstain from inconsistency. In the West, logic rests on the law of non-contradiction; we cannot simultaneously say "A is B" and "A is not B" without inviting the accusation that we are either illogical or have contradicted ourselves. These constraints, according to Lévy-Bruhl, have no force in pre-literate societies. Statements issue from emotional sensations, not intellectual rigor, from strongly felt relations, not conceptual modes of categorization.[124] It was related in an earlier section, for example, that totemic identification does not distinguish animals as a genus from animals as individuals; but there is no reason to believe that harming a single animal automatically means harming the entire species; this is not a logical, demonstrable proposition, only one that is felt under the laws of mystical participation.[125]

Equally relevant to Lam is Lévy-Bruhl's assertion that most non-Western societies confuse singular and plural, and do not endorse the dualistic principle of body and soul. There is no uniform consistency, but, on the basis of multiple reports, Lévy-Bruhl posits that the majority of "primitives" believe in human beings having a multiplicity of souls, which may inhabit and leave their hosts at will, without necessarily altering an individual's life expectancy (death occurs only when the souls depart *en masse*). Some of these spirits, like homunculi, take the form of human individuals in miniature.[126] This belief provides a plausible explanation for the multiple appendages, limbs, heads, and arms that sprout from so many of Lam's hybrid forms, as well as for his proclivity to assign singular titles to multi-figural compositions. Lam seems to have visualized, if not endorsed, a far more pluralistic view of the mind than conventional Western divisions allow (e.g., body and soul, rational and emotional, conscious and unconscious), a

view also unfettered by the unambiguous hierarchies those same dyadic relationships invoke (e.g., good and evil, dominance and subservience, control versus lack of control). To be sure, Lam must have been struck by the visual characteristics of Senufo Kpeli-yehe masks,[127] some of which display multiple heads, with smaller human figures, horns, or bird forms emerging from unexpected locations (fig. 14); but Lévy-Bruhl would have provided the cultural rationale, the underlying reason, for such visual pluralism.

This alternative view of the mind warrants the visual complexity evident in Lam's works. The dizzying plurality of figures, all moving in various directions without a clear pattern or central focus, evokes a mind absent a clear command-and-control structure. The fragmentation of figures, in turn, into a plurality of sub-figures, also erodes the distinction between the natural and the supernatural. "Between a neat conception of spirits who are like real demons or gods, all of whom have their names, attributes, and their cults," Lévy-Bruhl writes, "…there is room for an infinity of intermediary forms, some more precise, others more nebulous, more vague, whose contours are less defined, but none less real for a non-conceptual mentality where the laws of participation still dominate."[128] A similar plurality, incidentally, governs Cuban Santería, a belief system in which human beings accrue a multiplicity of guardian angels, comparable to the patron saints of Christianity, who, invisibly and unbeknownst to anyone, labor to keep danger at bay. What is more, the line between these guardians and Santería priests even begins to blur, as if no clear demarcations exist between the natural and the supernatural. Analogously, Lam's paintings not only evoke a plurality of figures and sub-figures; they also, quite cleverly, withhold the very interpretive key necessary to decode what belongs to whom. In this way, a very different conceptualization and representation of the human being is visualized from the one operating in Western culture, even from the dualism underlying Picasso's Minotaur.

If ample evidence exists to corroborate the abstract expressionists' interest in Lévy-Bruhl, regrettably, no such evidence exists with respect to Lam, and, perhaps for this reason, no exegetical case has yet been made for interpreting Lam's work in this light. But Lam could easily

14. Senufo (Ivory Coast), *Kpeli-yehe mask,*
n.d. Wood, 50.5 cm, private collection.

have absorbed Lévy-Bruhlian concepts through Michel Leiris, the very person who, at the instigation of Picasso, instructed Lam in African art,[129] as well as from the intellectuals he befriended after returning to Cuba: most notably, Lydia Cabrera, Alejo Carpentier, and Fernando Ortiz.

Pioneers of a sort, and strong supporters of Lam's work, the three played a critical role in making Afro-Cuban studies a respectable discipline. Through their association, Lam deepened his knowledge of his own culture, and complemented his emotionally charged childhood experiences with his godmother with a more detached, intellectual perspective. In their statements, moreover, Cabrera, Carpentier, and Ortiz betray how much their view of Afro-Cuban culture was informed by Lévy-Bruhlian notions. Cabrera, for one, was exposed to Lévy-Bruhl's ideas in Paris where she also met Leiris.[130] If Lévy-Bruhl argued that the "primitive" does not differentiate the natural from the supernatural, or mere mental associations from legitimate causal links between objects or occurrences, Cabrera likewise wrote that, for many an Afro-Cuban, "All is required is that he repeats several times a marvelous event that he invents, as a poet does, for it to transform itself insensibly and inscribe itself in his consciousness as something that really happened to him."[131] This proclivity, she continues, attests to the Afro-Cuban's "great emotive religi-

osity, his credulousness, and, consequently, the permanent and incalculable influence that sorcerers and magic continually exert on his life."[132] "In an environment such as ours, incredibly impregnated with magic, the Afro-Cubans continue to react with the same *primitive mentality* [italics added to stress the obvious reference to Lévy-Bruhl's book of the same name] as their ancestors, before any natural accident or setback (be it perfectly inexplicable or perfectly explicable, it does not matter) that intervene in their life. And this, despite public education, university, or the Catholicism they perfectly reconcile with their own ideas and that has not altered their religious beliefs."[133]

Afro-Cubans, Cabrera submits, remain African in character. They invoke the same natural divinities (that reside in rocks, seashells, bark, or roots) and perpetuate the same ancient magical practices as their forebears. Afro-Cubans are persuaded that they live among spirits that, for good or ill, influence every aspect of their lives. For this reason, "they have difficulty accepting a purely scientific explanation of any illness that affects them, or the natural causes that provoke it."[134] This clearly echoes Lévy-Bruhl's assertions that, in pre-literate societies, illness is a mystical state, attributable to invisible and supernatural, rather than natural forces.[135] The ease with which Afro-Cubans fall into trances at the slightest provocation, Cabrera continues,

betrays their susceptibility to autosuggestion, a "congenital condition to which the majority is predisposed," and which leads them to accept the omnipresence of the supernatural world.[136] "Logic," Cabrera writes, in pure Lévy-Bruhlian fashion, "has nothing to do with faith."[137]

Alejo Carpentier's doctrine of magical realism, moreover, of seeing "the marvelous in the real,"[138] of understanding that everything "fabulous…is nonetheless just as real,"[139] equally betrays the influence of Lévy-Bruhl's definition of "primitive mentality." Even more to the point, and to one of Cabrera's observations cited above, is the anthropologist's notion that "Between this world and the other, between sensible reality and the beyond, the primitive individual makes no distinction. He truly lives with invisible spirits and with impalpable forces. These realities are, for him, the most real."[140] Lam himself approximated such pronouncements when he declared that painting should "not be a fiction but life itself."[141] In this regard, Charles Merewether hits the nail right on the head when he writes that both Carpentier's concept and Lam's work accommodate "the co-existence and interplay of different orders of reality."[142] Merewether only overlooks the connecting link supplied by Lévy-Bruhl. It is typical of "primitive" societies, the anthropologist insists, to attribute identical properties to real objects as to their corresponding representations,[143] to the natural and the supernatural, to the magical and the empirical.[144]

Often called the father of Cuban anthropology, Ortiz was perhaps even more significantly impacted by Lévy-Bruhl. In a lecture of 1937, for instance, "Religion in Mulatto Poetry," he writes: "The black of Africa lives submerged in religion and magic. His intense religion is concomitant with the paralogical mentality that does not analyze the causes of phenomena. […] Religion kills his intellectual curiosity with the consciousness that he has to know the magical and suprahuman cause of everything, particularly those of the unusual and surprising."[145] If the content of the passage were not Lévy-Bruhlian enough, particularly the point that members of non-Western cultures overlook the laws of causality, the term "paralogical mentality" provides a dead giveaway.

Given that Lam, Cabrera, Carpentier, and Ortiz were friends, one could conjecture that the liberties Lam takes with human anatomy—allowing it to merge with animal forms or with its surrounding environment—were informed, no less than Pollock's, as much by his study of non-Western art, as by exposure, albeit indirectly, to Lévy-Bruhl's ideas. For Cuban scholars who acquired intellectual training in Europe, returning to Cuba provoked both feelings of displacement and a desire for autonomy from that very same training. Fortuitously, Lévy-Bruhl stressed the characteristics of non-Western cultures that transgressed the criteria of Western rationalism: an acceptance of magic, a tolerance for contradiction and pre-logical ways of thinking, a reliance on faith and affect, and the construction of meaning through mystical laws of participation. Paradoxically, Lévy-Bruhl also supplied an intellectual framework by which those same characteristics could be identified, categorized, and made intelligible. One says "paradoxically," not simply because those same "pre-logical" patterns of thought were being subjected to "logical" analysis, but because Lévy-Bruhl was himself a European, a direct exponent of that same Western rationalism to which non-Western mentality (according to his own account, at least) was so opposed.

Whether Lévy-Bruhl's ideas are at all accurate, or a product of the Western paternalistic and ethnocentric attitudes Cuban intellectuals wanted to escape, is a legitimate question to ask, especially if his own Eurocentric prejudices were picked up, even if inadvertently, by Lam and his Cuban champions. The very concept of "mentality" is itself vulnerable to criticism, no less, in turn, than the strict demarcation between "primitive" and "modern" mentality.[146] (It bears mention that Lévy-Bruhl later softened his position, abandoning the strict division of "primitive" from "modern" forms of mental operations, and conceding that pre-logical and mystical ways of thinking, though more pronounced in "primitive" societies, are discernible in many forms of human behavior.[147]) Although this question might require another study in its own right, one might say, if only parenthetically, that, while Lévy-Bruhl's early ideas helped Cuban intellectuals celebrate their own native traditions by identifying patterns of thought acting outside the grip of Western rationalism, these intellectuals also moved beyond Lévy-Bruhl's limited, Eurocentric perspec-

tive. By celebrating these belief systems in their work, and Lam in his art, Cuban intellectuals began, unlike Lévy-Bruhl, awarding them, if only tacitly, the higher status of religion rather than the lower one of magic. In the process, the field of Afro-Cuban studies, not to mention the worship practices of the Afro-Cubans themselves, gained greater legitimacy. Emblematic of this paradigmatic shift was their eventual substitution of the word Santería, "the worship of saints," for that most pejorative of terms, "brujeria"—sorcery or witchcraft.[148]

Even so, Lévy-Bruhl provides a sound enough intellectual template to resolve many of the interpretive conundrums previously mentioned. The question of Lam's titles was broached earlier because their mutability (even interchangeability) frustrated attempts to interpret his work. But if he had gotten wind of Lévy-Bruhl's ideas, Lam would have known that, just as images in many non-Western cultures are imbued with the same spirit as the objects or persons they represent, names are also invested with mystical qualities. More than mere labels, names are dangerous to pronounce because they can alert, provoke, or compel a named spirit or animal to appear. Lévy-Bruhl relates how hunters feel it in their power to inhibit a prey's abilities by substituting its name for that of a weaker animal of the same family—say, "cat" for "tiger" or "leopard."[149] Similarly, Lam may have learned from Cabrera that, in Afro-Cuban rituals, one may evade a spirit's wrath for transgressing certain alimentary taboos simply by avoiding the name of the forbidden food.[150] In which case, asking why the same composition could be called *Oggun* and *The Mango King* (figs. 12–13) is irrelevant; asking the question itself means employing a mode of thinking with which the mystical rules of participation are incompatible.

Lévy-Bruhl versus Lévi-Strauss

As much as the ideas of Lévy-Bruhl help advance the interpretation of Lam's work, given that Leiris, Cabrera, Ortiz, and Carpentier were significantly impacted by the anthropologist's ideas, this premise does not mean that these same ideas need be accepted uncritically. On the contrary, what Lévy-Bruhl pejoratively defines as "primitive mentality" has been expounded here to outline the set of assumptions under which Lam and the intellectuals he

befriended came to understand the non-Western mind. By the time a newer generation of anthropologists came on the scene, some of these ideas had become fully discredited, and by none other than Claude Lévi-Strauss, whom Lam actually met because both traveled on the same vessel from Marseilles to Martinique when escaping the Nazi invasion of France. How much Lam knew of Lévi-Strauss's ideas remains unclear. Lam's second wife, Helena Holzer, nonetheless wrote that: "Lévi-Strauss related to us detailed observations of collective phenomena in rituals and myths of the Brazilian black population. Wifredo was fascinated."[151] When they met, however, the anthropologist had yet to develop the structuralist methodology for which he is most famous, and for all the details he provides of the boat trip to Martinique in *Tristes Tropiques*—explaining why Lévi-Strauss is so often mentioned in the Lam literature—the anthropologist refers to Lam not even once.

On the other hand, Lévi-Strauss and Breton, who was also on the trip, developed a "lasting friendship."[152] It is thus highly likely that, upon his return to France, while reconnecting with important members of the surrealist movement, Lam would have learned of the anthropologist's ideas, if only because the surrealists followed his work very closely. In fact, Lévi-Strauss socialized with Lam and other surrealists on numerous occasions, and even hung two of Lam's drawings in his office at the Collège de France.[153] Even so, a Lévi-Straussian interpretation of Lam's work is hardly contingent on the artist being familiar with any of the anthropologist's key premises. One says "hardly contingent" because Lévi-Strauss's ambitions were to identify patterns of thought and social organization acting outside of conscious awareness: the way we communicate verbally in everyday situations without necessarily being cognizant of the complex grammatical and syntactical rules that underwrite language.[154] Of course, these patterns of thought and social organization were originally implemented for specific purposes. But over time, they were repeated, unthinkingly, from force of habit, and considered natural, simply part of the order of things. For Lévi-Strauss, then, it is crucial "to grasp the unconscious structure underlying each institution and each custom."[155] Lam's knowledge of Lévi-Strauss, in this regard, is beside the point.

If Lévi-Strauss is mentioned in the Lam literature, however, it is only in connection with the voyage to Martinique. To this author's knowledge, no attempt has yet been made to connect the two men in a serious and sustained manner, or to investigate whether Lévi-Strauss's ideas may also advance the interpretation of Lam's work. Admittedly, Edward Lucie-Smith declared that: "Picasso, Breton, Lévi-Strauss, and Césaire can be regarded as the cornerstones of Lam's later work."[156] But, as sound as this assessment may be, Lucie-Smith adduced no evidence to bolster it and elaborated no further. This reticence is especially unfortunate because, although the influences of Picasso, Breton, and Césaire have been well documented, concordances with Lévi-Strauss—or with Lévy-Bruhl, for that matter—have received no critical attention in Lam scholarship.

At first, this mode of investigation may strike the reader as paradoxical, most notably, because Lévi-Strauss's approach was diametrically opposed to Lévy-Bruhl's. Throughout his career, Lévi-Strauss debunked the concept of totemism, and hoped to dispel the view that non-Western mentality is affective and unsystematic. In fact, he continually attacked Lévy-Bruhl's major contentions that "primitive" mentality qualifies as both pre-logical, or as radically different from ours. Whenever Lévi-Strauss uses terms such as "savage" or "primitive," he invariably employs prefixes such as "so-called" or "so-labeled" to temper their paternalizing implications.[157] There are no distinctive characteristics, he argues, either in terms of language, culture, or worldview, by which consistent differentiations between literate and pre-literate societies may be established.[158] These oversights may have stemmed from Lévy-Bruhl's training as a philosopher, and his decision to forgo anthropological fieldwork in favor of relying on secondary accounts whose reliability and impartiality were at best questionable. Lévi-Strauss was also trained in philosophy,[159] but conducted extensive fieldwork among non-Western cultures (at least, early on); and informed by the work of Ferdinand de Saussure, he moved anthropology away from its philosophical moorings toward linguistics. In the process, fundamental to Lévi-Strauss's methodology were Saussure's stress on the conventionality and arbitrariness of language, and, just as importantly, on the systematic rules according to which

arbitrary signs must be organized to form effective systems of communication. No less seminal was Saussure's other major postulate: that whatever rules govern language also govern other products of culture. If language reveals *its* system, so the argument goes, discovering the system underlying any cultural artifact simply requires treating that cultural artifact *as a language*.

Accordingly, Lévi-Strauss strove to expose the organizational patterns underlying non-Western social practices, religious rites, and mythic narratives. And against Lévy-Bruhl's armchair musings, he described them as no less logical than their analogs in modern, technological societies. Pre-literate cultures, he insisted, categorize the natural world according to strict methods of observation and a disinterested thirst for knowledge worthy of Western science. Likewise, if Lévy-Bruhl contends that the dearth of generic terms in most non-Western languages betrays their speakers' ineptitude for abstract thought, or their inability to construct general concepts,[160] Lévi-Strauss rejoins that degrees of abstraction stand at different levels in different cultures: what is regarded as "abstract" in one culture may be regarded as "concrete" in another and vice-versa.[161] (This axiom can also be turned against Christian missionaries who alternatively accused natives of "superstition"—because they believed in unseen spirits—or "materialism"—because they proved skeptical of the virgin birth or the resurrection.[162])

"The thought we call primitive," Lévi-Strauss argues, "is founded on [a] demand for order. This is equally true of all thought but it is through the properties common to all thought that we can most easily begin to understand forms of thought which seem very strange to us."[163] With this sentence, Lévi-Strauss dispels the view that logic is distinctive to Western culture. And by stressing that all human cognition is predicated on a demand for order—a communality that makes the mental operations of pre-industrial cultures intelligible to us—he places Western and non-Western cultures on equal footing. Intriguingly, though Lévi-Strauss strongly criticized Jung's concept of the collective unconscious, the political implications of his ideas are not dissimilar: namely, that, underneath our differences, we all think and construct meaning the same way.

On his account, magic should not be interpreted in opposition to, or as an early form of, science, but as a distinct yet comparably articulated system. This does not mean that the two are identical, none more likely to predict or affect the behavior of our physical environment than the other. But it means that both can be likened "as two parallel modes of acquiring knowledge."[164]

According to Lévi-Strauss, individuals living in pre-industrial cultures tend, like us, to make sense of their ambient environment by engaging in rigorous classification.[165] "Native classifications [of animals and plants] are not only methodological and based on carefully built up theoretical knowledge. They are also at times comparable from a formal point of view, to those still in use in zoology and botany."[166] This position not simply valorizes how non-Western cultures categorize the physical world; it also stresses how difficult the interpretations of myths and rituals prove "without an exact identification of the plants and animals" involved.[167] As can be gathered from his critique of Jung, Lévi-Strauss argues that mythical narratives follow rules similar to those employed in the classification of nature, transforming "systems of abstract relations" into objects of "aesthetic contemplation."[168] To understand these relations, one must keep in mind that "It is not the elements themselves but only the relations between them that are constant. […] The terms never have any intrinsic significance. Their meaning is one of 'position'—a function of the history and cultural context on the one hand and of the structural system in which they are called upon to appear in the other."[169]

Typically for a structuralist thinker, Lévi-Strauss affirms that the meaning of a symbol is a function of how the symbol is different from the other symbols to which it is opposed, and a function of how the symbol operates within the entire system. Among the Osage Sioux, for instance, the eagle qualifies as a land animal. Though this may seem incomprehensible to us, or attributable to the pre-logical ways in which the primal mind operates, Lévi-Strauss sees specific sets of associations in force, associations that are arbitrary and thus different from culture to culture. For the Osage, the eagle is "associated with lightning, lightning with fire, fire with coal and coal with the earth. The

eagle is thus one of the 'masters of coal,' that is, a land animal."[170] Another culture might use a completely different set of associations and connect animals, say, with the trees they inhabit.[171] "This seeming 'primitive undifferentiation,'" Lévi-Strauss insists, "is not so much an absence of differentiation as a different system of differentiation from ours."[172] In Cuban Santería, plants and fruits of yellow or orange coloration, such as sunflowers, oranges, or mangoes, depend on Ochún, the goddess of love but also of wealth—and therefore gold.[173] And since gold is a metal, gold falls under the aegis of Oggun. Thus, if an eagle can be called the master of coal, and be considered a land animal in one culture, a mango can be associated with wealth and metal in another. What Lévy-Bruhl attributes to pre-logical laws of participation, Lévi-Strauss attributes to complex arbitrary relations. And precisely because they qualify as arbitrary, there is literally no limit on the kinds of meanings signs can convey; they can only be interpreted *in relation* to the other signs in the system, usually organized around a network of binary oppositions. No matter what culture, "the same very simple structure of opposites recurs [even if] the semantic load is reversed."[174]

From such examples, Lévi-Strauss concludes that "the practico-theoretical logics governing the life and thought of so-called primitive societies are shaped by the insistence on differentiation…the existence of differentiating features is of much greater importance than their content."[175] Once this mode of analysis is employed, not only are Lévy-Bruhl's ideas on affect and participation severely undermined, but the very concept of totemism also collapses. In fact, Lévi-Strauss, though he was hardly the first to do so,[176] dismisses totemism as an illusion,[177] always using the term in the same way as he uses "primitive" or "savage," that is, accompanied by a prefix such as "so-called" or "so-described." In pure Saussurian fashion, Lévi-Strauss stresses that the arbitrariness of signs suggests that there are no positive terms, only relations between elements. Analogously, "to say that clan A is 'descended' from the bear and that clan B is 'descended' from the eagle is nothing more than a concrete and abbreviated way of stating the relationship between A and B as analogous to the relationship between species."[178] Any prohibition against eating a totem animal, therefore, does not identify an inherent danger pertaining

to a specific plant or animal, especially since members of other clans eat the same plant or animal with impunity. But it does differentiate group A, which eats the animal, from group B, which does not. The same can be said of other customs: while some clans don their own totem animal's parts to enhance their strength and wisdom, others are expressly forbidden from doing so; while some clans have prohibitions against eating their totem, others do not; while some are subject to exogamic laws, others are not.[179] Again, these reinforce Lévi-Strauss's point that "prohibitions result not from intrinsic properties of the species to which they apply but from the place they are given in one or more systems of significance."[180]

It is only within such a system that meaningful hierarchies can form. In the Congo, for example, Luapula clans joke with each other about their respective standing, but only according to specific rules. The Mushroom clan can joke with the Anthill clan because mushrooms grow on anthills, and the Leopard clan with the Goat clan because leopards eat goats, and the Iron clan with all animal clans because animals are killed with metal implements.[181] Applying these principles, one might offer the following interpretation of Oggun's similarity to the Mango King in Lam's work. What we are confronting are not indiscriminate interchangeabilities based on mystical laws of participation, but very specific sets of analogous relationships and discriminatory modes of classifications. Considering Lévi-Strauss's stress on the kinds of associations some cultures impose (such as the eagle with lightning and the eagle with coal), we propose that Oggun can be associated not only with metals, but with kings, because monarchical authority is enforced by means of metal weaponry, and also with fruits, because they are cut with metal implements. Albeit unconsciously, Lam was concocting a scenario where Oggun's position among gods is equivalent to the Mango King's among monarchs, and the mango's among fruit. Though no intrinsic similarity exists between Oggun, the Mango King, and the mango, their relative positions in the complex network of relationships of which they are a part may be recognized as equivalent.

A Lévi-Straussian Interpretation of Lam's Femme-Cheval

The true purpose of totemic (or so-called totemic) classification, therefore, is not to enable a mystical, pre-logical participation with the natural world; it is, rather, to permit human beings to distinguish—classify—*themselves* through clearly recognizable symbols such as plants or animals.[182] "Men's conception of the relations between nature and culture," Lévi-Strauss writes, "is a function of modifications of their social relations."[183] A relation "to the cosmos may be no more than a transfigured form of relation to the group."[184] Arbitrary and constructed social differences between different human groups are thus given legitimacy by being modeled after, compared to, and represented by, actual objective differences between plant and animal species in the natural world—differences that are then projected, and made real, by functional cultural differences among different *human* groups.[185]

Not surprisingly, this mode of explanation extends to myths. Extrapolating from Lévi-Strauss's penetrating insight, we propose that the surrealists' Freudian interpretation of the Minotaur is off the mark. Instead of conflating human and animal to evoke the bestial side of the psyche repressed in the unconscious, the myth may actually be fulfilling a far more practical function: namely, warning women of the dangers of having relations with a members of a "foreign" or "alien" group, a group to which they are forbidden access by social rules governing marriage, or simply by exclusionary or discriminatory practices. In some cultures, for instance, interracial relations are considered no better than incest, inducing both revulsion and a desire for revenge.[186] (Among these cultures, curiously enough, is the America where Lévi-Strauss wrote *The Elementary Structures of Kinship*, if one remembers that, in many Southern states, interracial relations were then illegal.) The offspring of such relations, the image of the Minotaur warns, would be monstrous and unlikely to gain social acceptance. Under a Lévi-Straussian interpretation, then, what is really at play in the myth of the Minotaur is *not* a prohibition against human and animal relations—but one against relations between different *human* social groups. The meaning of the myth is not so much psychological as socio-political.

49

"Primitive societies have, and not without justification, been said to treat the limits of their tribal group as the frontiers of humanity and to regard everyone outside them as foreigners, that is, as dirty, coarse sub-men or even non-men."[187]

The very fact that such prohibitions exist—either socially, legally, or in the form of myth—suggests that such inter-marriages are perceived to be potentially threatening to the social, ethnic, political, or religious integrity of the group. For this reason, they incur punishment of the severest kind in many cultures.[188] "A very great number of primitive tribes," Lévi-Strauss observes, "simply refer to themselves by the term 'men' in their language, showing that in their eyes an essential characteristic of man disappears outside the limits of the group. […] In Dobu, the white man is considered as 'another kind,' not really a human being in the native sense of the word, but as a being with different qualities."[189]

Even if human cultures regard each other as alien, and rarely let their members intermarry, that does not mean that they cannot marry at all. Restrictions do not simply apply to sexual relations between men and women belong-ing to rival groups; they also apply to men and women belonging to the same group. In tackling the prohibition against incest—a taboo governing most, if not to say all, human cultures—Lévi-Strauss focuses on the positive implications of the prohibition. If men cannot marry cer-tain women (mothers, sisters, daughters, nieces, cousins), they allow those same women to marry outside the fam-ily group. Though anthropologists previously attributed the universality of the incest taboo to either moral revul-sion or the biological need to diversify the gene pool, Lévi-Strauss rejoins that, although restrictions exist in all societies, those restrictions are widely inconsistent.[190] It is therefore instructive to see the incest taboo as a social question, as the very trigger for, as well as embodiment of, cultural organization itself.[191] For Lévi-Strauss, in fact, the incest taboo represents the very means through which "the transition from nature to culture is accomplished."[192] Since men cannot keep certain women to themselves, they offer them as gifts—as objects of exchange—to other men, men who give up their "forbidden" women in turn, so long, of

course, as the groups do not see each other as sufficiently alien. These relationships establish and cement alliances, a kind of glue that brings disparate groups together to found larger societies. It forces human beings, in other words, to overcome their natural fear of and suspicions toward strangers.

The incest taboo, then, is not about repressed sexual desire as much as about breaking isolation and strengthening the social fabric; it thrusts individuals into connections with other individuals, groups into connection with other groups, etc. These connections engender a host of wider benefits, especially if the reciprocity integral to the union of marriage supplies a model for commercial, economic, or other forms of cultural exchange. Not surprisingly, the negative repercussions of incest appear in numerous mythic narratives: not just the Oedipal myth, but varia-tions on Afro-Cuban myths also broach the same ques-tion, one, in fact, dealing with Oggun's incestual relations with his mother Iyémmu.[193]

In this regard, as myths move through different iterations, they emerge, not so much as a system of belief, but as a means of encouraging moral rectitude, if not to say a mode of social control, one whose very efficacy relies, paradox-ically, on pretending to be, not a means of encouraging moral rectitude or social control, but a system of belief. At this point, then, the particular issues raised by Lam's deployment of the femme-cheval (plate 45) may be more susceptible to interpretation. It will be recalled that the femme-cheval symbolizes an individual's spiritual journey during initiation rituals: "In Santería symbology a horse signifies the possession or empowerment of a devotee by an orisha; when a practitioner becomes possessed, that per-son is described as being 'ridden' by that spirit."[194] When a devotee is "ridden" by a spirit during Afro-Cuban initia-tion ceremonies, then the horse—following Lévi-Strauss's premise that animal identification is, in reality, a means of differentiating human groups—distinguishes two separate classes of individuals: in this case, the initiates from the non-initiates, the "possessed" from the rest of the popu-lation.

But if we extrapolate from Lévi-Strauss's other insight— that the incest prohibition is a trigger for establishing social

relations between groups, and that the exchange of women helps cement these relations—then the femme-cheval may be interpreted as functioning in an analogous way. If rules are at the core of social organization, rules of exchange are among the most important. "The prohibition against incest is thus the group's assertion that where relationships between the sexes are concerned, a person cannot do just what he pleases. The positive aspect of the prohibition is to initiate organization."[195] Under these rules, the prohibition against sexual relations with female relatives prompts men to give those same relatives away in marriage to other men, whose own relatives they, in turn, may now claim. "In this way, every negative stipulation of the prohibition has its positive counterpart."[196] In this system, everything is guided by the principle of fairness and reciprocity; as the circle of relationships expands beyond the family, the group, the village, or even the culture, alliances form and connections are forged. "Marriage between outsiders is a social advance (because it integrates wider groups)."[197]

Against this backdrop, we offer the following interpretation of the femme-cheval, one in which she stands as the diametrical opposite of the Minotaur. Ridden by a spirit, the woman is given over—if only temporarily—to that spirit in exchange for favors (material comfort, professional or amorous success, protection from illness, or other benefits). Here, the relations established are *not* between different *human* groups, but *between the human and the supernatural*. Cabrera insists how, for the Afro-Cuban community, life is permeated with the supernatural, and that the forest, for example, is populated by spirits, hostile or benevolent, who intervene, positively or negatively, in human lives. Since many plants growing in the forest have magical and curative properties, they are employed, almost on a daily basis, for individual wellbeing. Spirits are invoked for the same reasons. But whenever Afro-Cubans petition a spirit or take a medicinal plant from its environment, a certain attitude of respect and reverence is required. Permission must be asked and a gift provided in return.[198]

The femme-cheval incarnates such a gift. She confirms both the Afro-Cuban worldview according to which an indissoluble link exists between the natural and supernatural, and the general principle of reciprocity underlying

that link. Just as exchanging women cements social bonds between different human groups, the "horse" strengthens the bond between the saint who rides and the human world that (voluntarily) surrenders it. As human beings are given over as votive offerings, the spirits that inhabit them will look kindly on humanity because, while they possess a human being, that being is completely within their power. "In a certain way," Cabrera writes, "the 'horses' fulfill the same function they had in primitive societies. In taking over a medium, the orisha speaks through him, and with all of its divine authority. The orisha gives advice when asked or gives it spontaneously; it can scold and even threaten those that 'vacillate,' that is, those that behave badly, with a *pikuti*, a punishment."[199] Saints can demand money, but, instead of keeping it for themselves, redistribute it to those in need. They can diagnose disease and prescribe cures, or they can take revenge on human beings who ill behave or do not show spirits the proper respect. The "horses," then, even if they are nothing but intermediaries, become the saint or orisha during the time of possession. As such, they function as a mode of direct communication between the here and now, and the hereafter. Possession as mediation permits the divine and earthly realms to establish forms of communication they could not otherwise. It may be, Lévi-Strauss posits, "that all mythology leads, in the final analysis, to the posing and resolution of problems of communication."[200]

As the symbology of the femme-cheval reinforces the Afro-Cuban worldview of a powerful bond existing between the natural and supernatural, and the culture's ideal of balance and reciprocity, it is also thought to mirror the order of the natural world itself. "Considered from the most general viewpoint," Lévi-Strauss writes, "the incest prohibition expresses the transition from the natural fact of consanguinity to the cultural fact of alliance. Nature by itself already moves to the double rhythm of receiving and giving, which finds expression in the opposition of marriage and descent."[201] Of course, giving and receiving are never perfectly reciprocal, neither in the cultural nor in the natural domain; but it is in looking to one *as a model* that the justification for the other exists.

A similar asymmetry exists between the weaker power

of the human and the greater power of the spirit world. That is why spirits need to be shown proper respect and given the proper gifts in exchange for any requests asked of them. Anyone suspected of faking a possession violates this principle and becomes the object of contempt. "When trances are patently and grossly simulated without the slightest skill," Cabrera writes, "anyone can tell. And they are referred to with disdain as 'little saints,' or false saints." Her informants insist that: "There are saints and plenty of false saints." "Those upon whom false saints descend are far from showing the impressive state of apprehension and the indisputable abnormality that are characteristic of the possession under the grip of a true saint. They play for most part a role like the worst of actors."[202]

In contradistinction, those who are truly possessed have a higher standing in their culture. And culture is the operative term. Just as "mother," "sister," and "daughter" are social as much as biological designations, the femme-cheval's standing in society is equally relational. Like the Minotaur, she is half-human, half-animal, but, as intercessor between natural and supernatural domains, she stands in a privileged position in the community, and, in this sense, she is the opposite of the Minotaur. If the Minotaur serves as a warning of the dangers of sexual relations with an outside group, a group who is deemed so alien as to make relations between in- and out-group tantamount to incest, the femme-cheval incarnates the willing surrender of a precious resource—a woman—to insure good relations between the natural and supernatural realms. That is why the Minotaur is killed in ancient myth, and the femme-cheval valorized in Afro-Cuban culture. The discharge of her responsibility, therefore, is not psychological but purely social, one that invites speculation that possessions do not occur in private situations, only within the organized and public venue of a ritualistic ceremony.

Yet, just as the myth of the Minotaur had political implications, implications whereby one group—namely, men—control the relations of another group—namely, women—it may be instructive to see whether similar forms of social (largely, patriarchal) control are also in force here. It is intriguing, after all, that although spirits may ride either men or women, Lam's figure is specifically

female: a *femme*-cheval, not an *homme*-cheval. In Lévi-Strauss's account, even as men and women of different groups marry, it is the women who are specifically considered the object of exchange. ("In human society, it is the men who exchange the women, and not vice versa."[203]) In Lam's iconography also, it is women who are surrendered to the orishas as testaments of humanity's good faith. The gender-specificity of the horse cannot help but have broader implications. As women become objects of exchange—either to establish relations between different human groups, or between humans and supernatural beings—the fact of being given over to a foreign group or to supernatural beings awards them the status of other:

> A woman, like the moiety from which she derives her social status, has no specific or individual characteristics…which makes her unfit for commerce with men bearing the same name. The sole reason is that she is the same whereas she must (and therefore can) become other. Once she becomes other (by her allocation to men of the opposite moiety), she therefore becomes liable to play the same role, vis-à-vis the men of her own moiety, as she originally played to the men of the opposite moiety. In [some cultures, during] feasts, the same presents can be exchanged…the same women that were originally offered can be exchanged in return.[204]

There is an intricate, insoluble relationship, Lévi-Strauss argues, between kinship and alterity. First, if women are given over to a group as a gift, it is to establish an alliance that did not exist, or was in need of reinforcement, prior to the exchange. By definition, the two groups stood in some form of opposition. Second, by the very act of being handed over, the woman now belongs to the group to which she is destined, not to her group of origin. For all intents and purposes, she is now other as well. The status of the horse in Afro-Cuban culture is equally dynamic. Once ridden, the horse, in its alterity, belongs to the supernatural world. Once other, though, it can be returned, restored to the human world after possession.

The very hybridity of Lam's femme-cheval, arguably, visualizes this dynamic. Yet Lam does Lévi-Strauss one better:

his hybrid form, as mentioned above, is a *femme*-cheval, not an *homme*-cheval. Implicit in this gender-specificity is the tacit assumption that women are somehow *already* other *within their own group*, a perceived alterity that carries broader connotations, namely, that women provide ideal candidates for possession. Why? Because women are—stereotypically speaking—considered more instinctual than men, the state of hypnotic possession is believed to differ less from their normal behavior. Because women are—again, stereotypically speaking—considered more impulsive than men, they are deemed more susceptible to merge with the animal/spirit world. Just as women are exchanged in marriage to construct alliances and build social bonds between different human groups, they are also given over to orishas to petition favors and build conduits between the natural and supernatural domains. Women serve the same function in both religious and secular forms of ritual.

That this form of exchange represents a form of subordination is beyond question. As is Lam's complicity in sustaining the social structure that enforces it. Certain scholars have already noticed this paradox. While he and other black artists produced images that liberate the Afro-Cuban "other" from the "oppressive construct of race," Merewether writes, "they remain caught in a complex imaging of woman, the other they cannot abandon. To liberate this other represented a crisis in the construction of male subjectivity for those Latin American artists and writers whose formation remained embedded in European modernism."[205] Similarly, Sims admits that "The personifications of the femme-cheval become more ominous in character in the 1970s with their wide, blank or black, staring eyes, gaping teeth, and pronounced physiognomic features—especially jaws and foreheads. Some are positively bestial as their jawbones pierce the outer skin, and several large teeth or tusks protrude out of the corner of their mouths."[206] But Sims is not willing to ascribe Lam's objectification of woman entirely to his connection to European culture. One cannot ignore the possibility, she entertains, that even "as a black or a Cuban, Lam, the politically colonized entity, becomes [in turn] a colonizer of women as sexualized entities. Such incongruities have been the focus of contemporary feminist writing by African-American women."[207] The West, after all, retains no monopoly on the oppression of women, and the proximity of the woman to the animal in Lam's imagery suggests, if only tacitly, that women are unruly and bestial, therefore undeserving of equal status with men. On this basis, they become the perfect objects of exchange between the human and the spirit world.

This is not the way women symbolize themselves, of course; it is the way men symbolize women. But given its intimate relation to religious ritual, this form of symbolization is crafted in such a way as to make its own prejudicial assumptions look natural, i.e., independent of cultural intervention. Women, in fact, must turn away from the altar at specific points in Santería rituals, denying them access to select moments of the ceremony, and symbolically excluding them from the totality of the experience. The collapse of woman and animal in Lam is somewhat analogous. It legitimizes the surrender of women to supernatural spirits as well as to a patriarchal social order—even a non-Western patriarchal order. Horses may be valorized in the Afro-Cuban belief system, but, ironically enough, in the sense that an object about to be sacrificed (or thought expendable) is valorized.

It is, admittedly, difficult to ascertain the full implications of Lam's femme-cheval; implications that cannot be restricted to a single meaning. But the relevance of Lévi-Strauss's ideas allows particular aspects of Lam's evocations of non-Western symbology (and the ways in which these aspects are meaningful politically) to emerge in sharper relief: for example, the way Lam was less politically conscious of the exploitation of women than of the exploitation of blacks. In this regard, it should be mentioned that Lévi-Strauss's analyses of kinship have also been accused of anti-feminism, particularly because of the way women are portrayed as objects of exchange in systems of regulation enforced by men,[208] even if, in this context, women are described as "the most precious" objects of exchange.[209] But this accusation is patently unfair. Nothing could be more consistent with a feminist agenda than exposing the way men regulate reciprocal social mechanisms where women are commodified, objectified, and made to function as objects of trade. Sexism lies in the *practice* of exchanging women, not in the *analysis* of the practice. Lévi-Strauss's

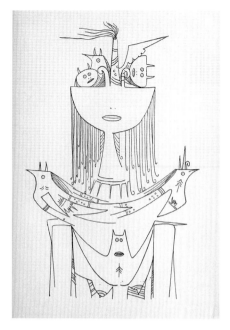

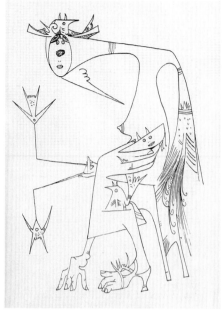

15. Wifredo Lam, *Untitled*, *Medium: Communication Surréaliste* (Jan. 1955): 59.

16. Wifredo Lam, *Untitled*, *Medium: Communication Surréaliste* (Jan. 1955): 3.

larger lesson, without equivocation, is that even marriage rituals, no less than mythical narratives and religious ceremonies, have political subtexts.

Detotalization and Retotalization

In conjunction with merging human and animal, Lam's mature morphology also betrays a proclivity to break figures down into smaller figures, animals into smaller animals, and so on. Although an analogy may be drawn between this facet of Lam's work and the belief in a multiplicity of souls described above, another may also be drawn with aspects of non-Western mental operations described by Lévi-Strauss. Among these operations is the way elements register as meaningful along various levels. "The societies which we call primitive do not have a sharp division between the various levels of classification. They represent them as stages or moments in a continuous transition."[210] As a result, one need not compare like with like: person with person, animal with animal, plant with plant. The relation of one person to another may be equivalent to the relation between one animal and another, or parts of a person may be equivalent to parts of an animal, and so on; consequently, the elements may not be identical but can be said to serve similar functions, if only at different levels of classification. As long as the structures are analogous—and the oppositions comparable—the relationships operate similarly.

In such systems, analogies form when entities are broken down into their components. "The real question," Lévi-Strauss contends, "is not whether the touch of a woodpecker's beak does in fact cure toothache. It is rather whether there is a point of view from which a woodpecker's beak and a man's tooth can be seen as 'going together.'"[211] If an animal is decomposed into smaller constituent parts, it is according to a law of correspondence (muzzle = beak, paw = wing).[212] In such a system, it is possible, Lévi-Strauss posits, "to pass from categories to elements to species...by a sort of imaginary dismembering of each species, which progressively re-establishes the totality on another plane." To describe this double movement, Lévi-Strauss coins the terms "detotalization" and "retotalization."[213]

Given Lam's propensity to mix human and animal forms and break figures down into smaller units, Lévi-Strauss's terms are particularly apt. An untitled drawing of 1955 (fig. 15) represents a woman with three birds, a bat, and two smaller heads (though the exact species to which these latter belong remains undetermined). Yet it is intriguing to see how Lam has "detotalized" the figure: the top of the head, for example, is missing, but two smaller heads

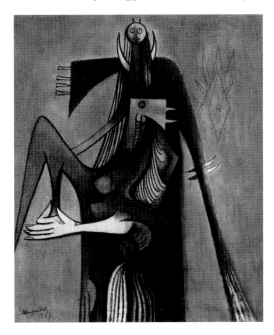

17. Wifredo Lam, *The Oracle and the Green Bird [L'Oracle et l'oiseau vert]*, 1947 [47.43]. Oil on burlap, 107 cm x 89 cm, San Francisco Museum of Modern Art, 92.265.

replace her missing eyes. A bird rests asymmetrically atop her head, but, as if to maintain complete balance, its beak lies to one side and its wing to the other. The same may be said of the two birds below her head, their plumage connecting with the woman's hair and their heads with her shoulders. Above her breasts, a bat supplies a smaller, schematic version of the woman's missing head, while its outstretched wings parallel the dynamic extension of the shoulders by means of two birds moving, again symmetrically, left and right.

Insofar as the figure is "detotalized," it is also "retotalized" by means of stand-ins and equivalent parts that, in combination, maintain a degree—almost like a Calder mobile—of balance, corroborating Graziella Pogolotti's hunch that Lam tends to preserve the bilateral equilibrium of his compositions.[214] This effect is more difficult to sustain in another drawing of 1955 (fig. 16) because the work is asymmetrical, but the same rules are in operation throughout. The figure's head dons another bird on its head, the wings moving outward in both directions. A wing seems to extend downward, almost like a beard, but is counteracted, compositionally, by the exaggerated extension of the neck. The figure has a wing, but her other arm, as if to maintain symmetry, sprouts two appendages, which sprout appendages of their own and terminate in two small arms, heads,

and horns. The figure has only a single breast, but the head of another creature keeps the equilibrium intact.

Though not all of Lam's paintings will obey such strict symmetrical rules, a logic seems to govern the way his figures are mixed, decomposed, and recomposed. Intriguingly, Cabrera describes Osain, a powerful orisha, in strikingly similar terms. The saint's body is asymmetrical, yet balanced: he "has only one foot, the right foot, one arm, the left arm, and one eye. He has one inordinately large ear, that does not hear, and the other, very small, is so sensitive that it grasps the most inaudible and far off noises such as the step of an ant and the flapping of a butterfly's wing."[215] Lam's *The Oracle and the Green Bird* of 1947 (fig. 17) may not reference Osain specifically, but it is also illustrates the principle of symmetry within asymmetry. The figures' limbs are obviously unequal, yet Lam manages to redress iniquities and maintain compositional balance.

This question of balance does not simply pertain to physical anatomy (either human or orisha); it extends, symbolically, to the greater order of nature, and, as we have seen, to the religio-philosophical rules human beings obey while interacting with it. If one picks medicinal herbs or plants in the forest without permission, or without paying tribute to the appropriate saint, the plants will lose their desired

effects. If something is taken, something must be given; equilibrium reigns everywhere. To upset this order, is to do so at one's own peril.[216]

An example of this peril may be represented in *[Yoruba Ritual]* of 1946 (plate 42), a drawing divided into a celestial zone above and a terrestrial one below, perhaps to maintain the distinction between natural and supernatural worlds. In the terrestrial one, a male and female human/animal hybrid figure cower on the ground, the female figure in particular—identifiable by her breasts—seems stricken with terror. The male figure above her holds a knife in one hand and what appear to be herbs in the other. We propose that the herbs were cut with the very knife that the figure brandishes with his other hand, and that this act was somehow unlawful, or committed without requisite permission. The rationale for this reading is the presence of a vengeful spirit hovering over the couple and the direct cause of their alarm. Just as a parent brandishes a broken object in order to chastise the child who tipped it over, the spirit holds the same knife and herbs in his own hands, as if to stress the severity of the male figure's transgression.

This severity cannot be overemphasized. One of Cabrera's informants told her: "Where there is an herb, there is a cure." There is no Afro-Cuban, she insists, who does not have recourse to nature for the health of his body or mind. "We are healers by nature," the informant adds, "we depend on the forest."[217] The forest, then, is not a simple geographical location. It is a place of inordinate cultural and medicinal significance, and explains the importance awarded to nature, both in Lam's art and in Afro-Cuban culture as a whole. Modern industrial materials—metal, cement, concrete—not only destroy natural spaces; they destroy the symbolic origin of that culture's belief system and the literal origin of its physical survival.[218] "Only a completely irresponsible, reckless individual would consent to cut down a kapok tree," Cabrera explains, "for this tree not only symbolizes but incarnates the all powerful nature of God. Cubans see in this tree the mysterious presence of the spirit world. They fear occult forces, the invisible and supernatural presence that resides there and would turn on them in a terrible desire for revenge. The majority would categorically refuse to commit such a sacrilegious act as it

would, sooner or later, bring them bad luck."[219]

In this regard, the untitled drawing of 1946 (plate 41) may be interpreted as a more subtle version of *[Yoruba Ritual]*, though the cowering couple is more stylized in appearance, and so closely conjoined that the two separate figures could just as easily be read as a singular figure with two heads. (Perhaps, this amalgamation suggests that the closer the emotional fate of the two figures, the more their bodies will merge.) Intriguingly, the vengeful spirit no longer wields the dagger and herbs—insinuating that the couple's transgression is of a different order—and is considerably smaller in size than its incarnation in *[Yoruba Ritual]*, explaining the decreased level of alarm it elicits from the reclining couple. Even so, its presence functions as an unmistakable reminder of the importance awarded to the supernatural in the Afro-Cuban worldview—and, no less significantly, of the spirit world's constant attentiveness to any violation of balance and equilibrium.

Lam's Atemporal Space

On this account, the merger of human and animal or plant symbolizes the merger of the natural and supernatural, two orders that, given their asymmetrical power structures, must remain on good terms if, mutatis mutandis, the human social structure itself is to endure. Since balance, equilibrium, reciprocity, parity are focal aspects of Afro-Cuban philosophy, they guide Lam's work with parallel consistency. When asked about the significance of his hybrid animal forms, however, Lam replied, somewhat cryptically: "They pose a problem of a more general kind, namely, that of man and his history."[220] This, admittedly, is a difficult statement to interpret. What could Lam possibly mean? How do his imaginary forms, as fantastical as they are, at all relate, if only on the level of analogy, to concrete historical events? What is more, the majority of twentieth-century artists—Lam, his surrealist and abstract expressionist colleagues in particular—considered the conventions of "history painting" to be passé, an ossified tradition antithetical to the more radical modernist project to which they were so committed.

Intriguingly, Édouard Jaguer, echoing Lam's statement, wrote that the artist's "exoticism," if it exists at all, is "tem-

poral rather than spatial."[221] As compelling as this observation is, Jaguer, regrettably, explained neither what he meant by it, nor how Lam's complex hybrid forms could be connected to the idea of time or history.

Lévi-Strauss, again, proves more useful. While describing so-called totemic classifications, he posits that they exist under what he calls an "atemporal" regime, a term he uses to explain how so-called totemic systems reconcile such contradictory notions as "classification" and "history." These notions are contradictory because totemic classifications divide living beings into original zoological and botanical species, on one side, and derivative human species, on the other. But if plants and animals are asserted to have existed *before* and even to have engendered human beings, all these species, original and derivative, animal and human, imaginative *and* real, continue to exist *simultaneously* in mythic narratives. This is what Lévi-Strauss means by humans and animals perduring under an atemporal regime. "The two series exist in time but under an atemporal regime, since, being both real, they sail through time together. […] The original series is always there, ready to serve as a system of reference for the interpretation and rectification of the changes taking place in the derivative series."[222]

To stress the atemporal is, of course, a typical structuralist move. The meaning of signs is thought to stem from their function in a present system (synchronically), not from their extension of historical precedents (diachronically). Transposing this approach to Greek mythology, for example, we might say that many creatures combine human and animal (e.g., satyrs, centaurs, sirens, gorgons, griffons, and the Minotaur), others combine multiple animals (e.g., Chimera, Sphinx, and Cerberus), and others simply reshuffle human anatomy (e.g., Argus or the Cyclops). Yet, in mythical narratives, all these creatures coexist alongside humans and animals in their present form. Different species are not only shown as sailing "though time together," but they are even accompanied by an infinite array of transitional forms. In concert with breaking down (detotalizing) and reconstructing (retotalizing) his figures, Lam also establishes a similar kind of space, a space wherein everything happens, not gradually or incrementally, but at once, instantaneously—or, as Lévi-Strauss would say, "atempo-rally."

L'Action, one of Lam's Haitian paintings of 1946 (plate 40) might be interpreted in precisely this way. A horned figure seems to be holding a head in its hands, from which yet another head emerges—ostensibly vertically, while, from the head of the major figure, a leaf emerges—ostensibly horizontally. As Lévi-Strauss may posit, the contradictory notions of classification and history are thereby reconciled because plant, animal, and their human progeny are all represented simultaneously in the same visual field. What is more, the image, like a musical score, invites readings along different axes, vertically or horizontally, establishing different kinds of relations. In this way, if Lam indeed sought to invent new forms that raise the problem of "man and his history," his visual solutions share a great deal with the ways myths resolve that same problem (at least, according to Lévi-Strauss).

An untitled drawing (plate 46) may also be interpreted as representing the detotalization and retotalization of mythical figures under an atemporal regime. Although the clusters denote three discrete hybrids, closer inspection reveals remarkable links between them. The lowest combines avian and equine forms, with a small horned head—very typical of Lam—protruding immediately underneath the bird's skull. The second hybrid form has taken flight, casting any remnants of equine anatomy aside (except perhaps for the skirt of the horse's tail extending in the air as if it were feathers), and although avian details (beak and wings) remain, the head is oddly oriented for a bird in flight. The small horned head and the horse's tail again reappear in the second and third version of the hybrid form, the last now even higher aloft, only absent the more conspicuous avian features.

As they rise, the hybrid forms simplify—as is to be expected from animals striving to compress their body aerodynamically—yet, ironically, avian characteristics decrease as the forms ascend: in fact, the highest form is the least bird-like. Since the creatures do not belong to any known zoological category, we cannot say whether these are three *different* creatures—at various stages in an evolutionary development, as it were—or *the same* creature—capable of streamlining itself—at three different moments in time. In fact,

57

there is no reason why—if we decide to impose a sequential progression on the image—that evolution moves from bottom to top, rather than the other way. Perhaps the order is not incremental at all, and the middle form is the progenitor of both. In effect, multiple options are viable. If there were a better visual illustration than Plate 46 of Lévi-Strauss's notion that, in myth, it is possible "to pass from categories to elements to species…by a sort of imaginary dismembering of each species, which progressively re-establishes the totality on another plane,"[223] it would indeed be difficult to find.

Curiously, we come to a rare point where Lévi-Strauss and Lévy-Bruhl actually see eye to eye, insofar as the former's "atemporal" regime aligns with the latter's stress on the ways in which members of pre-industrial cultures, endorsing mystical laws of participation, overlook causal relationships among phenomena. Causal relationships, Lévy-Bruhl continues, "connect phenomena through time, in necessary fashion, and arrange them in such a way as to establish an irreversible series of events."[224] Attributing events to mystical forces, however, natives do not order cause and effect in time and space. "Primitive mentality," in Lévy-Bruhlian terms, disconnects cause and effect from chronological and spatial coordinates; in this respect, causality is "extra-spatial, and, consequently, and in at least one respect, extra-temporal."[225] That the mystical forces responsible for events are ungraspable by ordinary perceptual means prevents, or so Lévy-Bruhl claims, their precise calibration in space and time. "They float, they radiate, so to say, from an inaccessible region; they surround human beings from all sides, so much so that they are not surprised to feel their presence in many places at once."[226]

This rare convergence between Lévy-Bruhl and Lévi-Strauss strengthens an analogous reading of Lam's spatial configurations as a- or extra-temporal. Not simply because Lam collapses disparate evolutionary species; but also because one anthropologist conceptualizes the nature of mystical forces, and the other the chronological components of myth, in a vividly *spatial* manner—or, to put it differently, in a manner that makes them easy to transcribe *visually*. Lévy-Bruhl sees invisible mystical forces "floating," "radiating," or "surrounding" human beings in "many places at once"; while Lévi-Strauss sees mythic narratives as unfolding like musical scores, encoding chronological sequence both vertically and horizontally, as if materially frozen in time. Similarly, Lam's work operates in the static, spatial domain of painting, but allows, if only on the level of analogy, the natural and the supernatural, the classificatory and the historical, the present and the past to unfold "simultaneously."

In this regard, the space in Lam's paintings approximates, if not visualizes, contemporary anthropological ideas about the way the human mind works at its most basic level. To grasp its particularities, one must relinquish the set of expectations with which we have been conditioned to approach works of art in the West. Lévy-Bruhl writes that because Westerners "conceptualize phenomena, without even thinking about it, in terms of irreversible series, within determined and measurable intervals, and because causes and effects appear to us to be arranged in ambient space, time also seems like a quantum continuum, divisible in identical parts, that succeed each other in perfect regularity."[227] But to those who are indifferent to such regularity, and who pay no attention to the irreversible succession of cause and effect, the representation of time is indistinct and ill defined. "And what is said of time also applies to space, for the same reasons. The kind of space that we think of as perfectly homogeneous—not only the space of geometry, but the space implicated in our everyday concepts—appears to us like a background, indifferent to the objects in front of it."[228]

Because "primitives" do not live, but feel themselves living, in a different space than us, Lévy-Bruhl suggests that the idea of absolute time and space is not a natural, given aspect of the human mind, and that different concepts of space will engender different representations.[229] Analogously, we offer the hypothesis, however speculative, that Lam was cognizant of, and may even have attempted to visualize, such a version of space and time in his work. In Afro-Cuban culture, as Cabrera writes, and as Lam no doubt knew, many believe themselves to converse with deities and deceased loved ones who visit them regularly. "And with the help of a great number of mediums, the souls of the dead can leave space to speak to their friends

or parents, smoke the tobacco or cigar that they appreciated during their lifetime, give the opinions on current events, and intervene on any issue."[230] In another context, Cabrera refers to Afro-Cuban narratives as having established "a time outside of time,"[231] a variation, if one wills, of an atemporal regime.

Politics

Even if Lévy-Bruhl's and Lévi-Strauss's ideas are reconcilable on one point—a point on which Lam would, most likely, have concurred—this convergence should not obviate their irreconcilability on other fronts, especially the political one. Lévy-Bruhl's absolute demarcation between Western and non-Western mentality, for instance, though he reneged it later, is patently incompatible with Lévi-Strauss's attempts to place both on equal footing. These differences do not simply reflect the kind of wrangling typical among rival academic factions. Lévy-Bruhl's ideas, as Lévi-Strauss was keenly aware, provided ample ammunition to those hoping to drive a wedge between industrial and pre-industrial cultures: "The savage mind," Lévi-Strauss writes, "is logical in the same sense and the same fashion as ours…[and] contrary to Lévy-Bruhl's opinion, its thought proceeds through understanding, not affectivity, with the aid of distinctions and oppositions, not by confusion and participation."[232] In fact, Lévi-Strauss deplored the way concepts such as totemism strengthened "the case of those who tried to separate primitive institutions from our own."[233] Lévi-Strauss was delicate on this point in his scholarly writings, but this statement is but a lightly disguised reference to how anthropological ideas adversely impacted the status of indigenous peoples under the yoke of colonialism. In other words, Lévi-Strauss hoped his work would counterbalance how immensely useful Lévy-Bruhl proved to those justifying the exploitation of non-European races on the grounds of their alleged inferiority.

In 1925, for instance, Lévy-Bruhl wrote in defense of establishing rigorous methods in anthropological research, but the motive, as he described it, was hardly a disinterested search for knowledge:

> To valorize our colonies as completely and economically as possible, everyone recognizes that we need more than capital. We also need scholars, technicians, who compile methodical inventories of their natural resources (mines, forests, cultivated lands, etc.), and recommend the best means of exploitation. But is the most important of these natural resources, without which we cannot access the others, especially in equatorial or tropical regions, not the indigenous population? Is there no greater urgency than studying it no less methodically, in order to obtain an exact and profound knowledge of its languages, religions, social organizations, which we ignore at our own peril? The majority of powers that are in possession of colonies of this kind have understood this. There are chairs in Ethnology in the United States, in England, in certain British colonies (South Africa, Australia, etc.), in Germany, in Holland, in Belgium. Here [in France], there exist for a long time, dispersed among our great scientific institutes, classes that more or less touch on ethnology, but, until now, nothing organized.[234]

As nebulous as the concept of "primitive mentality" may be, its implications, at least for colonized cultures, were disastrous. First, the assumption that "primitive" and "modern" mentality are incommensurate compelled colonizers to "convert" indigenous populations to their own ways of thinking through a process of "civilizing"—only to eradicate many native cultural traditions in the process. Second, after converting to this new "mentality," native populations began to request the very rights their newly found status should have conferred upon them, only to see their requests refused on the grounds that their old habits had not been sufficiently abandoned. This is not, of course, to lay the blame purely on anthropology. From the very onset of colonialism, native populations were mercilessly decimated because they were judged to be inferior beings whose vile ways of life justified their enslavement or, worse, their extermination. Lévy-Bruhl simply extended similar prejudices well into the twentieth century, now under the alleged umbrella of social "science," allowing anthropological ideas to cast a long, but infamous, political shadow.

The political implications of anthropological debates are related here, not simply because Lévy-Bruhl plays such an important role in this essay, but because Lam's close friend, Aimé Césaire, also referenced them, with a sharper tone, in his *Discours sur le colonialisme*. In fairness to Lévy-Bruhl, it is important to reiterate that he softened (but did not radically modify) his ideas late in life. In his famous exchange with the English anthropologist Evans Pritchard, he even admitted to over-exaggerating the difference between literate and pre-literate cultures *on purpose*, making the contrast appear more acute than it really was.[235] And though he advocated greater knowledge of non-Western cultures to facilitate the exploitation of a colonial empire's natural resources, he later tempered this position, hoping this knowledge could have more salutary effects on the relationships between colonizer and colonized. In his late *Carnets*, for example, Lévy-Bruhl recounts the story of a certain Mr. Grubb from whom an Indian asked compensation for vegetables stolen from his garden. Mr. Grubb professes his innocence on account of having been 150 miles away at the time of the presumed theft. The Indian concedes the fact, but persists in requesting damages despite the soundness of the alibi. Stunned, Grubb eventually realizes that it was in a dream that the Indian saw him enter his garden and take the vegetables. For the Indian, who appears completely sound in spirit, the dream is real. Consequently, there is no inconsistency in Grubb being in two places at once: in the garden *and* 150 miles away at the same time. It is as if two different Grubbs existed.[236]

There is a sense here of Lévy-Bruhl and Lévi-Strauss again meeting on common ground; not simply because the possibility of Grubb being in two places at once evokes an atemporal regime, but also because Lévy-Bruhl suggests that legal disputes cannot be resolved unless one takes the particularities of indigenous mentality into question. The notion, for example, so common among whites, that the earth can be bought or sold is inconceivable in many pre-literate societies, a disconnect that is bound to provoke misunderstandings, disputes, and violence between cultures. From there, evictions and even exterminations of entire populations frequently follow. During conflicts, whites feel justified in largely ignoring the mystical obligations indigenous populations are committed to keep. Not

so much because they do not bother learning the customs of other cultures, but because of a self-serving desire to seize land and resources. "This chapter in the history of relations between whites and indigenous populations," Lévy-Bruhl concludes, "offers a scenario as monotonous as it is revolting."[237]

Lam would have been very sensitive to such issues. One of his own mulatto ancestors—his mother's great-uncle, José Castillo—was also cheated out of his land by a Spaniard, and even lost his hand as a punishment for trying to obtain reparations—hence his surname "Mano cortada," or "cut hand." Whether the disembodied limbs in some of Lam's works might reference the loss of land, the forfeiture of identity, or the colonial exploitation of non-Western cultures is, of course, difficult to say. But it would not have been the first time artists symbolized such losses through the amputation of a limb (the metaphor of society as a human body has also been with us since the ancient Greeks).

Yet even as Lévy-Bruhl pressed for greater understanding between cultures, and disavowed some of his most extreme ideas, he did not radically depart from his basic premises. Césaire exposed how scholars still readily cited him, hypocritically, to denigrate the claim that Western and non-Western cultures were equal in worth and esteem.[238] Especially notorious in this regard was a certain Roger Caillois, who launched a bitter attack on none other than Lévi-Strauss, whose valorizing of non-Western cultures in a book entitled *Race and History*, Caillois insisted, was tantamount to betraying Western civilization. For Caillois, Lévi-Strauss undermined the teleological view according to which history moves toward greater progress and enlightenment, culminating, predictably, in Western technical and cultural achievements. In its stead, Lévi-Strauss offers the unacceptable notion that no civilization should be privileged over another.[239] This position, Caillois complains, imperils the very religious, civic, intellectual, moral, and aesthetic principles upon which any advanced culture stands. Modern culture, Caillois protests, of which Lévi-Strauss is a product, has capitulated to pernicious forces that read right out of the surrealist playbook: instinctuality, the unconscious, a taste for dream imagery, for sensual

gratification, for the delirium of the insane, for the drawings of children, and for the sculptures of primitive peoples (here without quotation marks to convey the spiteful edge of Caillois's rhetoric). In fact, it is no coincidence, for Caillois, that Lévi-Strauss is frequently praised in surrealist publications.[240]

Importantly for our purposes—because Césaire draws attention to this debate in his *Discours*—Caillois not only presents Lévy-Bruhl as a counter-pole to Lévi-Strauss, but also commends the former's writings as a prophylactic against, or as an effective means to dispel, these moral "illusions." Ironically, Lévy-Bruhl first came to Caillois's attention because a friend sought to convince him of Western culture's overreliance on the sterile principle of non-contradiction. But Caillois did not bite. Any mentality that rests on the law of participation, he concluded, is illogical and, as a result, cannot qualify as intellectually rigorous.[241]

Of course, it goes without saying that Caillois missed the point of Lévi-Strauss's arguments. Though this is not the place to engage in a point-by-point refutation of his diatribes, he is mentioned in this context to highlight the degree to which Lévy-Bruhl's premise that non-Western cultures were pre-logical—an assessment claiming the authority of anthropological science—became a powerful weapon for those intent on enforcing European colonial claims throughout the globe. And anthropology was not the only social science similarly implicated. The very psychoanalysis that triggered the surrealist revolution, a movement Césaire had himself praised as a means of self-knowledge and emancipation, was also twisted, to his dismay, to disseminate the racist prejudice that non-Europeans are child-like, have no desire for independence, and long to be subjugated.[242] As could be predicted, Lévi-Strauss reacted violently against these distortions, stressing how colonialism "brutally destroyed traditional social structures and forced colonized peoples into a tragic choice between the West and nothing."[243]

Having placed Lévy-Bruhl in one corner and Lévi-Strauss in the other, Césaire—no less than Caillois, but from the opposite side—clearly grasped the political implications of different anthropological positions. In view of his close friendship with Lam, and the latter's claim that his art was an act of decolonization, it is very likely that both discussed how anthropological and psychological arguments related directly to the thematics of their work, and to the broader questions art and literature were meant to raise. Lam's worldview, after all, was profoundly inflected by both psychology and anthropology. How he managed to resolve the tension between ideas that could assist the forward direction of his art, but advance potentially nefarious political purposes, is not exactly clear.

Perhaps Césaire provided a model. For all of his powerful and eloquent denunciation of colonialism, his analyses of its cruelty and intolerance, its dehumanization of colonizer and colonized alike, Césaire hardly advocated a naïve return to some imaginary, pre-colonial utopia. Recognizing how fraught with pitfalls the global situation had become, he maintained that "putting different civilizations together in contact with each other is good; to marry different worlds is excellent; that a civilization, whatever its own genius may be, withers if it withdraws into itself; that exchange is like oxygen, and that, the great blessing of Europe was that by having been a crossroads, a point of convergence between all ideas, a receptacle of all philosophies, a welcoming point of all feelings, it was in the most propitious position to redistribute these energies."[244]

A tall order, to be sure, especially as entire peoples, their customs and languages, are disappearing with alarming frequency. But as long as separate cultures meet on equal footing, within a framework of mutual respect, outside of asymmetrical power relationships, then reciprocal exchange can only be a positive development. If his writing style is any indication, one immediately senses how much Césaire relished the sophistication and elegance of the French language—a sophistication and elegance that made his critique of colonialism far more difficult to dismiss among the Imperial powers. Despite the many political transgressions of the French nation, Césaire still appreciated its culture, literature, and philosophy. Late in life, he declared that: "What we need is fraternity. […] There are no big and small peoples. We are all peoples…I believe in humanity and in fraternity."[245] "I am a man," he also declared, "in love not with culture, but with cultures, all cultures."[246]

Césaire thus strove to maintain a balance between con-

demning the excesses of white racism and avoiding the rejection of everything Western culture could offer, between instilling racial pride in anyone of African descent and avoiding losing sight of a shared, common humanity. To his mind, the ideals of the Enlightenment had been ill applied, but not necessarily ill conceived, by Western culture. (The blacker we are, he told his friend, the Senegalese poet and theoretician Léopold Sédar Senghor, the more universal we will become.[247]) Césaire and Breton, as was already mentioned, had no less mutual admiration for one another than Breton and Lam, establishing a strong convergence and cooperation between surrealism and Négritude. For these reasons, several scholars have argued that Lam's work also aligns with Négritude. Sims proposed that "Lam must be considered one of the pioneers of African self-reclamation, the progenitor of an art that is comparable to the concept of Négritude that impelled the poetry and politics of Aimé Césaire and Léopold Senghor, two of the originators of this philosophical and political stance."[248] Similarly, Robert Linsley posits that Lam "is really the painter of Negritude, and the development of his work, its difficulties and successes, can best be understood in the light of the later history of Negritude."[249]

This assessment is sound. By all accounts, Lam and Césaire were quite taken with each other. According to Holzer, Lam admired Césaire's "poetic observations and descriptions of life as a black man in an environment of white dominance. He had at last found a companion soul. Wifredo and Aimé wanted to awaken the Black, wanted him to be proud, wanted him to learn to do important things, so he could be independent and free, and with justified self-confidence."[250] Just as Césaire packaged his anti-colonial message in the most sophisticated French poetry and prose, Lam packaged his "act of decolonization" in the modernist language that was all the rage in Western Europe, thereby guaranteeing that his "Trojan horse" would find its way, surreptitiously, into the fortress of Western civilization. In a certain sense, of course, one could dismiss this tactic as a form of capitulation, an example of what Edward Said called, a "holdover of Empire," a belief, even among colonized peoples, that artistic achievements only matter if framed in the terms defined by, or recognized in larger context of, the colonial culture.[251] But it was a risk worth

taking, a tactical flanking maneuver in order to obtain a larger strategic objective.

Since the affinities between Lam and Césaire are unassailable (e.g., their hope to stimulate pride among blacks without categorically rejecting everything Western culture could offer), a fly still remains in the interpretive ointment. Namely, does Césaire's clear siding with Lévi-Strauss against Lévy-Bruhl not contradict one of the principal arguments presented in this essay? Specifically, that Lam's foregrounding of Afro-Cuban culture actually owes a great deal to Lévy-Bruhlian notions?

Not necessarily. As powerful as his arguments proved in discrediting Lévy-Bruhl's, and in eroding qualitative distinctions between Western and non-Western cultures, Lévi-Strauss, many began to think, moved too far in the opposite direction. To be sure, his emphasis on order and structure effectively countered the pejorative stereotype of the "primitive." But, in the process, the social importance and cultural value of magic and mysticism, not to mention the power of affect, were downplayed in the extreme. In the end, perhaps Lévi-Strauss simply reconceptualized the other in his own image. From the other side, as useful as his ideas proved to those who defended colonial interests, and sought to keep native populations in a state of servitude, Lévy-Bruhl's very emphasis on magic and mysticism provided Cuban intellectuals with effective means to valorize and feel pride in their own hybrid culture. As previously mentioned, Alejo Carpentier's concept of magical realism, of reconciling opposites, was clearly modeled after Lévy-Bruhl's notion that "primitive mentality" disobeys the law of non-contradiction. Although not easy to define, magical realism, according to David Shefferman, "refers to aesthetic production that attempts to account for the social simultaneity of radically different epistemologies. The 'magical realist' work presents divergent worldviews alongside each other—such as indigenous creation myths that encounter modern astronomy—without trying to explain or privilege any of them."[252] Holding widely different perspectives together within the structure of a single literary work, on the one hand, was meant to reflect a certain cultural heterogeneity; on the other, to elicit disconcerting effects and provoke politically emancipatory action

by refusing to accommodate literary practice to the logic of Western rationalism.

Similarly, Santería supplied Lam with a cultural enclave to which white Western culture had no real access, a realm where the descendants of slaves could maintain cultural autonomy and local control. As such, it emerged as a focal point around which solidarity might emerge and resistance might spring—a domain whose larger implications were as much political as religious. No wonder, Charles Merewether writes that Lam "created a primitivist image of Afro-Cuban culture that extends and pushes to the point of excess the Western projection of Cuban culture as savage, primordial, and threatening."[253]

For this reason, as much as Lévy-Bruhl's ideas largely thwarted any emancipatory agenda, his influence was not entirely discounted. This course was potentially dangerous, if only because adopting Lévy-Bruhlian notions ran the risk, as Merewether intimates, of confirming the most negative stereotypes projected upon the non-Western. But even if Lévy-Bruhl qualified non-Western mentality as pre-logical and affective, these very terms—like "nègre" for Césaire—could be commandeered and redefined by subalterns to demarcate a cultural sphere lying outside the power of Western rationalism to regulate. It frequently happens that, when oppressed or ostracized by society, marginal groups co-opt slurs and insults—the very markers of otherness—and transform attempts to injure into signs of self-definition and even pride. Similarly, Merewether makes the point that Cuban intellectuals appropriated "primitivism" "in order to challenge the West and the colonial dynamic."[254] For Shefferman, *a specifically Cuban* quality can be said to emerge from such transpositions: a form of irreverent transformation and displacement of elements that implicitly recognizes the power of the magical as a transformative, redemptive force, yet, at the same time, gives artists and writers the license to do what they will with the very diversity of sources they amalgamate, be they African, European, or native to Cuba.[255]

Lam's very European intellectual guides employed a similar tactic—but in reverse. None other than Michel Leiris, whom Picasso asked to expose Lam to African art, was quite taken with Lévy-Bruhl's ideas. "I tried to escape this European mentality that aggravated me like an ill-fitting suit," he wrote, "by reading books on 'primitive' mentality which engages—if one believes Lévy-Bruhl and other theorists—the role of our affective forces and imaginative capacities in a far freer way than so-called civilized mentality."[256] Much of surrealism, Breton wrote, was motivated by the "imperious need we felt to finish with the old antinomies of the kind action and dream, past and future, reason and madness, high and low, etc."[257] Among the premises to which the surrealists adhered was "The idea that any object may be 'contained' in any other."[258] The surrealists would have rejected Lévy-Bruhl's derogatory, absolutist categorizations, but, ironically enough, they described surrealism in terms strikingly similar to his definition of "primitive mentality."

Lam easily fits in this context: his desire "was to integrate in painting the entire transcultural dialogue that took place in Cuba between aborigines, Spaniards, Africans, Chinese, French immigrants, pirates and all elements that formed the Caribbean."[259] This same hybridity was then combined with European modernism: Picasso, surrealism, and even certain aspects of American abstract expressionism, all filtered through a set of ideas forged by Western psychologists and anthropologists. In this way, his anti-colonial message—i.e., the reclaiming and celebration of Cuba's African heritage—could be communicated through the more readily accessible conduit of a fundamentally Western modernist idiom. Again, one is reminded of Lam's statement that he was fifty-percent Cartesian, fifty-percent savage. Of course, he could have formulated that statement in another way; he could have said: "I'm fifty-percent Lévy-Bruhlian, fifty-percent Lévi-Straussian."

Claude Cernuschi

I would like to thank Nancy Netzer and Elizabeth T. Goizueta for their invitation to contribute to this catalogue, and to Elizabeth, again, for her close reading of the essay, her many suggestions for improvement, her remarkable overseeing and stewardship of this project, and her shepherding during a memorable research trip to Cuba. Kate Shugert and John McCoy deserve particular mention for all of their work, especially editing and design, and Adeane Bregman for her help with biographical sources and every aspect of my scholarly research. I also recognize the assistance of friends and colleagues, David Castriota, Roberto S. Goizueta, Jeffery Howe, Michael Mulhern, and Andrew Tavarelli, and the exceptional contributions of Diana Larsen, Martha Richardson, and Beatriz Peña. A very special acknowledgment is made here to Roberto Cobas Amate, curator of the Wifredo Lam collection in the Museo Nacional de Bellas Artes in Havana, not only for his hospitality and kindness, but also for his wisdom and encouragement, and for sharing his profound knowledge of Lam and Cuban culture so generously. I also thank Ursula Cernuschi and Suzy Forster for their continual affection and support. And lastly, I dedicate this essay, in friendship, to André and Eva Kempinski.

1 Edna M. Rodríguez-Mangual, *Lydia Cabrera and the Construction of an Afro-Cuban Cultural Identity* (Chapel Hill: University of North Carolina Press, 2004), 4.

2 Fernando Ortiz, *Cuban Counterpoint: Tobacco and Sugar* (New York: Knopf, 1947), 129.

3 Kinshasha Holman Conwill, foreword to *Wifredo Lam and His Contemporaries, 1938–1952*, ed. Maria R. Balderrama, exh. cat. (New York: Studio Museum, Harlem, 1992), 11.

4 Excerpt from letter to Helena Holzer, 1946, cited in Jacques Leenhardt, *Wifredo Lam* (Paris: Éditions HC, 2009), 180.

5 See Antonio Núñez Jiménez, *Wifredo Lam* (Havana: Letras Cubanas, 1982), 82–83. I would like to thank Elizabeth Goizueta for bringing my attention to these passages.

6 Wifredo Lam, "'My Painting is an Act of Decolonization,' an Interview with Wifredo Lam by Gerardo Mosquera (1980)," trans. Colleen Kattau and David Craven, *Journal of Surrealism and the Americas* 3, nos. 1–2 (2009): 3.

7 Helena Benitez, *Wifredo and Helena: My Life with Wifredo Lam, 1939–1950* (Lausanne: Sylvio Acatos, 1999), 53–54.

8 Lam cited in Max-Pol Fouchet, *Wifredo Lam* (Barcelona: Ediciones Polígrafa, 1976), 183.

9 Benitez, *Wifredo and Helena*, 157.

10 Curtis L. Carter, "Wifredo Lam: Cultural Globalizer," in *Wifredo Lam in North America*, exh. cat. (Milwaukee: Haggerty Museum of Art, Marquette University, 2008), 12.

11 Ibid., 19.

12 Benitez, *Wifredo and Helena*, 91.

13 William Rubin, "Modernist Primitivism: An Introduction," in *"Primitivism" in Twentieth-Century Art*, exh. cat. (New York: Museum of Modern Art, 1984), 14.

14 Eskil Lam, "Avant-propos," in Leenhardt, *Wifredo Lam*, 9.

15 Carlos Franqui, "Pintará Wifredo Lam un mural para Caracas," *Diario Nacional*, cited in Lowery Stokes Sims, *Wifredo Lam and the International Avant-Garde, 1923–1982* (Austin: University of Texas Press, 2002), 209.

16 Sims, *International Avant-Garde*, 1.

17 Conwill, *Lam and His Contemporaries*, 11.

18 Robert Linsley, "Wifredo Lam: Painter of Negritude," *Art History* 11, no. 4 (Dec. 1988): 527.

19 Jason Edward Kaufman, "Wifredo Lam, Multicultural Modernist," *World and I* 8, no. 3 (Mar. 1993): 135.

20 Gerardo Mosquera, "Modernity and Africana: Wifredo Lam on His Island," in *Wifredo Lam*, exh. cat. (Barcelona: Fundació Joan Miró, 1993), 174.

21 Lam, "Interview by Gerardo Mosquera," 2.

22 Ibid., 5.

23 Ibid., 3.

24 Ibid.

25 Sims, *International Avant-Garde*, 237–38.

26 Lam, "Interview by Gerardo Mosquera," 3.

27 Fouchet, *Wifredo Lam*, 188.

28 Charles Merewether, "At the Crossroads of Modernism: A Liminal Terrain," in *Wifredo Lam: A Retrospective of Works on Paper*, ed. Elizabeth Ferrer, Diane Garvey Nesin, and Daniel Jussim, exh. cat. (New York: Americas Society, 1992), 15, 22, 24, 32.

29 Fouchet, *Wifredo Lam*, 110.

30 Wifredo Lam, "Mon amitié avec Picasso, 1938," in *Wifredo Lam, 1902–1982: Obra sobre papel*, ed. Lucía García-Noriega y Nieto, exh. cat. (Polanco: Fundación Cultural Televisa, 1992), 14.

31 Pierre Loeb, "Wifredo Lam," *Tropiques*, nos. 6–7 (Feb. 1943): 61–62.

32 Lam cited in Fouchet, *Wifredo Lam*, 118.

33 Lydia Cabrera, *La Forêt et les Dieux: Religions afro-cubaines et médecine sacrée à Cuba*, trans. Béatrice de Chavagnac (Paris: Jean-Michel Place, 2003), 591.

34 Jean Louis Paudrat, "Afriques en confluences," in *Lam métis*, exh. cat. (Paris: Éditions Musée Dapper, 2001), 76.

35 Ibid., 77.

36 André Breton, *Le surréalisme et la peinture* (Paris: Gallimard, 1965).

37 See Madeleine Rousseau, "Wifredo Lam, peintre cubain," *Présence Africaine* 4 (1948): 591.

38 Interview of Feb. 7, 1990, referenced in Julia P. Herzberg, "Naissance d'un style et d'une vision du monde," in *Lam métis*, 239n24.

39 Paudrat, "Afriques en confluences," 83.

40 This point is important to our discussion because Lam's attribution of similarities between his work and African art to "ancestral memory" was repeated, uncritically, by some of his admirers. Max-Pol Fouchet, for instance, writes that Lam's "timeless expression…comes close to primitive cosmogonies" (Fouchet, *Wifredo Lam*, 6).

41 Claude Lévi-Strauss, *Structural Anthropology*, trans. Claire Jacobson and Brooke Grundfest Schoepf (New York: Basic Books, 1963), 58–59.

42 Claude Lévi-Strauss, *The Savage Mind* (Chicago: University of Chicago Press, 1966), 136.

43 Claude Lévi-Strauss, *Totemism*, trans. Rodney Needham (Boston: Beacon Press, 1963), 268.

44 Lévi-Strauss, *Savage Mind*, 65.

45 Fouchet, *Wifredo Lam*, 28.

46 Ibid., 34.

47 Fernando Ortiz, "Por la integración cubana de blancos y negros." Lecture originally delivered Dec. 12, 1942; published in *Revista de la Biblioteca Nacional José Martí* 23 (1981): 23.

48 Cabrera, *La Forêt et les Dieux*, 20.

49 See Benitez, *Wifredo and Helena*, 92.

50 Cabrera, *La Forêt et les Dieux*, 39.

51 Sims, *International Avant-Garde*, 1.

52 Lam cited in Fouchet, *Wifredo Lam*, 120.

53 Lowery Stokes Sims, "Lam's *Femme Cheval*: Avatar of Beauty," in *Lam in North America*, 28.

54 Lam, "Interview by Gerardo Mosquera," 4.

55 Ibid., 6.

56 Fernando Ortiz, *Los bailes y el teatro de los negros en el folklore de Cuba* (Havana: Letras Cubanas, 1993), 124.

57 André Breton, *Surrealism and Painting*, trans. S. W. Taylor (New York: Harper and Row, 1972), 333.

58 Aimé Césaire, "Wifredo Lam," *Cahiers d'art* 20–21 (1945–46): 357–59.

59 Suzanne Césaire, "Maladie d'une civilization," *Tropiques*, no. 5 (Apr. 1942): 45.

60 See 38 above.

61 See Lowery Stokes Sims, "Myths and Primitivism: The Work of Wifredo Lam in the Context of the New York School and the School of Paris, 1942–1952," in Balderrama, *Lam and His Contemporaries*, 79.

62 Herzberg, "Naissance d'un style," 117.

63 Adolph Gottlieb and Mark Rothko, "The Portrait and the Modern Artist," *Radio WNYC*, Oct. 13, 1943, http://www.warholstars.org/abstractexpressionism/abstract/markrothko.html.

64 Lam cited in Fouchet, *Wifredo Lam*, 188–89.

65 Gottlieb and Rothko, "Portrait and the Modern Artist."

66 Selden Rodman, *Conversations with Artists* (New York: Devin-Adair, 1957), 82.

67 "Jackson Pollock: A Questionnaire," *Arts and Architecture* 61 (Feb. 1944): 14.

68 Merewether, "Crossroads of Modernism," 24.

69 Gottlieb and Rothko, "Portrait and the Modern Artist."

70 Edward Tylor, "Animism," in *The Making of Man: An Outline of Anthropology*, ed. V. F. Calverton (New York: Modern Library, 1931), 640ff.

71 Ibid., 647.

72 Ibid., 648.

73 Lucien Lévy-Bruhl, *Les fonctions mentales dans les sociétés inférieures* (Paris: Félix Alcan, 1912), 98–99.

74 See J. Déchelette, "The Art of the Reindeer Epoch," 100ff and A. A. Goldenweiser, "Totemism: An Essay on Religion and Society," 473ff in Calverton, *Making of Man*.

75 Lévy-Bruhl, *Les fonctions mentales*, 100.

76 See ibid., 31.

77 Ibid., 105.

78 See Jeffrey Potter, *To a Violent Grave: An Oral Biography of Jackson Pollock* (New York: Putman, 1985), 88.

79 Diamond Jenness, "The Carrier Indians of the Bulkley River," *Bulletin of the Bureau of American Ethnology* 133 (1943): 540.

80 Lévy-Bruhl, *Les fonctions mentales*, 32.

81 Julia P. Herzberg, "Wifredo Lam: The Development of a Style and World View, The Havana Years, 1941–1952," in Balderrama, *Lam and His Contemporaries*, 35.

82 Cabrera, *La Forêt et les Dieux*, 29.

83 Ibid., 61.

84 Césaire, "Wifredo Lam," 357–59.

85 Robert Motherwell, *The Collected Writings of Robert Motherwell*, ed. Stephanie Terenzio (New York: Oxford University Press, 1992), 86.

86 Carlos Franqui, "El ritorno de Wifredo Lam," *Carteles* (Dec. 12, 1954): 98, cited in Sims, *International Avant-Garde*, 114.

87 Interview of Feb. 7, 1990, referenced in Herzberg, "Naissance d'un style," 239n14.

88 Frédéric Keck, *Lévy-Bruhl: Entre philosophie et anthropologie* (Paris: CNRS Éditions, 2008), 240.

89 Joseph Campbell, foreword to *Divine Horsemen: Voodoo Gods of Haiti*, by Maya Deren (New York: Chelsea House, 1970), xvii.

90 Fouchet, *Wifredo Lam*, 44.

91 Leenhardt, *Wifredo Lam*, 178.

92 Merewether, "Crossroads of Modernism," 20.

93 Paudrat, "Afriques en confluences," 85.

94 Herzberg, "Naissance d'un style," 102.

95 Sims, *International Avant-Garde*, 55.

96 Valerie J. Fletcher, "Wifredo Lam: Art of Pride and Anger," in *Lam in North America*, 54.

97 See Merewether, "Crossroads of Modernism," 26.

98 Benitez, *Wifredo and Helena*, 167.

99 Mosquera, "Modernity and Africana," 79.

100 Herzberg, "Naissance d'un style," 117.

101 Manuel Pereira, "Lam del Caribe," *Cultura* (1977), cited in Sims, *International Avant-Garde*, 162.

102 It should also be mentioned that the title is somewhat erroneous since Malembo is not a deity; a curious inaccuracy since the title was suggested by Lydia Cabrera, who was studying the customs and beliefs of Afro-Cubans, and frequently suggested titles to Lam, most likely, in connection to the research she was conducting. See Herzberg, "Development of a Style," 40.

103 Lam cited in Fouchet, *Wifredo Lam*, 204. Lowery Stokes Sims holds a different opinion. The abstract expressionists, she writes, "for the most part cultivated more indeterminate forms, leaving them to suggest rather than delineate. Their use of primal symbology was also more improvisational than that of Lam, who through the mid-1940s worked from a specific and consistent iconography with a clearly recognizable symbology" (Sims,

"Myths and Primitivism," 77).

104 Fouchet, *Wifredo Lam*, 196.

105 William Baziotes cited in *The New York School*, ed. Maurice Tuchman (New York: New York Graphic Society, 1970), 39.

106 Richard Schiff, ed., *Barnett Newman: Selected Writings and Interviews* (New York: Knopf, 1990), 258.

107 Jackson Pollock, "My Painting," *Possibilities* 1 (Winter 1947–48): 83.

108 Motherwell, *Collected Writings*, 77–78.

109 Lévy-Bruhl, *Les fonctions mentales*, 108ff.

110 Lucien Lévy-Bruhl, "The Solidarity of the Individual with His Group," in Calverton, *Making of Man*, 251.

111 Lévy-Bruhl, *Les fonctions mentales*, 92.

112 Ibid., 2.

113 Ibid., 6, 3.

114 Ibid., 9.

115 Ibid., 16.

116 Ibid., 20.

117 Ibid., 28.

118 Ibid., 29.

119 Ibid., 30.

120 Ibid., 39–40.

121 Ibid., 198.

122 Ibid., 70, 73.

123 Ibid., 77.

124 Ibid., 78, 79.

125 Ibid., 101.

126 Ibid., 87.

127 See Jacques Leenhardt, "Wifredo Lam, ou la quête d'un language pictural universel," in *Wifredo Lam: Oeuvres de Cuba*, ed. Pierre Gaudibert and Jacques Leenhardt (Paris: Librarie Séguier, 1989), 44.

128 Lucien Lévy-Bruhl, *La mentalité primitive* (Paris: Presses Universitaires de France, 1976), 73.

129 See Michel Leiris, *Miroir de l'Afrique* (Paris: Gallimard, 1995), 878.

130 Julia Cuervo Hewitt, *Voices out of Africa in Twentieth-Century Spanish Caribbean Literature* (Danvers: Rosemont, 2009), 346.

131 Cabrera, *La Forêt et les Dieux*, 26.

132 Ibid.

133 Ibid., 29.

134 Ibid., 34.

135 See Lévy-Bruhl, *Les fonctions mentales*, 306ff.

136 Cabrera, *La Forêt et les Dieux*, 42.

137 Ibid., 50.

138 Alejo Carpentier, prologue to *El reino de este mundo* (1949), reprinted and translated in David Adam Shefferman, "Displacing Magic: Afro-Cuban Studies and the Production of Santería" (PhD diss., University of North Carolina, Chapel Hill, 2006), 287.

139 Ibid., 51.

140 Lévy-Bruhl, *La mentalité primitive*, 41.

141 Carlos Ximénes Arroyo, "Pintor, Wifredo Lam," in *Wifredo Lam: La cosecha de un brujo*, ed. José Manuel Noceda (Havana: Letras Cubanas, 2002), 514.

142 Merewether, "Crossroads of Modernism," 24.

143 Lévy-Bruhl, *Les fonctions mentales*, 40ff.

144 Ibid., 66.

145 Ortiz's lecture is cited in Shefferman, "Displacing Magic," 131.

146 See Keck, *Lévy-Bruhl*, 5.

147 Lucien Lévy-Bruhl, *Carnets* (Paris: Presses Universitaires de France, 1949), 82.

148 See Shefferman, "Displacing Magic," esp. 240ff.

149 Lévy-Bruhl, *Les fonctions mentales*, 46.

150 Cabrera, *La Forêt et les Dieux*, 283.

151 Benitez, *Wifredo and Helena*, 54.

152 Claude Lévi-Strauss, *Tristes Tropiques*, trans. John and Doreen Weightman (New York: Atheneum, 1975), 25.

153 For Lévi-Strauss's socialization with the surrealists, see Didier Eribon, *Conversations with Claude Lévi-Strauss*, trans. Paula Wissing (Chicago: University of Chicago Press, 1991), 31; for Lévi-Strauss's hanging of two Lam drawings in his office, the information was imparted to me by Eva Kempinski, Lévi-Strauss's assistant.

154 See Lévi-Strauss, *Structural Anthropology*, 18ff, 56ff, 121ff.

155 Ibid., 21.

156 Edward Lucie-Smith, "Wifredo Lam and the Caribbean," in *Lam in North America*, 65.

157 Claude Lévi-Strauss, *Myth and Meaning* (London: Routledge, 1978), 16.

158 Claude Lévi-Strauss, *Anthropology and Myth* (Oxford: Basil Blackwell, 1987), 12.

159 Lévi-Strauss, *Myth and Meaning*, 11.

160 Lévy-Bruhl, *Les fonctions mentales*, 190. Lévy-Bruhl also notes that terminology in non-Western languages can be remarkably diverse, especially when relationships of space are conveyed: "In the majority of languages employed by societies of the inferior type, personal and demonstrative pronouns present a considerable number of forms, in order to express relations of distance, of relative position, of visibility, of presence and absence, between the subject and the object" (ibid., 164). The sensitivity with which non-Western languages specify the relative distances, scale, form, and spatial relations bespeak the attentiveness to the relationships between objects in space. Intriguingly, the adverbs that are meant to describe time are extrapolated from those meant to describe space, and, thereafter, have maintained both significations (ibid., 165). Is it possible, then, for the multifaceted forms in Lam's paintings to evoke not only spatial, but chronological relations? In other words, the multiple images we detect in Lam's paintings may be the same person at different moments in time, another way, if one wills, to subvert the logical rendition of space and introduce a synthetic, additive element. Since Lam was well versed in modernist painting, it is very likely that he was familiar with Italian futurism, particularly, its repetition of a figure's contour to evoke its passage through time.

161 Lévi-Strauss, *Savage Mind*, 1–3.

162 See Lévy-Bruhl, *La mentalité primitive*, 31ff.

163 Lévi-Strauss, *Savage Mind*, 10.

164 Ibid., 13.

165 Ibid., 14–15.

166 Ibid., 43.

167 Ibid., 46.

168 Ibid., 25.

169 Ibid., 53, 55.

170 Ibid., 59.

171 Ibid., 60.

172 Claude Lévi-Strauss, *The Elementary Structures of Kinship* (Boston: Beacon Press, 1969), 94.

173 Cabrera, *La Forêt et les Dieux*, 15.

174 Lévi-Strauss, *Savage Mind*, 64.

175 Ibid., 75.

176 See A. A. Goldenweiser, "Totemism: An Analytical Study," *Journal of American Folklore* 33 (1910): 179–273.

177 Lévi-Strauss, *Totemism*, 15ff.

178 Ibid., 31.

179 Lévi-Strauss, *Savage Mind*, 99ff.

180 Ibid., 99.

181 Ibid., 62.

182 Ibid., 107.

183 Ibid., 117.

184 Lévi-Strauss, *Anthropology and Myth*, 20.

185 Lévi-Strauss, *Savage Mind*, 123–24.

186 Lévi-Strauss, *Structures of Kinship*, 10.

187 Lévi-Strauss, *Savage Mind*, 166.

188 Lévi-Strauss, *Structures of Kinship*, 18.

189 Ibid., 46.

190 Ibid., 9.

191 Ibid., 12.

192 Ibid., 24.

193 Obatalá, Oggun's father, surprised his son in the act and condemned him to work night and day until the end of the world. Obatalá did not curse Iyémmu, but prevented her from having any more children. He buried the first but was so taken with the second child, Changó, that he did not keep his word. Once grown up, and hearing of Oggun's behavior, Changó sought revenge and triggered a war against his brother. Cabrera, *La Forêt et les Dieux*, 255–56.

194 Fletcher, "Art of Pride and Anger," 54.

195 Lévi-Strauss, *Structures of Kinship*, 43, 45.

196 Ibid., 51.

197 Ibid., 48.

198 See Cabrera, *La Forêt et les Dieux*, 25ff.

199 Ibid., 46.

200 Lévi-Strauss, *Anthropology and Myth*, 108.

201 Lévi-Strauss, *Structures of Kinship*, 30.

202 Cabrera, *La Forêt et les Dieux*, 50–51.

203 Lévi-Strauss, *Structural Anthropology*, 47; *Structures of Kinship*, 115.

204 Lévi-Strauss, *Structures of Kinship*, 114.

205 Merewether, "Crossroads of Modernism," 22.

206 Sims, "Lam's *Femme Cheval*," 33.

207 Ibid., 35.

208 See Lévi-Strauss, *Structural Anthropology*, 61.

209 See Lévi-Strauss, *Structures of Kinship*, 61, 65.

210 Lévi-Strauss, *Savage Mind*, 138.

211 Ibid., 9.

212 Ibid., 147.

213 Ibid., 148. When preparing meals, certain societies divide animals into distinct parts and allocate them to individuals according to their place in the hierarchical divisions of the culture: the best cuts of meat go the highest born, and the animal is progressively divided according to this prescribed plan. Animal anatomy thus corresponds to the analogous parts of the cultural fabric.

214 Graziella Pogolotti, "Naissance d'une poétique," in Gaudibert and Leenhardt, *Oeuvres de Cuba*, 23.

215 Cabrera, *La Forêt et les Dieux*, 85.

216 Ibid., 131ff.

217 Ibid., 79.

218 Ibid., 80.

219 Ibid., 208.

220 Lam cited in Roland Dumas, "Wifredo Lam ou le chant profond de l'art," in Gaudibert and Leenhardt, *Oeuvres de Cuba*, 10.

221 Édouard Jaguer, "Les armes miraculeuses de Wifredo Lam," in *Wifredo Lam: 1902–1982*, exh. cat. (Paris: Musée d'art moderne de la ville de Paris, 1983), 87.

222 Lévi-Strauss, *Savage Mind*, 232–33.

223 Ibid., 148.

224 Lévy-Bruhl, *La mentalité primitive*, 95.

225 Ibid., 96.

226 Ibid.

227 Ibid., 98.

228 Ibid., 99–100.

229 Ibid., 100.

230 Cabrera, *La Forêt et les Dieux*, 42.

231 Lydia Cabrera, *Cuentos para adultos niños y retrasados mentales* (Miami: Ediciones CR, 1983), 72.

232 Lévi-Strauss, *Savage Mind*, 268.

233 Lévi-Strauss, *Totemism*, 103.

234 Lucien Lévy-Bruhl, "L'Institut d'Ethnologie de l'Université de Paris," *Revue d'éthnographie et des traditions populaires* 6, nos. 23–24 (1925): 234.

235 See "Une lettre de Lucien Lévy Bruhl au professeur Evans Pritchard," *Revue Philosophique de la France et de l'Étranger* 147 (1957): 407–13.

236 Lévy-Bruhl, *Carnets*, 10–11.

237 See Keck, *Lévy-Bruhl*, 201.

238 Aimé Césaire, *Discours sur le colonialisme* (Paris: Présence Africaine, 1989), 49.

239 Roger Caillois, "Illusions à rebours I," *La Nouvelle Revue Française* 24 (Dec. 1954): 1011.

240 Roger Caillois, "Illusions à rebours II," *La Nouvelle Revue Française* 25 (Jan. 1955): 67.

241 Ibid., 68–69.

242 Césaire, *Discours sur le colonialisme*, 38.

243 Claude Lévi-Strauss, "Diogène couché," *Les Temps Modernes* 110 (1955): 1194.

244 Césaire, *Discours sur le colonialisme*, 9.

245 Aimé Césaire, interviewed in the film *Aimé Césaire: Un nègre fondamental*, directed by Laurent Hasse and Aimé Chevallier (Paris: France 5 Productions, 2007).

246 Charles H. Rowell, "It Is through Poetry That One Copes with Solitude: An Interview with Aimé Césaire," *Callaloo* 38 (Winter 1989): 54.

247 Ibid., 64.

248 Sims, "Myths and Primitivism," 79.

249 Linsley, "Painter of Negritude," 527.

250 Benitez, *Wifredo and Helena*, 56.

251 See Edward W. Said, *Culture and Imperialism* (New York: Random House, 1993).

252 Shefferman, "Displacing Magic," 32.

253 Merewether, "Crossroads of Modernism," 15.

254 Ibid.

255 Shefferman, "Displacing Magic," 15.

256 Leiris, *Miroir de l'Afrique*, 878.

257 André Breton, "L'un dans l'autre," *Médium: Communication Surréaliste* 2 (Feb. 1954): 17.

258 Ibid., 18.

259 Adelaida de Juan, "Lam una silla en la jungla," in Noceda, *La cosecha de un brujo*, 421.

WIFREDO LAM: THE ASCENDING SPIRAL

Roberto Cobas Amate

To Alejo Carpentier

WIFREDO LAM RETURNED TO CUBA IN August 1941 after a long and dangerous journey. He came to America, like so many other intellectuals and artists, to leave behind the horrible tragedy of the war in Europe. After an absence of nearly eighteen years, Lam's emotions upon his return were conflicted: there was the joy of reuniting with loved ones, tempered by the bitter understanding of starting all over again in a context in which he was unknown.[1]

His testimony is of key importance to understanding his emotions at that moment: "Since I had left everything behind me in Paris, I had to start from scratch, as it were, and I no longer knew where my feelings lay. This filled me with anguish, because I found myself in much the same situation as before I left Cuba, when I had no great horizons before me."[2] The reinsertion of Lam into the Cuban cultural context during the forties was complex and difficult. For an artist whose work developed in the very heart of modernism, and was an active member of the Paris School, praised by Picasso and admired by Breton, Lam found it difficult to be in tune with the Cuban art world, which had advanced a different dynamism. By that time, Cuban modernism had already consolidated a strong and original expression, established on the rediscovery of traditions contained in an idealized memory of the colonial past whose features of opulence were still visible in the legacy of the architecture and furniture of a white-creole culture with Hispanic roots. This recovery of memory was intimately connected with the poetic and intellectual thought of José Lezama Lima and the generation of other Cuban intellectuals and artists who would gather around the *Orígenes* magazine. Instead, Lam's cultural interests had been linked strongly, since his time in Paris, to the appreciation and enjoyment of African art. His first significant works emerge—as much in morphology as in spirituality—in the style of *Untitled* [40.05] and *Femme avec enfant en gris* [40.20] from that study.

For Lam, if there was something worth rescuing and saving in Cuba it was the dignity of the Afro-Cuban man and his ancestral culture. In this respect, the artist said:

> I wanted with all my heart to paint the drama of my country, but by thoroughly expressing the Negro spirit, the beauty of the plastic art of the blacks. In this way I could act as a Trojan horse that would spew forth hallucinating figures with the power to surprise, to disturb the dreams of the exploiters.[3]

Such is the essence of his thought. However, his advance in this direction is understated and his initial results can be considered somewhat frustrating, despite André Breton's enthusiasm for the gouaches that Lam sent the Pierre Matisse Gallery for his exhibition in New York in 1942. Due to the vicissitudes of the war, Lam's works painted in Havana from August 1941 through most of 1942 show how earlier unfinished phases were dominating his artistic expression. The powerful personalities of Picasso and Breton still coexisted in his thoughts. Thus, *Femme et enfant* of 1941 [41.08] evokes his Parisian maternity-themed works in a composition of cubist structure marked by the ascendance of African sculpture. In this work, Lam timidly introduces the presence of some colonial railings that bring to the scene a new geographical and cultural position: Havana. Meanwhile, his study for a portrait of Helena, 1941 and *Le Roi de bilboquet*, 1942 (fig. 1), paintings on paper, rescue images previously confined to modest notebooks drawn in Marseilles that accompanied Lam on his return to the island.

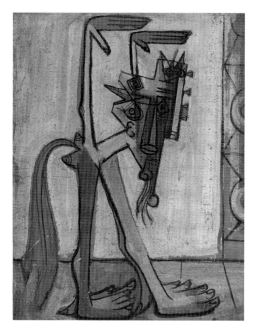

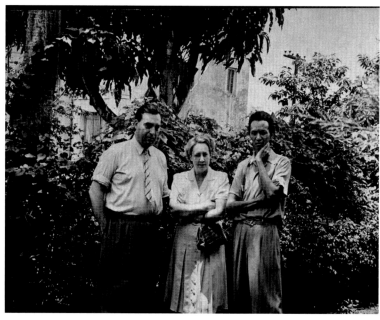

1. Wifredo Lam, *Le Roi de bilboquet*, 1942 [42.104]. Gouache on paper, 106 x 85 cm, Museo Nacional de Bellas Artes, Havana, 07.292.

2. Pierre Mabille, Lydia Cabrera, and Wifredo Lam in Havana, 1945.

While Lam was striving to redefine himself in his birthplace, other Cuban artists had already affirmed their own artistic discourse in the search for a native expression of identity. Such are the cases of Amelia Peláez with her exquisite creole still lifes; René Portocarrero and his nostalgic interiors of Cerro; Victor Manuel and his idyllic landscapes of Matanzas; Mariano Rodríguez and his spectacular roosters, a plethora of color and movement. United with other equally relevant figures, they formed images that rapidly became icons of Cuban painting at the time.

However, Lam did not despair. He worked methodically but intensely to find original solutions for the first cycle of Cuban works that followed his French experience so closely. Lam's friendship with the Cuban writer and ethnologist Lydia Cabrera would prove critical to his artistic evolution (fig. 2). As a researcher of folklore and Afro-Cuban customs, Cabrera demonstrated a deep poetic sensitivity for their interpretation, as observed in her extraordinary book *Cuentos negros de Cuba*, published in Havana in 1940.[4] Thanks to Cabrera, Lam drew upon the poetry contained in Afro-Cuban beliefs. Unexplored territory, this poetry became the catalyst for a painting that would act as an isolated but powerful pole within fine arts at the time.[5] By virtue of this revelation, Lam surpassed the boundaries of analytical cubism, impregnating it with a new life, an unknown lyricism.

From that moment on, Lam intensely began to adapt cubism and surrealism to the magical "virgin" world he recently discovered: "Here, in Cuba there were things that were pure surrealism. For example, Afro-Cuban beliefs; one could see the poetry preserved in their magical primitive state."[6] He worked tirelessly, painting on kraft paper. The experience was successful and *Figure au coq* [43.09], *Maternidad en verde* [42.38], and *Figure sur fond vert* [42.115] made their appearances among other oils and temperas that would constitute antecedents for important transcendental paintings in Lam's oeuvre. This road led him to *La Jungla* [43.12], *La Silla* (fig. 3), *Le Matin vert* [43.10], and other works in which he achieved an unprecedented aesthetic interpretation of the convulsed and complex American reality. The vitality of these paintings and the regenerative power they radiate suddenly placed Lam at the vanguard of Cuban fine arts at the time.

The works by Lam during his first Cuban period awakened the enthusiasm of writer Alejo Carpentier who had returned from Europe in 1939 after an eleven-year absence. Lam met Carpentier in Spain in 1933 and both artists met again in Havana, establishing a close relationship. Carpentier was an impassioned defender of African

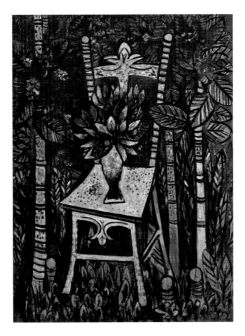

3. Wifredo Lam, *La Silla*, 1943 [43.27]. Oil on canvas, 115 x 81 cm,
Museo Nacional de Bellas Artes, Havana, 07.296.

roots in Cuban culture. His first novel, *Ecué-Yamba-Ó*, published in Madrid in 1933, was a sensitive approach to that subject. Previously, when Carpentier was working with Afro-Cuban subjects from a surrealist perspective, he enthusiastically promoted Eduardo Abela, another Cuban living in Paris in the late twenties. Carpentier also actively supported the incorporation of black rhythms into concert music performed by Amadeo Roldán and Alejandro García Cartula. As such, it is not surprising to note that Lam's paintings would deeply awaken Carpentier's interest and obtain his unconditional support, expressed in critiques and praiseworthy commentaries that appeared in several Cuban and foreign cultural publications. In these, he endorses, with the sharpness of his judgment, the importance of Lam's work in the context of 1940s Latin American art. It would be Carpentier who signals Lam's unprecedented importance in 1944: "The monumental painting *La Jungla*, and all those which heralded it and originated from it, represent a transcendental contribution to the new world of American Art."[7] In *La Jungla*, Lam synthesizes the principal artistic contributions of the avant-garde—those of Picasso, Cézanne, Matisse—and makes them instruments for expressing, in images of a disconcerting artistic and conceptual density, a primal poetic sensitivity that could only appear in "Nuestra América."[8]

Lam achieves works of great importance in which he fully incorporates the expressive richness of lush vegetation and exuberant tropical fruits—skillfully integrating the sexual imagery of the banana and papaya—while simultaneously working on a group of compositions that advances his study of the optical effects of light and color and their use based on a cubist structure. This dazzling effect is evident in a series of oils on paper mostly done between 1943 and 1944, characterized by impressionist, almost pointillist, brushwork that outlines imprecise contours of figures by means of contrasting color and light with the ochre background of the paper. This can be appreciated in *Femme aux bras levés* [43.13] and *Oiseau-Fleur [Dienda]* [45.21]. Lam's fascination for "Cuban light" is laid bare when he recalls with admiration:

> The transparency of light produces a magical effect on colors. Our light is so transparent that the leaves of some trees give the feeling that they are illuminated from inside because here the sun, even with closed eyes, gets inside, through the mouth, through the ears. I live a constant drunkenness of light in Cuba. In fact, I cannot speak about how I see colors but rather I speak of their transparency, which begins to suggest unprecedented relationships among their own values.[9]

71

Consolidating what will be the central nucleus of his poetics—around which will revolve the spiral of his later periods—Lam explores traditional painting subjects that incorporate a distinct visuality resulting from the synthesis of cubism and surrealism. The artist reaches a new pictorial dimension from that point on through the poetic interpretation of a singularly American reality. It is the artistic realization of *lo real maravilloso* ("the marvelous American reality"), the revolutionary thesis that Alejo Carpentier formulates in the prologue to his novel *El reino de este mundo*.[10] In this work, the distinguished novelist reveals the decadence of surrealism in the 1940s.[11] Carpentier points to the abuse of "the marvelous, manufactured by sleight of hand, by juxtaposing objects ordinarily never found together: the old, fraudulent story of the fortuitous encounter of the umbrella and the sewing machine on an operating table, which engendered ermine spoons, snails in a rainy taxi, the lion's head on the widow's pelvis in surrealist exhibitions."[12] Carpentier becomes aware of the magical essence of the American reality in a visit he makes to Haiti in 1943: "I find myself…confronted by the prodigious magical world, a syncretic world. […] There emerges in me…the perception of what I call the 'marvelous American reality' that differs from magical realism and surrealism as such."[13] It is in Wifredo Lam that Carpentier finds confirmation of his thesis of *lo real maravilloso*, pointing to it as a paradigm. He categorically affirms: "It had to be an American painter, the Cuban Wifredo Lam, who showed us the magic of the tropical vegetation, the uncontrolled creativity of our natural formations—with all their metamorphoses and symbioses—on monumental canvases whose expression is unique in contemporary art."[14]

Thus landscapes, still lifes, and portraits are transmuted, impregnated by a living magic present in daily life. The so-called *altares* are attributed to this cycle, a group of works done in 1944 in which Lam integrates elements taken from Santería and spiritualism and redefines the traditional theme of still lifes, providing them with a magical-symbolic content. These altars are made up of offerings dedicated to Afro-Cuban deities and spiritual entities that eat and drink like humans. One of the most suggestive paintings is *Le Diner* [44.46] in which three Elegguás appear on a platter on top of a table surrounded with vegetation. The representation of Elegguá—one of the major orishas of the Yoruba pantheon and possessor of the "keys of destiny that open and close the door to misfortune or happiness"[15]—indicates Lam's immersion into the Afro-Cuban religions, in which he moves with complete liberty and poetic sensitivity.

Also of great interest is Lam's manner of approaching portraits: one notes the change that occurs from those painted in Spain during the early twenties in a realistic style to those conceived in Havana with his constant companion, Helena Holzer, as muse. In the drawings of Marseilles, Helena's face already served as an essential source of inspiration. Her handsome profile and delicate beauty can be recognized in those ink drawings done by the artist to illustrate André Breton's *Fata Morgana* (plate 22). Upon Lam's arrival in Havana, surrealism's influence still dominated his first works revolving around Helena. Included in these are the very interesting *Femme*, 1941 [41.02], which clearly indicates some of Lam's future artistic paths, as well as the naïve *Portrait d'Helena* [42.109] that transforms Helena into a graceful siren. However, in 1944, when Lam and Helena marry, Lam applies himself wholeheartedly to his work and carries out a masterful synthetic study that leads him, from painting to painting, from an almost realist understanding to a completely metamorphosed interpretation of the human figure. In these portraits Helena usually appears seated in repose, at times characteristically introspective or reflective, although these portraits do not necessarily reflect a physical or psychological resemblance. What interests Lam is the transformation of the subject into a new spiritual entity: the Caucasian profile of Helena disappears and her figure reappears, emerging triumphant amid the suggested vegetation of sugarcane stalks, with her face transformed into an African mask.

In other works Lam addresses the apparently antagonistic diversity of the universe, a conflict resolved through osmotic action in which all creatures, material or immaterial, participate in a reaffirmation of the unity of existence. The personages arising from this imagery are integrated into nature as a universal expression of life. In *Oiseau-Fleur*, 1944, or *Composition [Figura alada]*, 1946 [46.06], one can appreciate a poetic transmutation of the symbiosis of diverse worlds, apparently contrary and irreconcilable,

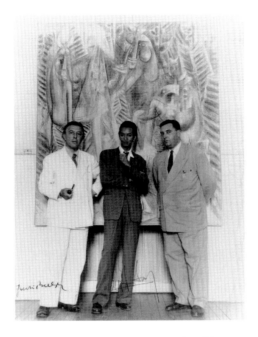

4. André Breton, Wifredo Lam, and Pierre Mabille in front of *Harpe Astrale*, 1944 [44.58] at Lam's Centre d'Art exhibition, Port-au-Prince, 1946.

reconciled in an act of perpetual fusion.

During the forties, a powerful cultural movement was created in the Antilles. Recently arrived European intellectuals fleeing the war marveled at the strength of the literature and art being achieved in these countries.[16] In this context, Haiti stood out for its cultural potential and its capacity to radiate it throughout the region. It was the moment of splendor for Haitian poetry, expressed with outstanding originality and quality in the works of René Bélance, Magloire Sainte-Aude, and René Depestre, among others. In addition, the Europeans émigrés discovered Haitian popular painting, whose most relevant figure—praised by Breton—would be Héctor Hyppolite.

Cuban writers and artists felt awed by the inspiring force of Haitian art and began to discover its fascinating culture, including poet Nicolás Guillén, novelist Alejo Carpentier whose visit served as a source of inspiration for *El reino de este mundo*, and painter Carlos Enríquez who gave a paper on European surrealism and held a personal exhibition in the Centre d'Art of Port-au-Prince in April and May 1945. Of particular interest is the exhibition *Les Peintres Modernes Cubains*, held also in the Centre d'Art, from January 18 to February 4, 1945. At the end of 1945, René Depestre founded, with other Haitian intellectuals, the avant-

garde art magazine *Ruche*, which dedicated a special issue to André Breton. All this interest for the arts occurred during writer Pierre Mabille's stay in the country as cultural attaché of Free France in Haiti. He was responsible for inviting Wifredo Lam to hold an exhibition in the country (fig. 4).

Much as Lam's passage through Marseilles decidedly influenced his later work accomplished in Havana, his trip to Haiti in early December 1945 with his wife Helena Holzer prompted an unexpected change in Lam's work. This change was due to an exhibition organized at the Centre d'Art of Port-au-Prince (along with a stay in Haiti of several months). More concretely, the change was a direct result of sustained conversations with Mabille and Breton (the latter also visiting the country where he would give a lecture on modern painting in February 1946), Lam's contact with the Haitian intellectual movement, and, in particular, his discovery of voodoo. The syncretic sense of his work was enriched by his admiration of Haitian literature and arts. Lam was surprised by the current of respect existing in the country toward the culture of black roots. This complex issue was addressed throughout the novel "boom" of the thirties. The interest of Haitian artists and writers for avant-garde movements in Europe was expressed in a poetry that combined voodoo with surrealism. However, what most impressed Lam were the voodoo ceremonies he

witnessed with Pierre Mabille and André Breton, which he relays in emotional terms when recalling one night in particular:

> What wild, savage beauty! A non-intellectual beauty, skin-deep, an absolutely naked human emotion. But André [Breton] could not stomach the spectacle and began to feel sick. I could not resist teasing the man who had written that "Beauty shall be convulsive or it is not true beauty."[17]

Lam exhibited in the Centre d'Art of Port-au-Prince from January 24 to February 3, 1946 and the exhibition opening was a major cultural event at which André Breton gave the introduction. Breton soon after delivered his lecture on modern art in Port-au-Prince in which he made important pronouncements about Lam's work, raising him to the level of paradigm in the sphere of surrealist thought at the time. Breton is emphatic when he affirms:

> Never, except with Lam, without the slightest stumble, has there appeared a union of the objective world and the magical world. Never except through him has anyone found the secret of unifying physical perception and mental representation that we have not ceased searching for in surrealism.[18]

Moreover, the close relationship Lam maintained with André Breton and Pierre Mabille in Haiti consolidated in Lam a renewed interest for alchemy and hermetic philosophy. On Haitian land, he had discovered, with great surprise, an integration of the local religion, voodoo, with practices from European witchcraft. The assimilation of these foundations, integrated with Afro-Caribbean cultural components already present in his paintings, allowed Lam to project a new discourse, an open exchange between cultures. It is in forging this integration that Lam's work acquires a new dimension, both dialectical and intercultural.

Recently arrived from Haiti, Wifredo Lam did not rest and organized an exhibition in the Lyceum of Havana from April 11 to 19, 1946. There he exhibited roughly twenty canvases painted between 1943 and 1946. These include *L'Action* (plate 40) and such anthological pieces as

Le Présent éternel [44.04] and *Les Noces chimiques* [44.91].[19] This exhibition marks a particularly significant moment as it is a compendium of the highest level achieved by the artist in his first Cuban cycle—the same that Alejo Carpentier would call "Wifredo Lam's classic phase"[20]—and the beginning of a second period, marked by the impression left on his spirit by Haitian culture, with significant changes rendered to his morphology, iconography, and color.

In this sense *Huracán* (fig. 5) constitutes an apotheosis of a new expression of the Americas as conceived by Wifredo Lam. It is an impressive work for its capacity to concentrate all the mystery of creation in a moment of apparent calm, when animistic forces meet in maximum tension. In this work gods and plants, animals and fruits, day and night converge, forming a unified whole. With *Huracán* Lam gives order to the chaos of creation. In this work—whose creative cycle also corresponds to the enigmatic *Chant de la forêt* [46.13]—the changes that would operate in his intense production of 1947 are evident.

In the works painted in 1947 there is a group of totemic figures animated by a disturbing aggressiveness, the reflection of a powerful spiritual upheaval and an internal need for expression. These works are born of a renewed desire to confront the viewer's apathy in the presence of a renewed and vital message. There is a radical renovation, at this time, in his artistic language. The sun-infused paintings of his first Cuban cycle (1942–45) are now replaced by esoteric paintings in which the shadows of the night reign.[21] Lam obtains this effect with a reduced palette of colors: black, ochre, and sienna. Thus arises one of his most impressive creative cycles that features the series known as *Canaima* along with other works characterized by a vibrant energy and the establishment of powerful forms, incisive and threatening. Here, his *Figure sur fond ocre* [47.17], *Torse de femme* [47.19], *Quatre figures sur fond ocre* [47.33], *Figures zoomorphes, I* [47.35], and *Personnage avec deux Elegguás* [47.06] appear, among others, in oil or tempera on kraft paper, in which a somber atmosphere prevails. The paintings of this series, although they boast of sufficient personality to stand on their own, together act as studies for the large compositions that summarize the conceptual and

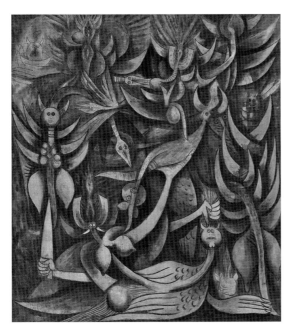

5. Wifredo Lam, *Huracán*, c. 1945–46 [46.03]. Oil and charcoal on canvas, 218.5 x 198 cm, Museo Nacional de Bellas Artes, Havana, 88.271.

6. Wifredo Lam, *Contrepoint [Composition]*, 1951 [51.07]. Oil on canvas, 217 x 196 cm, Museo Nacional de Bellas Artes, Havana, 07.203.

artistic questions of the period: *L'Atelier* (plate 44), *Nativité [Annonciation]* [47.40], *Les Noces* [47.53], and *Bélial, empereur des mouches* [48.11].

The monumentality of these powerful paintings of 1947 and 1948 give way, from 1949 on, to a different but equally impressive composition that also relies on an elegant and synthetic design. In these works the figures, drawn in charcoal, appear cut against a neutral background. Thus, themes already taken up reappear, such as the seated woman and maternity, to which he incorporates the *femme-cheval*—an emblematic figure with a powerful sensuality—as well as the Caribbean roosters.

Lam's 1950 exhibitions at the Pierre Matisse Gallery in New York in May and at Central Park in Havana in October were crucial to the new direction of his painting. Together with a group of imaginary portraits of slender women, Lam departs from the classical scheme of representation and subverts it with the inclusion of plants and zoomorphic elements, as evidenced in the style of *La Fiancée de Kiriwina*, 1949 [49.01] and *La Sirène du Niger*, 1950 [50.14]. He achieves other works that employ geometric motifs whose symbolism is left open to the interpretation of the viewer. Unusual for their rigorous design and austere application of color, these works tend toward abstraction

without surrendering to its demands. *Point de départ [Composition]* [50.52] and *Umbral [Seuil]* [50.48], both from 1950, and *Contrepoint [Composition]*, 1951 (fig. 6) establish a new development in his painting that achieves a conceptual openness from the plural character of its significance: "I have never created my pictures in terms of a symbolic tradition, but always on the basis of a poetic excitation."[22]

Beyond the simultaneity of his creations, whether they approach figuration or abstraction, or deal with new or recurring subjects, Lam commands a unique artistic discourse. This is due to the alignment of elements originating from different cultures—Afro-Caribbean, European, Asian, Oceanic—that should be appreciated in his works as "elements of entry for an open discourse."[23]

During the fifties Lam was deeply attracted to the art of the "primitive" cultures of New Guinea and added a group of sculptures from the region to his collection. His interest in these totemic sculptures' disturbing appearances would be reflected in new morphological variations of his painting. In a work such as *Quand je ne dors pas, je rêve*, 1955 (fig. 7), one observes the continued influence of African masks combined with the incorporation of elongated figures crossing from one edge of the composition to the other, resulting from a reinvention of his style based on

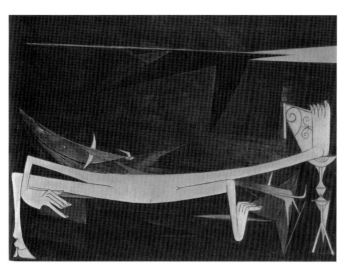

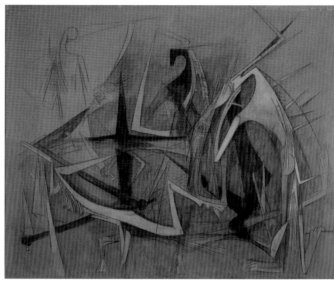

7. Wifredo Lam, *Quand je ne dors pas, je rêve*, 1955 [55.34]. Oil on canvas, 148 x 216 cm, Colección FEMSA, Monterrey.

8. Wifredo Lam, *La Sierra Maestra*, 1959 [59.04]. Gouache on paper on canvas, 247 x 310 cm, private collection.

New Guinean sculptural forms.[24]

During the sixties, Lam worked on a group of large compositions in which he synthesizes the conceptual and morphological advances of his paintings from the forties and fifties. This cycle begins with various works at the end of the fifties such as *Amanecer*, *Près des Îles Vierges* (plate 53), and *La Sierra Maestra* (fig. 8), created in 1959, which are at the forefront of the changes that appear in his painting. Lam's art is revitalized and acquires a new vigor with a social dimension that inundates museums and galleries. His canvases vibrate in unison with the rebellious spirit of the planet's dispossessed; they are consonant with the decolonization movements of African countries and the human rights struggles of Latin American guerrillas fighting for the dignity of the peoples of America.

His artistic language is characterized by the predominance of stylized drawing, mostly in charcoal, on monochromatic backgrounds. Consequently, figures arise in which a return to African masks can be observed, as in *Les Enfants sans âme*, 1964 [64.18]. At times, figures seem to float in space searching for a sidereal dimension as in the case of *L'Indésirable*, 1962 [62.32]. In works such as *Les Invités* [66.09] and *El día de Todos los Santos* painted in 1966, forms are anchored at the borders of the composition in a choreo-graphic concept.

El tercer mundo (fig. 9) was conceived in 1965–66 with a bright intensity at year's end in Havana—as was his most famous painting *La Jungla* over twenty years earlier—and marks an important climatic moment of this set. This canvas, which was first titled *Pájaro Victoria*, constitutes, according to the artist himself "my artistic homage to the Cuban Revolution."[25] Alejo Carpentier qualified it as a "monumental painting, an extraordinary painting for its proportions and contents."[26] *El tercer mundo*'s canvas is invaded by figures contorted in an intense dynamism that constitutes a synthesis of Lam's iconographic universe. The expansive energy of the work is compensated by the horizontality of the central figure, whose extremities extend from one edge of the composition to the other. *El tercer mundo*, comparable to Picasso's *Guernica* for its dramatic force and powerful poetic image, possesses the capacity to shake consciences and rapidly became an indispensable emblem of the era. This great cycle closes in 1970 with an oil painting that summarizes the conquests achieved in the period: *Les Abalochas dansent pour Dhambala, dieu de l'unité* (fig. 10), perhaps his last great work.

Wifredo Lam, poet of the mythical, knew how to discover, in the wealth of cultures overlooked by the powerful, the

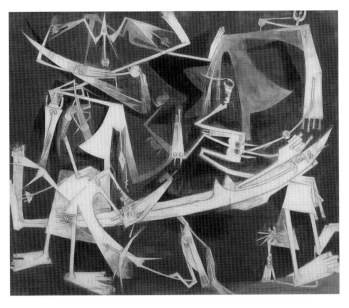

9. Wifredo Lam, *El tercer mundo*, c. 1965–66 [66.11]. Oil on canvas, 251 x 300 cm, Museo Nacional de Bellas Artes, Havana, 07.279.

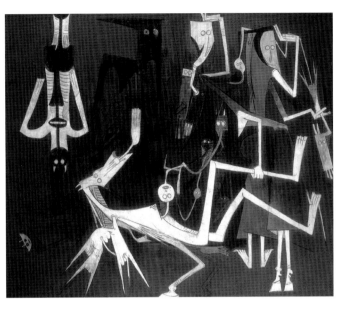

10. Wifredo Lam, *Les Abalochas dansent pour Dhambala, dieu de l'unité*, 1970 [70.72]. Oil on canvas, 213 x 244 cm, private collection.

energy that fed his own fire. He created, through his art, a bridge of unity that expanded understanding between men. The syncretic and integrating character of his work encouraged the development of a multicultural discourse in which he discovered how to reach all latitudes. Painting is the Esperanto of Lam because his art is nourished by the very essence of human knowledge. For this reason, his legacy maintains absolute applicability and today we identify him proudly as one of the few universal artists of the twentieth century.

Translated by Elizabeth T. Goizueta & Kate Shugert

Roberto Cobas Amate

1 Lydia Cabrera recognizes the situation when she points out that: "This 'authentic painter'—to use the phrase of Picasso…who we read about in modern painting exhibition catalogues together with Braque, Léger, Klee, Ernst, Miró, Gris, Chagall, Picasso…was a Cuban!" In Lydia Cabrera, "Un gran pintor: Wifredo Lam," literary supplement, *El Diario de la Marina* (May 17, 1942): 2.

2 Max-Pol Fouchet, *Wifredo Lam* (Barcelona: Ediciones Polígrafa, 1976), 183.

3 Ibid., 188.

4 Lydia Cabrera, *Cuentos negros de Cuba* (Havana: La Verónica), 1940. These stories were previously published in literary magazines in France such as *Cahiers du Sud*, *Revue de Paris*, and *Les Nouvelles Littéraires*.

5 Luz Merino Acosta has written an important valuation of this period included in "Mariano Rodríguez: La identidad del color," in *Mariano*, exh. cat. (Madrid: Centro Cultural Conde Duque, 1998), 17–29.

6 Gerardo Mosquera, "'Mi pintura es un acto de descolonización': Entrevista con Wifredo Lam," in *Exploraciones en la plástica cubana* (Havana: Letras Cubanas, 1983), 189.

7 Alejo Carpentier, "Reflexiones acerca de la pintura de Wifredo Lam," *Gaceta del Caribe*, July 1944, also published in Alejo Carpentier, *Conferencias* (Havana: Letras Cubanas, 1987), 226.

8 "Nuestra América" is the title of one of the most lucid political essays of the nineteenth century about the American continent, written by José Martí, the "Apostle of Cuban Independence."

9 Antonio Núñez Jiménez, *Wifredo Lam* (Havana: Letras Cubanas, 1982), 232.

10 Carpentier, upon his return to Cuba in 1943 from a trip to Haiti that profoundly influenced him, began to write *El reino de este mundo*, which he completed in Caracas in 1948. The prologue of this work, entitled "Lo real maravilloso de América," published in Caracas's *El Nacional* on Apr. 8, 1948, constitutes a fundamental text for the understanding of literature and art on the American continent. *El reino de este mundo* was first published in its entirety in 1949 in Mexico.

11 Carpentier severely judges surrealism when he proclaims: "after a magnificent trajectory of forty years it has became a factory of marvels" (*Conferencias*, 159).

12 Alejo Carpentier, prologue to *El reino de este mundo* (Havana: Letras Cubanas, 1987), 2.

13 Alejo Carpentier quoted by Araceli García-Carranza in *Bibliografía de Alejo Carpentier* (Havana: Letras Cubanas, 1984), 20.

14 Carpentier, *El reino de este mundo*, 3.

15 See Natalia Bolívar Aróstegui, *Los orishas en Cuba* (Havana: Ediciones Unión, 1990).

16 The Spanish surrealist painter Eugenio Granell, who resided permanently in Santo Domingo, wrote in 1949 with overwhelming admiration: "Everything indicates that the sea of the Antilles and its islands have a high destiny. Columbus did not exhaust the possibilities of his marvelous discovery: the Haitian priest Héctor Hyppolite, the Martinican poet Aimé Césaire, and the Cuban painter Wifredo Lam are three outstanding examples of this strange ability to discover the occult, revealing its power." Lucía García de Carpi, ed., *Eugenio Granell*, exh. cat. (Madrid: Fundación Mapfre, 1989), 244.

17 Fouchet, *Wifredo Lam*, 206.

18 Susana Martínez Garrido, ed., *André Breton y el surrealismo*, exh. cat. (Madrid: Museo Nacional Centro de Arte Reina Sofía, 1991), 359.

19 See Mirta Aguirre's critique on the exhibition of Lam, "Antillas en Wifredo Lam," *Hoy* (Apr. 14, 1946): 10.

20 Alejo Carpentier, "La pintura de Wifredo Lam," in *La cultura en Cuba y en el mundo* (Havana: Letras Cubanas, 2003), 115–21.

21 According to Helena Holzer, Lam's constant companion from 1939 and his wife between 1944 and 1951, the artist was frustrated as a result of a visit he made to France intent on reestablishing his residence in Paris during the second half of 1946. Circumstances forced him to return to Cuba, disillusioned, as Europe had not yet recovered from the ravages of war. See Helena Benitez, *Wifredo and Helena: My Life with Wifredo Lam, 1939–1950* (Lausanne: Sylvio Acatos, 1999).

22 Fouchet, *Wifredo Lam*, 204.

23 See Lázara Menéndez's "Un Eleguá para acercarse al cíclope," *Artecubano* 1 (2000): 72–79 for an important evaluation of the polysemic character of Lam's work.

24 Lam drew upon the artistic wealth of both Oceania and Africa for inspiration. On the other hand, Breton's passion was purely for the art of the Pacific Islands to the detriment of African art. According to Breton "Oceania is the greatest immemorial effort to interpret the physical and the mental" while about African art, he harshly expresses: "It is the art of farmers, hugging the ground." See Fouchet, *Wifredo Lam* and Martínez Garrido, *André Breton y el surrealismo* for expanded viewpoints on Lam and Breton.

25 Núñez Jiménez, *Wifredo Lam*, 217.

26 Carpentier, "La pintura de Wifredo Lam," 115–21.

MYSTERIUM TREMENDUM ET FASCINANS: THE PRE-THEISTIC ART OF WIFREDO LAM

Roberto S. Goizueta

SCHOLARS CONTINUE TO HAVE DIFFER-ing views on the role of religion in the works of Wifredo Lam. On one end of the interpretive spectrum are those who have discerned and emphasized the explicitly Afro-Cuban iconography (primarily that of Santería) in Lam's art.[1] At the other end of that spectrum are scholars who reject any such explicit identification and argue, instead, that Lam eschews any particular iconography in favor of a much more indefinite, inchoate, and hence universal religious poetics.[2] In this essay, I will propose that these interpretations be understood as interrelated rather than contradictory. I will suggest, conversely, that to absolutize either alternative is to reify the very (post)modern dichotomous epistemology—between the particular and the universal—that undermines the subversive character of Lam's aesthetic. Instead, I will propose that Lam's universalism is rooted in and mediated by an elemental, even if not fully developed, Afro-Cuban iconography; the universal as such does not exist except as made present in and through the particular. In other words, that iconography is what makes possible and gives expression to the deeper, "pre-iconic," "pre-theistic" sensibility (indeed the *pre*-iconic presupposes the iconic, as the *pre*-theistic presupposes the theistic). Interpreting Lam's work through the lens of (post)modern epistemologies that dichotomize the particular and the universal would undermine that art's subversive character. Such an interpretive strategy would reduce Lam's aesthetic either to an exoticized and hence marginalized "other" or to an abstract, deracinated universal incapable of resisting the very concrete forms of cultural, racial, and artistic domination.

The identification of Lam's art with Afro-Cuban religion has become almost commonplace. While not gainsaying its significance, however, any such identification is complicated by the fact that Lam was never an adept or practitioner of Santería. As Gerardo Mosquera notes, the Cuban painter's artistic retrieval of his own Afro-Cuban roots "always continued to be indebted to his academic training in Cuba and Spain, and his knowledge of the western classical tradition, to the epigonal methods of the Paris school and surrealism, to African geometrical figuration and, especially, to the direct influence of Picasso, Julio González, and Matisse."[3]

In this essay I will develop the argument that Lam's fundamental artistic concern is to give expression to a non-dualistic cosmology that, in turn, reveals what the Cuban anthropologist Fernando Ortiz calls a "pre-theistic" worldview.[4] More specifically, Lam's works evoke an experience of what the German theologian Rudolf Otto famously called "the numinous."[5] At the same time (and contra Ortiz), I will contend that such an evocation of the numinous is necessarily made possible by the symbolic elements in Lam's aesthetic, which are predominantly those of Afro-Cuban religion as mediated in the ways Mosquera notes above.

The alternative would be a purely abstract, conceptual universalism that could not provoke the kind of transformative reaction in the observer that Ortiz claims is produced by the art's universal character. We are moved not by a sunset, but by *this* sunset; not by a flower, but by *this* flower; not by the numinous, but by *this* manifestation of the numinous. What moves an observer is precisely the particular symbols. In the words of the Mexican philosopher José Vasconcelos: "The artist does not search for universals, the sculptor does not think of man [*sic*] in the abstract. [...] We know the failure of those sculptures which represent war or wisdom in the abstract, and the poor dramas which

in English are known as Everyman and Everywoman."[6] Or, again: "To know is to recognize the specific phenomenal activity that, in each case, reveals to us the Universe."[7] The power of any artistic work lies in its ability to convey (in Blake's felicitous phrase) "a world in a grain of sand and a heaven in a wild flower."[8] Universals may convince but they are powerless to convert; only the universal *in* the particular can move us to experience reality differently.

By proposing that Lam's syncretized Afro-Cuban particularity mediates a pre-theistic worldview, I will thus be arguing that it is universal *because* it is particular. Its universality is expressed in and through the Afro-Cuban, syncretic particularity of "a 'primitive'-modern cosmogony centered in the Caribbean, appropriating western methods of art and in the space opened by that art. He [Lam] stated clearly his strategy when he declared he was a 'Trojan horse.' Afro-American content thus penetrated the plastic arts of the West, setting off a battle to influence or be reified."[9] Ultimately, what Lam's religious aesthetic expresses is a non-dualistic cosmology that—in its Afro-Cuban syncretism—subverts the modern, Western, dichotomous worldview in which Lam himself was trained and which makes possible that very subversion.[10] In other words, Lam's pre-theistic worldview (as universal) is mediated by a retrieval of an Afro-Cuban cosmology (as particular), which retrieval is itself made possible by "the space opened by" Western art. The "space" to which Mosquera refers is the European surrealists' openness and attraction to Lam's Afro-Cuban roots. As long as that space was created and controlled by Western surrealists, however, Lam could only enter it as an exoticized "other" with little or nothing to say to modern European art itself; his art would be valued and admired *qua* particular and hence exotic (i.e., Afro-Cuban, Latin American, art of Santería). On the one hand, Lam would welcome the invitation to retrieve his roots. On the other hand, such a retrieval of his own particular roots would become for him, simultaneously, the means of expressing a universal, pre-theistic aesthetic—with inevitable implications beyond the context of Afro-Cuban Santería.

Sketch of a Phenomenology of Religion

If the religious character of Lam's corpus admits of divergent interpretations, even more contentious has been the history of the very term "religion." In considering whether Lam's art is pre-theistic or pre-iconic, therefore, it might be helpful to examine briefly what we mean by "religion." While that question has as many answers as there are scholars of religion, one helpful approach is that of phenomenology: What are some characteristics that, in one form or other, to one degree or other, seem to be shared across the spectrum of human phenomena we call "religions"? Of course, the very term "religion" is itself contested and presupposes the very dichotomy between the "religious" and the "secular" which Lam's work calls into question. Nevertheless, and admitting in advance that any such a phenomenological approach is inevitably limited and limiting, such an initial approach may still be helpful for heuristic purposes. With that caveat, I would propose a six-fold phenomenology of religion, that is, an analysis that focuses on six common characteristics: "non-empirical experience," symbols, narratives, rituals, beliefs, and ethics. In so doing, I will be drawing on the seminal work of Ninian Smart.[11]

What we call "religious experience" is not a distinct "experience" as such but simply a dimension of human experience, namely, that dimension of our common experience which we might call "non-empirical." As the adjective suggests, this term points to those aspects of our lives which we cannot understand or comprehend through merely empirical analysis, merely through the use of our five senses. Some common examples would be the experiences of death, birth, or falling in love. These are dimensions of human experience which we encounter as Mystery, as some reality beyond our ability to fully comprehend or control; here we are in the presence of something truly awe-some.

It is here that Ortiz's notion of the pre-theistic and Otto's notion of the numinous are rooted. What is most salient about non-empirical experience is that it is always an ambiguous, ambivalent experience. To use Otto's terminology, non-empirical experience is always both terrifying, or awe-some, and fascinating (*mysterium tremendum et*

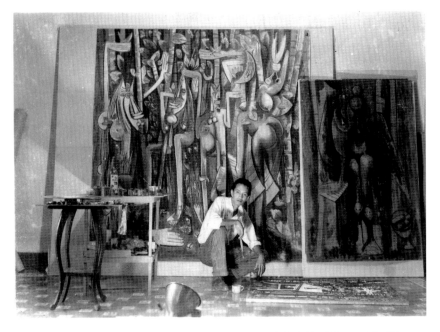

1. Wifredo Lam in front of *La Jungla*, 1942–43 [43.12] (l) and *Le Matin vert*, 1943 [43.10] (r) in his Havana studio, 1943. Paintings such as these "astonished" visitors to Lam's studio.

fascinans)—precisely *as* mystery, *as* non-empirical. In this sense, the theological notion of the numinous is analogous to the aesthetic notion of the sublime in that this latter "exhibits the same peculiar dual character as the numinous; it is at once daunting, and yet again singularly attracting, in its impress upon the mind. It humbles and at the same time exalts us, circumscribes and extends us beyond ourselves, on the one hand releasing in us a feeling analogous to fear, and on the other rejoicing us."[12] In his analyses of Lam's paintings, Ortiz likewise stresses the always ambiguous responses provoked by what he calls the pre-theistic dimension of experience expressed in the Cuban painter's work (fig. 1):

> Lam's work is not monotheistic, nor polytheistic, nor even pantheistic; its religious elements are *pretheistic*. […] They are the mystical dawning that precedes theogonies. It is the mysterious panic with its terrors and delights, but prior to pantheism. […] Two skittish young women who entered Lam's studio and saw some of his works left astonished. […] "They seem like spirits and things from the beyond," one commented. "I've seen this in dreams, the first time I had to sleep on the mountain," remembered another. A friend confesses to us: "I think

that those paintings have great, very profound meaning, but I can't describe it." Lam's is a primitivism not because of the chronology of his technique nor because of the nomenclature of his style in the history of art, but because of his atavistic themes and symbolism.[13]

While momentarily jerking us out of the humdrum of everyday existence, however, such fundamental ambiguity is ultimately intolerable in the long run; we cannot abide the insecurity, vulnerability, powerlessness, and incertitude that it implies, nor can we live day-to-day in a state of complete ambiguity. So we must try to reduce the ambiguity by objectifying the non-empirical experience, i.e., by making it *empirical*. In human communities, this objectification initially takes the form of rituals, symbols, and eventually narratives. By externalizing the experience and expressing it empirically (e.g., in religious objects, rites, devotions, music and dance, testimonies) we gain some measure of control over the experience, which we can now see, touch, and act out.

Yet even the symbol, narrative, and ritual that, in particular religions, will mediate this pre-theistic world remain ambiguous and not fully comprehensible. In the words of the philosopher Paul Ricoeur, then, "the symbol gives rise

to thought";[14] it compels us to ask "what does this *mean*?" Symbols, stories, and rituals demand interpretation and explanation. For instance, the meaning of the Christian ritual of the Eucharist and symbols of bread and wine remains ambiguous until it is articulated in the form of beliefs or doctrines, and explained by theology. Once we define and explain "what it means" we have reduced the ambiguity of the foundational non-empirical experience even further: "Oh, *that's* what we're doing when we gather around an altar to break bread and share the cup!"

Finally, however, the credibility of those beliefs and that theology still remains up in the air unless and until they are embodied in praxis, in human lives and actions: e.g., the Eucharistic symbols and ritual remain ambiguous until we see their meaning lived out in the actions of the participants, unless the ritual communion is translated into an actual, lived communion. So beliefs give rise to ethics: "If we claim to believe this, then we are called to behave in this manner." As the one who truly and most authentically embodies our beliefs, the saint or the holy person is the ultimate confirmation of the credibility of those beliefs and, thus, the one who most fully assuages our terror in the face of ambiguity.[15]

As mentioned above, this very cursory phenomenology of religion is meant to be more analytical and heuristic than explanatory. For instance, the fact that, for purposes of analysis, we might extract from the religious phenomenon something called "non-empirical experience"—as distinct from symbol, narrative, ritual, and ethics—should not be taken to imply that, in real life, we ever actually have "non-empirical experiences" in some pure form unmediated by symbols, narratives, rituals, and ethics. Because all human experiences are always, by definition, embodied they are always also mediated by empirical reality. Indeed, that is precisely what a religion is, namely, the sociohistorical objectification, embodiment, and institutionalization (through symbol, narrative, ritual, and ethics) of a community's non-empirical experience. As part of that community, one's experience will be mediated by those empirical particularities. So the phenomenological characteristics adumbrated above should not be read chronologically (e.g., *first* we have non-empirical experiences, *then* we express

these in symbols). We cannot access "the numinous" except in and through the symbols, rituals, narratives, etc., that we inherit from our religious traditions and communities. There is no universal experience of the numinous except in the particular forms of God, Allah, YHWH, Brahman, etc. Yet neither are these forms *absolutely* different.

This phenomenology of religion has at least three further implications. First, the purpose of any religion's symbols, narratives, rituals, and ethics is to reinforce, deepen, and enrich the believers' everyday encounters with the numinous. That is, religion is never an end in itself but a locus for believers' encounters with the numinous across generations. Conversely, when our fear of ambiguity is so strong that, instead, it blocks our access to that encounter by reducing religion *merely* to its empirical symbols, narratives, rituals, and ethics, religion devolves into idolatry (e.g., ritualism, dogmatism). We thus gain an illusory control and security by sacrificing an encounter with Mystery, which is always necessarily ambiguous and ambivalent. A second implication, then, is that the process of objectifying and externalizing non-empirical experience, the ambiguous encounter with Mystery, always circumscribes or delimits the ambiguity of that encounter. Thirdly, however, such circumscription is itself necessary for mediating the encounter. So religions themselves are ambiguous in that they are caught between the need to make Mystery present to a community, on the one hand, and the fact that, in order to satisfy that need, they demand an objectification of the encounter with Mystery, thereby necessarily delimiting and circumscribing the inherent ambiguity of that encounter.

It is this last point which is important as a corrective to a purely Ortizian reading of Lam. Namely, there *is no such "thing"* as pre-theistic art that is not simultaneously religious in some specific, even if inchoate sense; there is no such thing as *a* universal experience of the numinous that is not mediated by particular religious symbols, even if these are only suggestive. Thus, a truly "pre-iconic" or "universal" spirituality or mysticism is an intellectualist illusion. At the same time, however, all iconography or symbology gives expression to and, indeed, makes present that encounter with the numinous which is the ground of particular religions.

Lam's Art as Universal

When Ortiz suggests that, as pre-theistic, Lam's symbolic world remains embryonic, he is proposing that—within the phenomenological schematic above—Lam's symbolism emerges between the first and second stages, that is, between the foundational experience of the numinous and the first attempts at objectification represented by symbols themselves:

> At times one perceives in Lam some isolated or fragmentary designs that move us to think of supernatural beings because of their signification; similar to how in churches, for example, an eagle's head with a halo reminds us of John the Evangelist. […] We guess that a painting of Lam's could be titled *Ogun*, the warrior god of the Yorubas, and the author agreed; nevertheless, in the painting there was no image of a warrior. Afro-Cuban Santería represents him as a crusader fighting on horseback like the Santiago Matamoros [St. James the Moor-Slayer] of the Spaniards. […] Lam simplifies his allegorism even more; in his evolution of *Ogun* there is only the trace of a sharp knife, sign of war, between schematic lines of an undefined preternatural being, spots of bright red, that hint at the idea of blood, and shadows of mystery.[16]

Lam's aesthetic world, he argues, is not yet the world of religious symbol and ritual. It is a world straining to give expression to the numinous, but still beholden to and rooted in the fundamental ambiguity and ambivalence of that world of light and darkness, life and death, terror and ecstasy.

Gerardo Mosquera agrees that any symbolism in Lam's works is only suggestive and not well defined:

> Reference to Afro-Cuban imagery is very indirect. Almost no element is identifiable; even when the titles of the works refer to specific gods and their altars, they would remain unrecognizable even to the most erudite believer, since reinvention prevails over description. Lam's symbolism is very open; he himself has said: "I am not given to making use of exact symbology."[17]

Argeliers León, a friend of the painter and himself a noted Cuban ethnomusicologist, similarly proposed that "Lam's interest in these figures [of Santería] was more *anecdotal* than representative."[18] Ortiz (who first popularized the term "Afro-Cuban") observes that "Lam does not copy the African masks that he examined in museums, nor has he even seen those which regularly appear in certain Cuban liturgical dances, nor does he try to capture their fantastic morphology; but, in his own way, he imagines and paints the invisible and conceptual which those try to represent."[19]

Lam is not interested in any particular tradition of religious symbolism as such, suggests Ortiz, the artist wants to go deeper, to the pre-symbolic or pre-iconic. The Cuban anthropologist argues that, in Lam's work, "no image is defined or complete; his representations are clearly not amorphous, yet they are only inchoate."[20] "Lam's symbology," he writes, "is even more primitive [than that of the Santería deities]; in the merely animistic and pre-iconic phase of the ontology of mystery, when the forces of nature or the passions are represented."[21] Lam himself echoed these thoughts in comments he made concerning his masterpiece *Le Présent éternel* (fig. 2):

> In the upper right-hand corner of *The Eternal Present* I placed the symbol of Shango, the god of thunder. This is exceptional in my painting, for I do not usually employ a specific symbology. I have never created my pictures in terms of a symbolic tradition, but always on the basis of a poetic excitation.[22]

Ortiz thus locates Lam's religious aesthetic in the liminal in-between, for his aesthetic "is not magic, which commands and demands, nor religion, which pleads and obeys."[23] Lam's liminal aesthetic is to iconography what poetry is to narrative. Just as his art is not iconic, neither is it narratival.[24] Even the representational icon and the narrative are too detached from the non-empirical reality in which they are born and manifested.

Ortiz suggests that, while the natural human tendency is to repress or resolve the ambiguity of the numinous, Lam

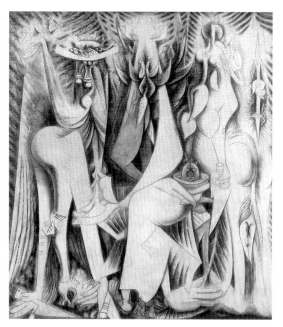

2. Wifredo Lam, *Le Présent éternel*, 1944 [44.04]. Oil on canvas, 215.9 x 196.9 cm, Museum of Art, Rhode Island School of Design, 66.154.

3. Wifredo Lam in front of *Bélial, empereur des mouches*, 1948 [48.11], with orisha at left.

never does. Yet Lam's work never wallows in ambiguity either, so his art is never depressing or paralyzing. Ortiz observes that:

> Despite his visions of the "terrifying mystery," as Otto would say, Lam's art, though serious, is not somber…Lam's marvelous metaphysic reflects the kindnesses and hopes of mystery more than its cruelties and despair. […] Lam's art is optimistic, benevolent, euphoric. It is philanthropic. Aimé Césaire, the Martinican poet, perceives in him a "spirit of creation." […] Even in his most disconcerting and pathetic paintings, there is almost always an affirmation of vitality. […] Lam's muses are those of mystery, but in this he always discovers a light, an eye, a germinal element, a living soul, even though it be a *lonely soul* that in the fires of purgatory suffers, knows…loves…and awaits an assured glory.[25]

No, Lam does not despair in the face of Mystery, with its irreducible ambiguities. Rather, he recognizes in those ambiguities the very wellspring of all authentic life, the very character of all created existence.

Lam's artistic voice is never univocal; it is, in his own words, a "poetic excitation." Indeed, such a poetic vision alone can give expression to the always ambiguous, syncretic character of the numinous: "The cosmic mystery, at once pain and joy; menace that terrifies and confidence that empowers on life's journey."[26] It is in this both/and, this in between terror and wonder that poetry, art, and—I would argue—religion are born. Lam's Elegguás (like the Santería deity itself, see plate 35 for an example) are never just innocent but also devilish, and the picaresque Elegguás are often accompanied by dragons (e.g., in *L'Ascension*, 1947 [plate 43] and *Composition*, 1970 [plate 66]). With its illuminated, upturned palm that descends into the dark world of Elegguás and dragons, this latter painting consoles even as it disturbs.

Lam's art emerges at the crossroads of terror and fascination, death and life, light and darkness, as a testament to the hope that it is precisely at those crossroads—in the interstices of created existence—that true life will emerge. Rather than fearing ambiguity, Lam refuses to tame its intrinsic "otherness" (as all particular religions inevitably do, to one or another degree). The power of the numinous, as the foundation of religion, derives not only from its inherent ambiguity but also from its "otherness," not only as transcending the subject's control or comprehension but also as transcending the very self. Lam's art moves beyond intra-psychic surrealism, beyond the "personal

unconscious" to the evocation of a cosmic "metaphysical power."[27] It emerges at the crossroads of the self and the cosmic Other. "While the Surrealists held that the spiritual world was part of the unconscious," writes Julia Herzberg, "to the Afro-Cuban, the spiritual world was part of everyday reality."[28]

Lam's Art as Particular

Yet it is precisely at the crossroads of the self and the Other that the necessity of symbolic mediation arises, since Mystery remains inaccessible except in and through corporeality, i.e., symbols and rituals at the very least. As absolutely incommunicable, absolute ambiguity would likewise be absolutely inaccessible; hence the inescapable need for symbol and ritual, even if these also inevitably delimit the experience of the numinous. To suppose that there can be some universal experience of the numinous is to make the mistake of reading the above phenomenological characteristics of religion chronologically, as if there could be some purely non-empirical experience that is not yet mediated empirically. Moreover, any absolute ambiguity would undermine the possibility of resistance; in the words of Terry Eagleton: "It is unwise to assume that ambiguity, indeterminacy, and undecidability are always subversive strikes against an arrogantly monological certitude; on the contrary, they are the stock-in-trade of many a juridical enquiry and official investigation."[29] Likewise, the most abstract, ambiguous art hangs on the walls of many an office building on Wall Street and Madison Avenue; sheer ambiguity is by no means necessarily revolutionary. One must thus attend to the concrete particularity of the numinous as this is expressed in Lam's works.

It is significant that, when one does encounter specific religious symbols in Lam's work, by far the most prevalent is that of Elegguá, the Santería god of the crossroads, the deity who transgresses borders. In *Le Sombre Malembo, Dieu du carrefour*, 1943 (plate 30) for instance, the crossroads (*carrefour*) are expressed by the intersecting vertical and horizontal figures, the polymorphic vegetal-animal-human figures, and the ubiquitous small, round heads with horns and wide-open eyes symbolizing Elegguá, an orisha who guards the crossroads between the natural and supernatural worlds. In the pantheon of Santería orishas (fig. 3),

Elegguá is precisely the guardian of the border between the natural world of the concrete particular and the supernatural world of the universal numinous. In other words, Elegguá is the deity who makes the universal present in the particular, thereby making possible an encounter with the numinous. Without Elegguá, the numinous would remain inaccessible because absolutely ambiguous.

Likewise, Lam's repeated use of the term *L'Annonciation* as a title is not coincidental (or so one might surmise). In 1944, he produced a painting with that title (plate 32) and, at about the same time, a similarly titled drawing. Then, in 1969, Lam produced a series of etchings that he later entitled *Annonciation*. Martinican poet Aimé Césaire, inspired by the drawings and in direct collaboration with Lam, wrote ten poems that were published with seven of the etchings in 1982 (plates 56–64).[30] Few Christian symbols express the character of the numinous as transgressing borders as powerfully as does the Annunciation. More precisely, the border transgressed here is that between the supernatural and the natural, i.e., between the universal and the particular:

> And the angel said to her, "Do not be afraid, Mary, for you have found favor with God. And behold, you will conceive in your womb and bear a son, and you shall call his name Jesus. He will be great and will be called the Son of the Most High. And the Lord God will give to him the throne of his father David, and he will reign over the house of Jacob forever, and of his kingdom there will be no end." And Mary said to the angel, "How will this be, since I am a virgin?" And the angel answered her, "The Holy Spirit will come upon you, and the power of the Most High will overshadow you; therefore the child to be born will be called holy—the Son of God." (Lk 1:30–35)

The numinous is made present in and through a specific baby born to a specific young Jewish girl at a specific time and place more than two millennia ago. Here, the angel Gabriel's function is analogous to that of Elegguá: the angel is the messenger that transgresses the border between the supernatural order and the natural order. Moreover, the

message delivered is that, henceforth, these orders will no longer remain in mutual isolation, but will be intimately united; henceforth we will know what the universal God looks like, by looking at God's particular manifestation in Jesus.

In his 1944 *L'Annonciation* the upside-down Eleggúa figures are now depicted with wings, signifying their syncretistic association with the angel Gabriel. And the praying woman is overwhelmed by an explosion of Eleggúa-angels, she herself taking on a winged appearance. Interrupting the overall ecstatic character of the scene, however, are those suggestive, if troubling, knives, swords, and horns so typical of Lam's works (allusions, perhaps, to the warrior Oggun, the hunter Ochosi, or other orishas, or maybe to the traditional Christian symbol of the horned Devil?).[31] The humorous-looking winged Eleggúa still shows its horns as if to remind us that this trans-border encounter with the supernatural—this message from another world—is not just "good" news; this encounter will make difficult demands and will disrupt and rupture our world ("I have not come to bring peace but a sword." Mt 10:34). The encounter with the supernatural—now no longer "outside" history but part of the warp and weft of everyday reality—is never without its awe-some, terrifying aspect. Even the overwhelming joy of birth is itself already the portent of death.

Lam's Annunciation works are powerful examples of precisely what he meant when he claimed that his art was a "Trojan horse." The subversive character of these works lies in the tension between the Christian title and the Afro-Cuban (Eleggúa) and syncretic iconography. What is ostensibly a Christian symbol is subverted, or de-centered when it is mediated by non-Christian symbols. (The same might be said of his 1947 *L'Ascension* [plate 43], another Christian-titled work.) In this sense, Lam's Annunciation works are examples of the same decolonization strategy that is exemplified by Santería itself, where ostensibly Christian saints are transformed by their association with orishas.

A similarly subversive transgression of borders, in this case between the eternal (universal) and the temporal (particular), is reflected in Lam's 1944 *Le Présent éternel* (fig.

2). Here again the supernatural, in the form of suggestive shapes that are at once wings and sharp knives, erupts into a world of rounded, protuberant vegetal-human life forms. Lam spoke of the painting as evoking "cross-breeding"—not just between races, one might add, but between species and spheres of reality.[32] The Changó figure suggested in the upper right-hand corner penetrates this fructiferous, hybrid world where, once again, we find Eleggúa peering out with eyes that simultaneously invite and menace. And, of course, the very title of this masterpiece suggests ambiguity and the transgression of borders. Here *chronos* becomes *kairos* as eternity peers out, like Eleggúa, from the depths of time itself. Yet what makes *kairos* accessible is precisely its manifestation in *chronos*; the present is but a manifestation of the eternal, but the eternal remains inaccessible without the present.

Finally, one cannot simply assume that, if there are relatively few examples of explicitly depicted orishas in Lam's work, this means that there are no religious symbols in Lam's work; symbols that are not fully developed are still symbols. One scholar whose interpretation of Lam's work has emphasized its specifically Afro-Cuban character is Julia Herzberg, who traces what she considers specific representations of orishas in Lam's paintings.[33] What Ortiz and Mosquera interpret to be merely suggestions of or allusions to Santería deities Herzberg perceives to be explicit representations. So, for instance, is the appearance of a royal palm or a ceiba tree in a Lam painting a reference to a specific deity? Herzberg thinks so: "Who in Cuba is unaware that Chango dwells in the royal palm or that Ogun prefers the ceiba tree?"[34] The question remains merely rhetorical however (as Herzberg clearly intends it) only if one assumes that Lam intended his paintings to be viewed only by Cubans, or, for that matter, if the royal palm and ceiba tree can only symbolize Changó and Oggun to the exclusion of other, less specific experiences of the numinous, e.g., beauty, warmth, fruitfulness. Ortiz and Mosquera would interpret such symbols less explicitly, preferring to see them as mere suggestions of the numinous rather than actual representations or symbolizations of the Sacred.

Agreeing with both Herzberg and Ortiz/Mosquera, I

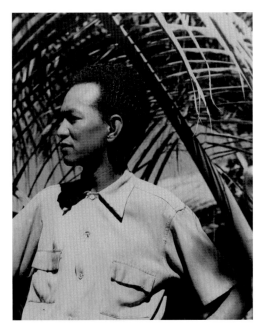

4. Wifredo Lam in Cuba, c. 1944.

would argue that Lam's works tap into universal experiences of the numinous (e.g., beauty) precisely because they are rooted in a particular syncretic, if idiosyncratic, Afro-Cuban worldview. In other words, the fact that practitioners of Santería associate Changó with the royal palm and Oggun with the ceiba tree is not coincidental; these are not arbitrary associations. (Analogously, the Christian association of bread and wine with the life-giving body and blood of Christ is not arbitrary; bread and wine have a significance beyond their explicitly Christian symbolization.) An ax or machete may indeed symbolize Oggun or Changó, but the former also evoke profound dimensions of universal human experience such as conflict, fear, violence, or creativity. It then comes as no surprise that, within the Santería cosmology, Oggun and Changó likewise evoke those experiences.

The power of Lam's art derives from its rootedness in a particular symbolic world. Like all great art, however, Lam's works never stray far from their roots in non-empirical experience, in the numinous or Sacred ground of existence. With the exception of Elegguá (who, as deity of the crossroads, has singular significance for Lam), the Cuban artist resists explicit references to deities for the same reason that many religions resist or prohibit explicit depictions of or references to the Sacred. Whether in the

form of names (in Judaism, YHWH) or images (in Islam, the Prophet), such explicit symbolizations inevitably circumscribe Mystery and limit the ambiguity of numinous experience—and hence its power. The necessary communication of that experience, however, demands *some* externalization or objectification. Lam discovers the rudiments of such an elemental symbolism in Santería without simply depicting the deities themselves—thereby domesticating their power by attempting to objectify the unobjectifiable. Indeed, Lam rarely depicts *anything* explicitly: a woman is represented by a breast or buttocks, a horse by a horse's head, a bird by wings, a palm tree by palm fronds, and all of these intermingled to create hybrid realities (fig. 4). Such an iconography—suggestive, elemental, allusive, and incipient rather than explicit, representative, and well-defined—makes possible a communication of the numinous at a "universal" level without thereby resolving its ambiguity any more than is necessary by the very act of communication itself.

The spiritual power of Lam's art derives from Lam's refusal to resolve prematurely the inherent ambiguity of the *mysterium tremendum et fascinans* expressed in his works. He succeeds because, to communicate that terrifying/fascinating reality, he likewise refuses to accept the modern dichotomy between particularity and universality, between

5. Wifredo Lam, c. 1971.

his own particular context ("a 'primitive'-modern cosmog-
ony centered in the Caribbean, appropriating western
methods of art and in the space opened by that art"[35]) and
the universal intentions of his art. Wifredo Lam is a uni-
versal artist because he is an Afro-Cuban, Latin American
artist (fig. 5). His art is pre-theistic because it is inspired by
Afro-Cuban religion. Lam's art is transcendent because it
embraces the tensions inherent in our very humanity.

1 See, e.g., Julia P. Herzberg, "Rereading Lam," in *Santería Aesthetics in Contemporary Latin American Art*, ed. Arturo Lindsay (Washington, DC: Smithsonian Institution Press, 1996), 149–69.

2 Perhaps the preeminent example is Fernando Ortiz; see the citations below.

3 Gerardo Mosquera, "Elegguá at the (Post?) Modern Crossroads: The Presence of Africa in the Visual Art of Cuba," in Lindsay, *Santería Aesthetics*, 229.

4 His aesthetic interest in cosmology distinguishes Lam's work from most European surrealism, which is fundamentally psychological, or oneiric, rather than cosmological. See Roberto González Echevarría's distinction between the phenomenological aesthetics of the German Franz Roh and the ontological magical realism of the Cuban Alejo Carpentier, in González Echevarría, *Alejo Carpentier: The Pilgrim at Home* (Ithaca: Cornell University Press, 1977).

5 Rudolf Otto, *The Idea of the Holy: An Inquiry into the Non-Rational Factor in the Idea of the Divine and Its Relation to the Rational*, trans. John W. Harvey (London: Oxford University Press, 1950).

6 José Vasconcelos, *Obras Completas*, 4 vols. (Distrito Federal: Libreros Mexicanos Unidos, 1958–61), 3:1321–22. Unless otherwise noted, all translations are my own.

7 Ibid., 4:888.

8 William Blake, *Blake: The Complete Poems*, ed. W. H. Stevenson (London: Longman, 1989), 589.

9 Mosquera, "(Post?)Modern Crossroads," 231.

10 Surrealism also subverts the modern dichotomous worldview, hence the surrealists' attraction to African and non-Western aesthetics. It is no coincidence, then, that Lam would be drawn to both Afro-Cuban cosmologies and surrealism. Indeed, Lam's syncretic integration of both is itself made possible by and presupposes such non-dualism. While an analysis of surrealism as non-dualistic is beyond the scope of this paper, I would call the reader's attention to Claude Cernuschi's rigorous and detailed analysis of such influences in his essay on Lam in this volume.

11 Ninian Smart, *Dimensions of the Sacred: An Anatomy of the World's Beliefs* (Berkeley: University of California Press, 1999) and *The Religious Experience* (Upper Saddle River: Prentice Hall, 1996).

12 Otto, *Idea of the Holy*, 42.

13 Fernando Ortiz, *Visiones sobre Lam* (Havana: Fundación Fernando Ortiz, 2002), 24–25. Max-Pol Fouchet also cites Lam relaying "When I was painting it [*The Jungle*] the doors and windows of my studio were open. And the passers-by could see it. They used to shout to each other: 'Don't look, it's the Devil!'" Max-Pol Fouchet, *Wifredo Lam*, trans. Kenneth Lyons (Barcelona: Ediciones Polígrafa, 1986), 32.

14 Roberto S. Goizueta, *Christ Our Companion: Toward a Theological Aesthetics of Liberation* (Maryknoll: Orbis Books, 2009); Hans Urs von Balthasar, *Love Alone Is Credible* (San Francisco: Ignatius Press, 2005).

15 Ricoeur quoted in David Tracy, *The Analogical Imagination: Christian Theology and the Culture of Pluralism* (New York: Crossroad, 1981), 13

16 Ortiz, *Visiones sobre Lam*, 22.

17 Mosquera, "(Post?)Modern Crossroads," 231.

18 León in Ortiz, *Visiones sobre Lam*, ix (emphasis in the original).

19 Ortiz, *Visiones sobre Lam*, 20.

20 Ibid., 22.

21 Ibid.

22 Quoted in Fouchet, *Wifredo Lam*, 34.

23 Ortiz, *Visiones sobre Lam*, 21.

24 I owe this insight to Roberto Cobas Amate of the Museo Nacional de Bellas Artes, Havana.

25 Ortiz, *Visiones sobre Lam*, 30–31.

26 Ibid., 21.

27 Ricardo Pau-Llosa, *Rafael Soriano and the Poetics of Light* (Coral Gables: Editorial Concepts, 1998), 13.

28 Herzberg, "Rereading Lam," 150–51.

29 Terry Eagleton, *The Ideology of the Aesthetic* (Oxford: Wiley-Blackwell, 1990), 379–80.

30 Eskil Lam and Dominique Tonneau-Ryckelynck, eds., *Wifredo Lam: Catalogue Raisonné; Prints Estampes Grafica* 版画 (Paris: Éditions Hervé Chopin, forthcoming). See also Elizabeth T. Goizueta, "Wifredo Lam's Poetic Imagination and the Spanish Baroque," 17–18, 20n101 for more on the *Annonciation*.

31 See Herzberg, "Rereading Lam," 159–60.

32 Lowery Stokes Sims, *Wifredo Lam and the International Avant-Garde, 1923–1982* (Austin: University of Texas Press, 2002), 57.

33 See especially Herzberg, "Rereading Lam" and Herzberg, "Wifredo Lam," in *Wifredo Lam: La cosecha de un brujo*, ed. José Manuel Noceda (Havana: Letras Cubanas, 2002), 344–64.

34 Herzberg, "Wifredo Lam," 350.

35 Mosquera, "(Post?)Modern Crossroads," 231.

WORKS IN THE EXHIBITION

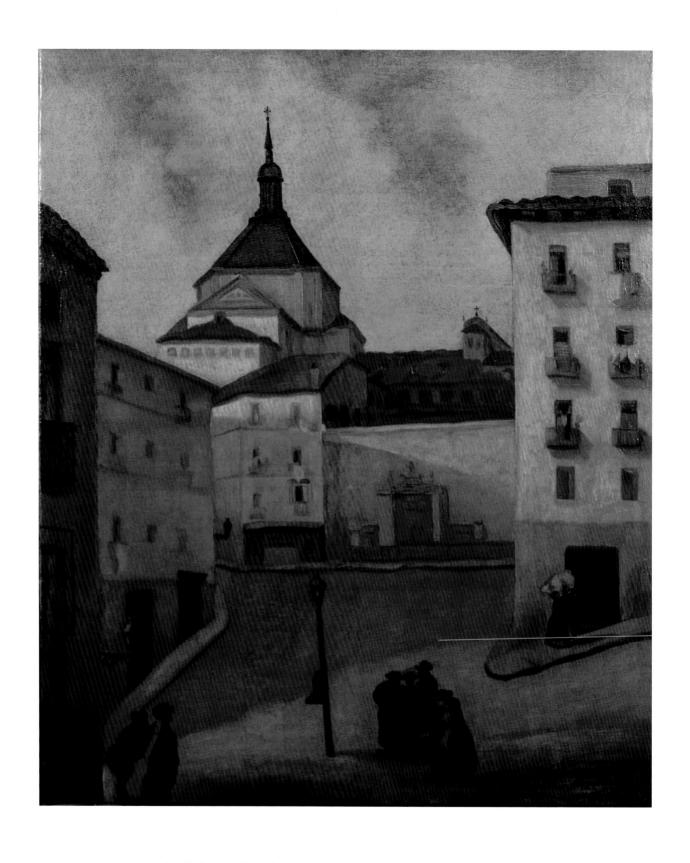

1. *Plaza de Segovia, Madrid,* **1923** [23.03]

Oil on canvas, 86 x 73 cm
Private collection

2. *Campesino [El Abuelo Joaquin] [Paysan de Castille]*, 1926 [D-26.05]

Pencil on paper, 59 x 45 cm
Private collection

3. *Campesina Castellana*, 1927 [D-27.01]

Pencil on paper, 60 x 50 cm
Private collection

4. *Bodegón, II,* 1927 [27.02]

Oil on canvas, 60 x 80 cm
Rudman Collection

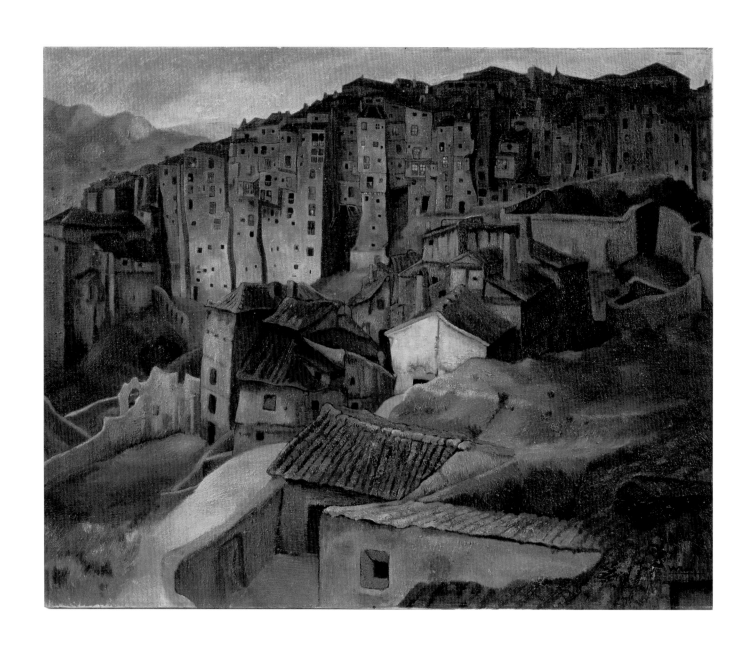

5. *Casas Colgadas, III [Paisaje de Cuenca]*, 1927 [27.11]

Oil on canvas, 94 x 118 cm
Rudman Collection

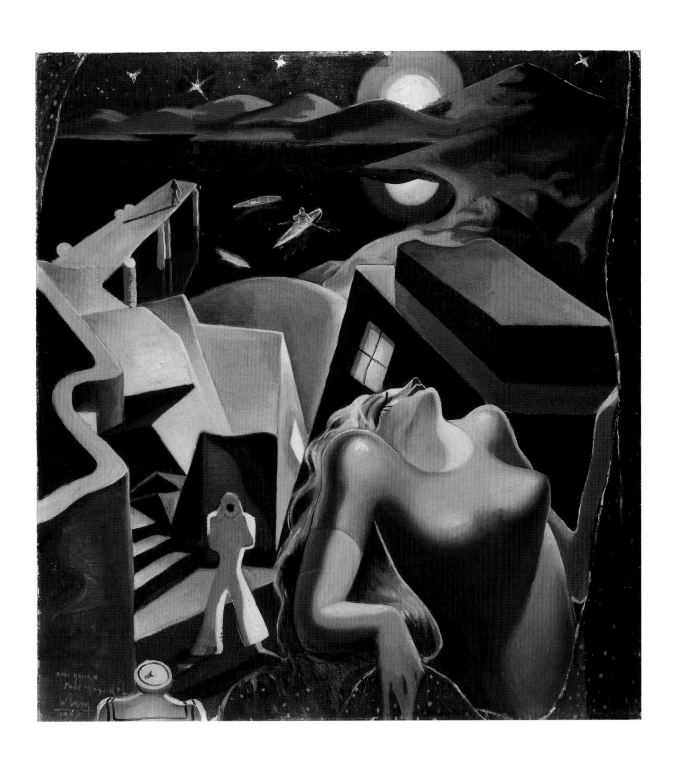

6. *Composición, I*, 1930 [30.02]

Oil on canvas, 80 x 75 cm
Private collection

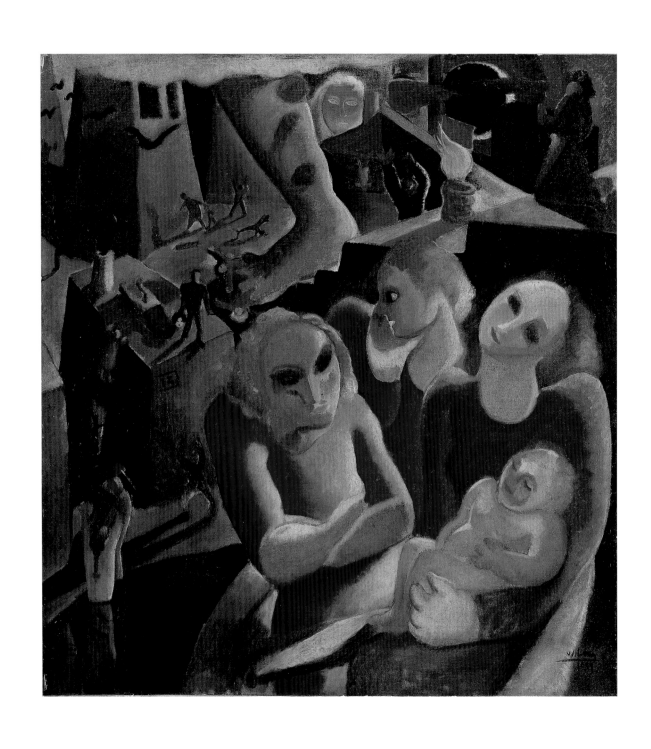

7. *Composición, II*, 1931 [31.01]

Oil on canvas, 76 x 70 cm
Rudman Collection

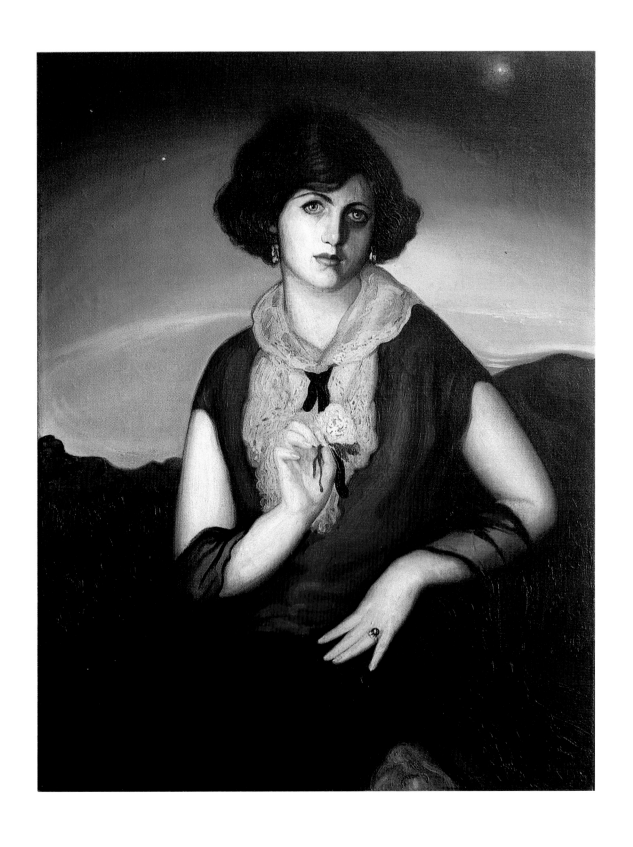

8. *Untitled*, 1931 [31.06]

Oil on canvas, 100 x 77 cm
Ramón and Nercys Cernuda Collection

9. *[Retrato de Adel Bina]*, **1933** [33.08]

Oil on canvas, 38 x 48 cm
Rudman Collection

10. *La Ventana, I,* **1935** [35.02]

Oil on canvas, 96 x 84 cm
Pérez Art Museum Miami, partial and promised gift of Jorge M. Pérez

11. *Untitled*, **1937** [37.20]

Gouache on paper (reverse of plate 12), 97 x 130 cm
Private collection

12. *Untitled*, 1937 [37.21]
Gouache on paper (reverse of plate 11), 130 x 97 cm
Private collection

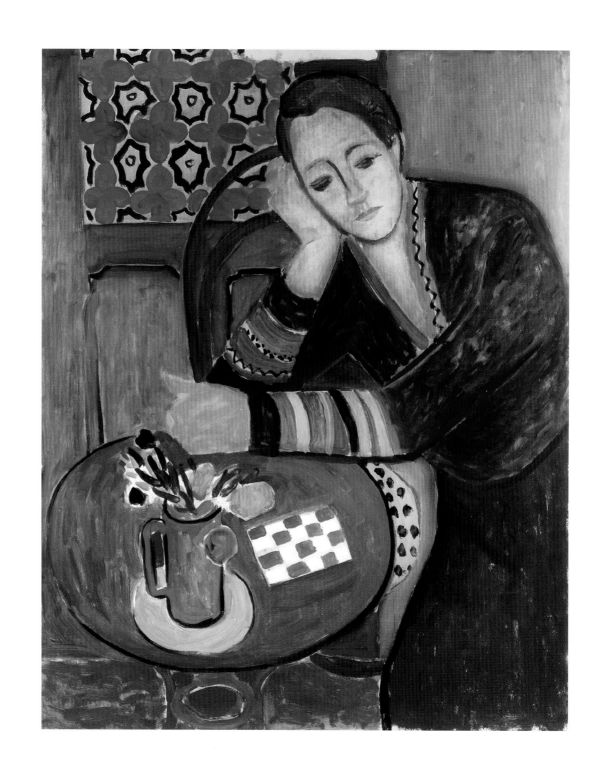

13. *[Retrato de la Sra. García de Castro, II]*, **1937** [37.31]

Oil on canvas, 100 x 80 cm
Rudman Collection

14. *Le Repos du modèle [Nu]*, **1938** [38.76]

Tempera on paper mounted on canvas, 146 x 155 cm
Private collection

15. *Figure*, 1939 [39.23]

Oil on wood panel, 107 x 63 cm
Jacques Herold Collection

16. *Nature morte [La Table blanche]*, **1939** [39.34]

Gouache on paper mounted on canvas, 100 x 70 cm
Pérez Art Museum Miami, partial and promised gift of Jorge M. Pérez

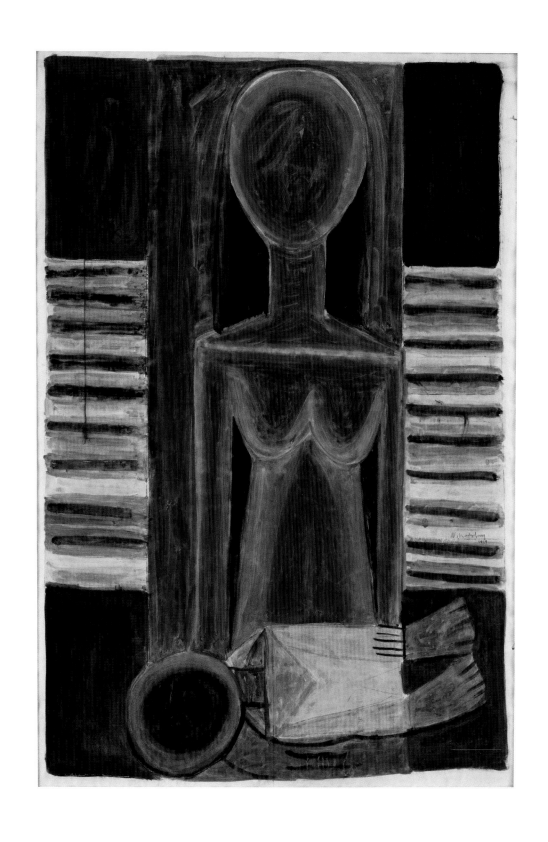

17. *Mère et enfant, II*, 1939 [39.36]

Gouache on paper, 106.5 x 74.9 cm
Museum of Modern Art, New York, 652.1939

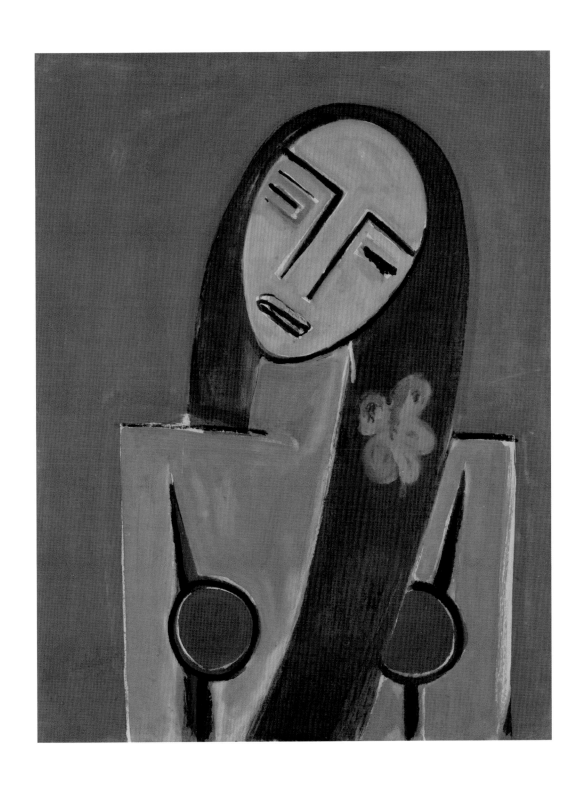

18. *Femme*, 1939 [39.48]

Oil on cardboard, 64 x 50 cm
Rudman Collection

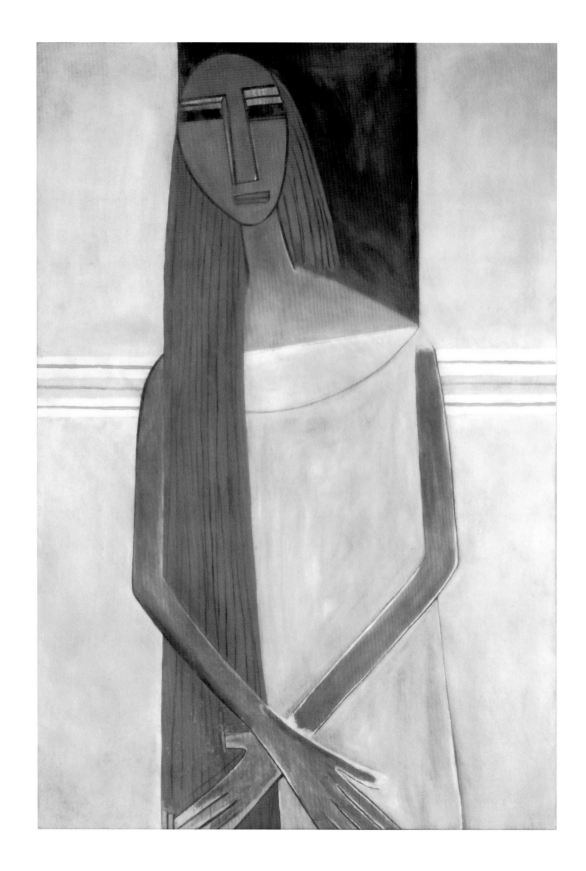

19. *Untitled*, **c. 1939** [39.49]

Oil on canvas, 114.9 x 80 cm
Rudman Collection

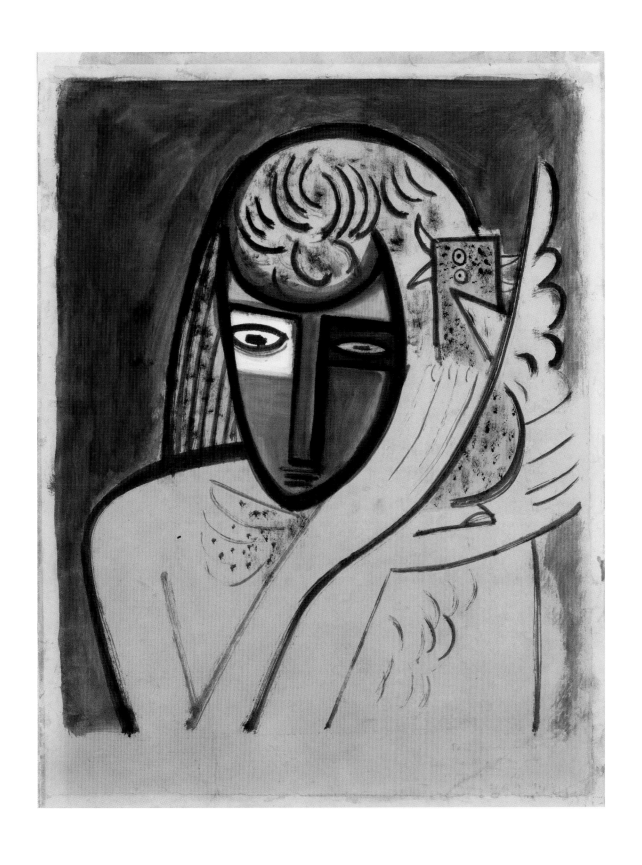

20. *Untitled*, c. **1940** [40.27]

Gouache on paper, 60 x 48 cm
Private collection

21. *Untitled*, **1943** [D-43.22]

Wood, paper, pigment, 26.7 x 47.5 cm
Private collection

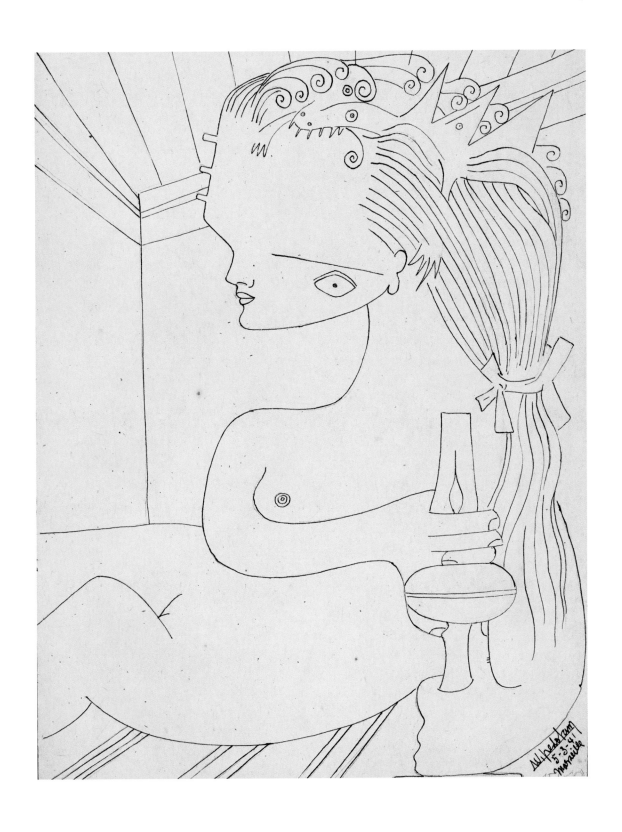

22. *[Portrait d'Helena], Carnets de Marseille,* **1941** [DM-41.53]

Pencil and ink on paper, 22 x 17 cm
Private collection

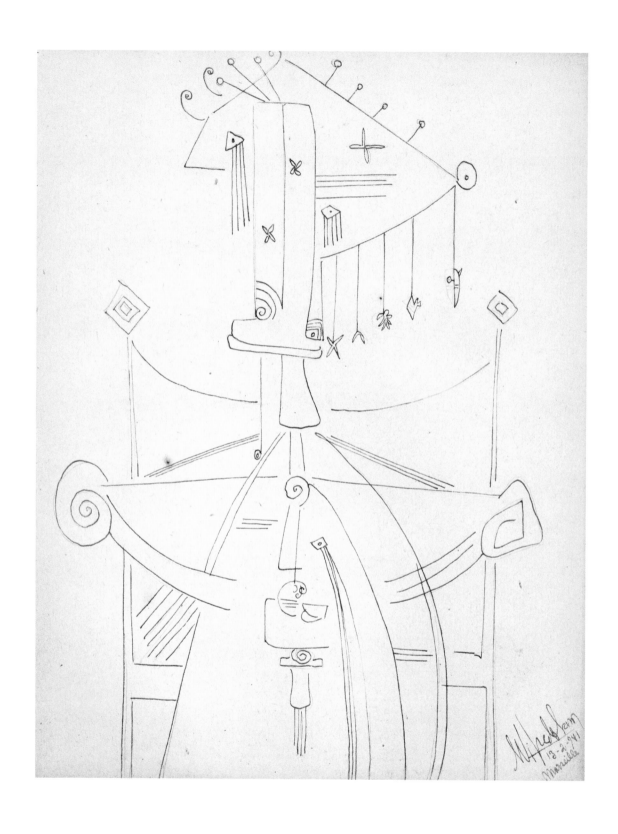

23. *[Personnage assis]*, *Carnets de Marseille*, **1941** [DM-41.04]

Pencil and ink on paper, 22 x 17 cm
Private collection

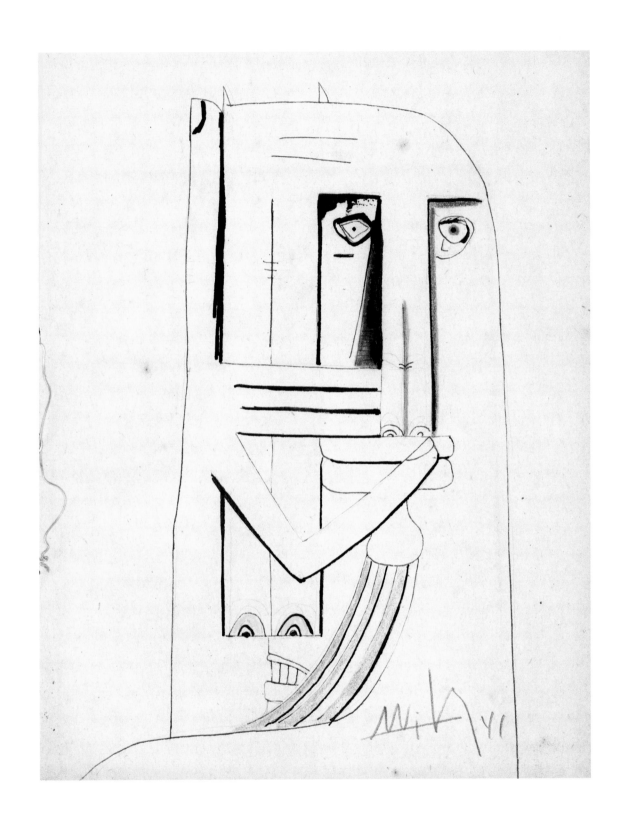

24. *[Tête], Carnets de Marseille,* **1941** [DM-41.64]

Pencil, pastels, and ink on paper, 22 x 17 cm
Private collection

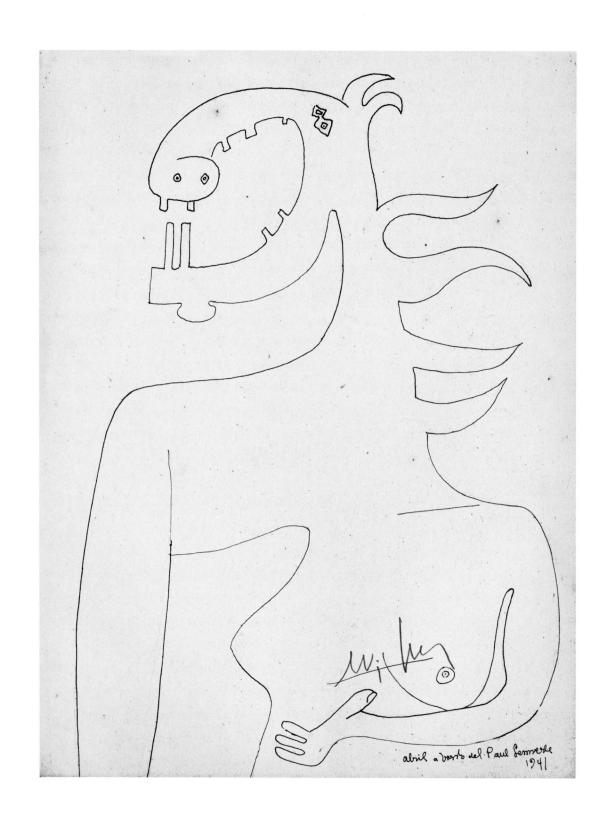

25. *[Personnage], Carnets de Marseille,* 1941 [DM-41.77]

Pencil and ink on paper, 22 x 17 cm
Private collection

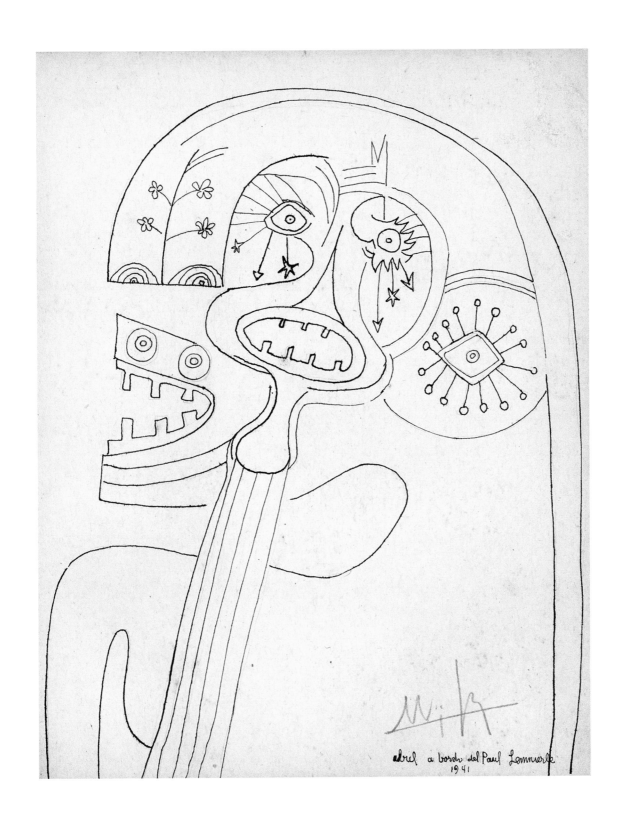

26. *[Personnage], Carnets de Marseille, 1941* [DM-41.80]

Pencil and ink on paper, 22 x 17 cm
Private collection

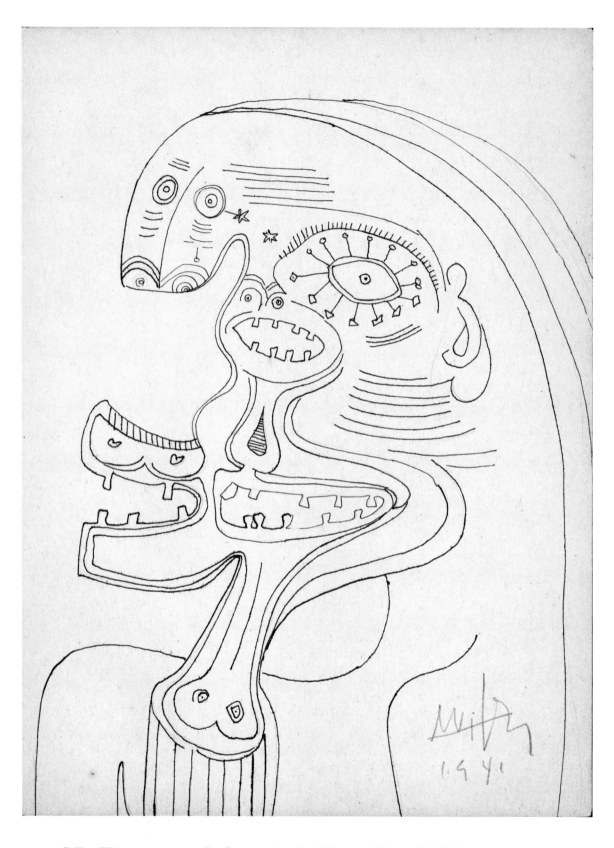

27. *[Personnage], Carnets de Marseille*, **1941** [DM-41.81]

Pencil and ink on paper, 22 x 17 cm
Private collection

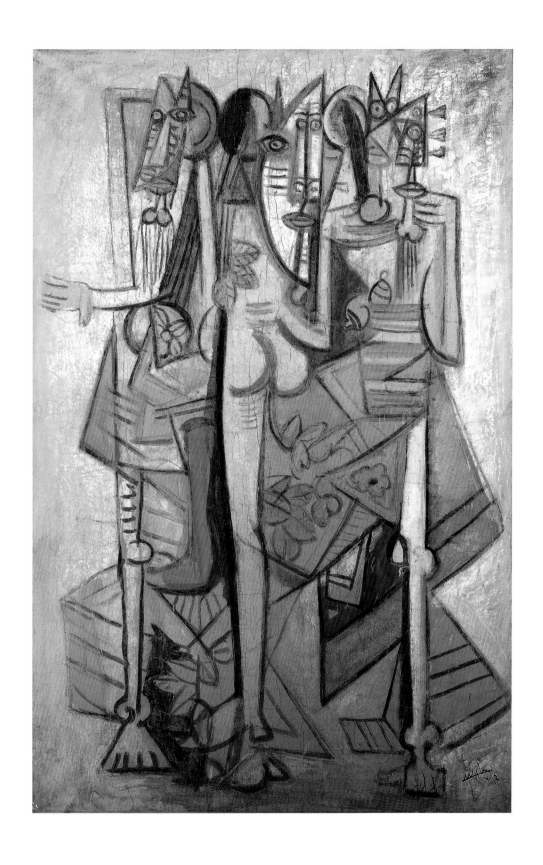

28. *La Réunion [Groupe]*, 1942 [42.101]

Tempera on paper mounted on canvas, 180 x 120 cm
Private collection

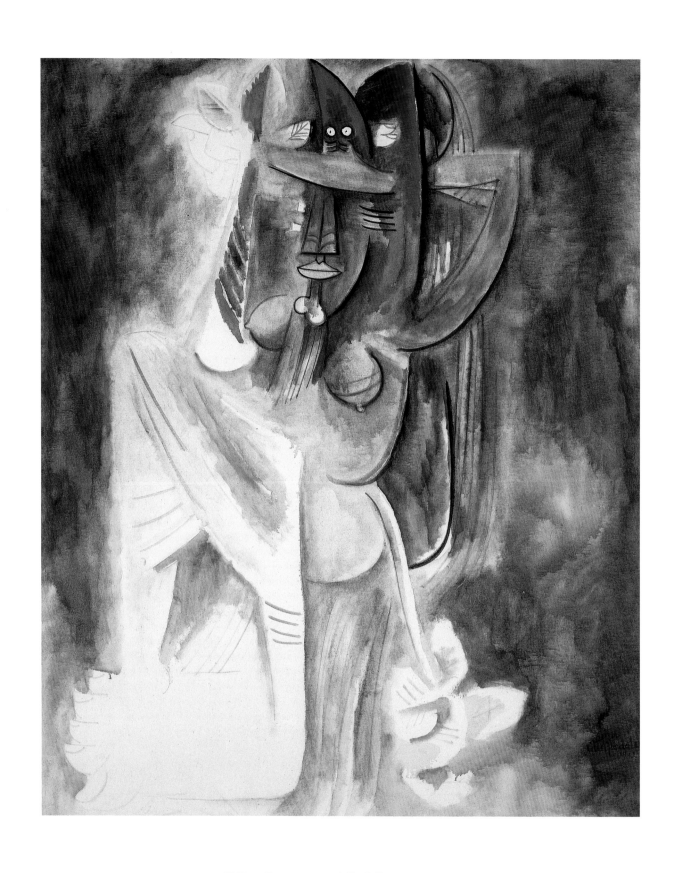

29. *Anamu*, 1942 [42.117]

Oil on canvas, 147.3 x 122.6 cm
Museum of Contemporary Art, Chicago, Gift of Joseph and Jory Shapiro, 1991.26

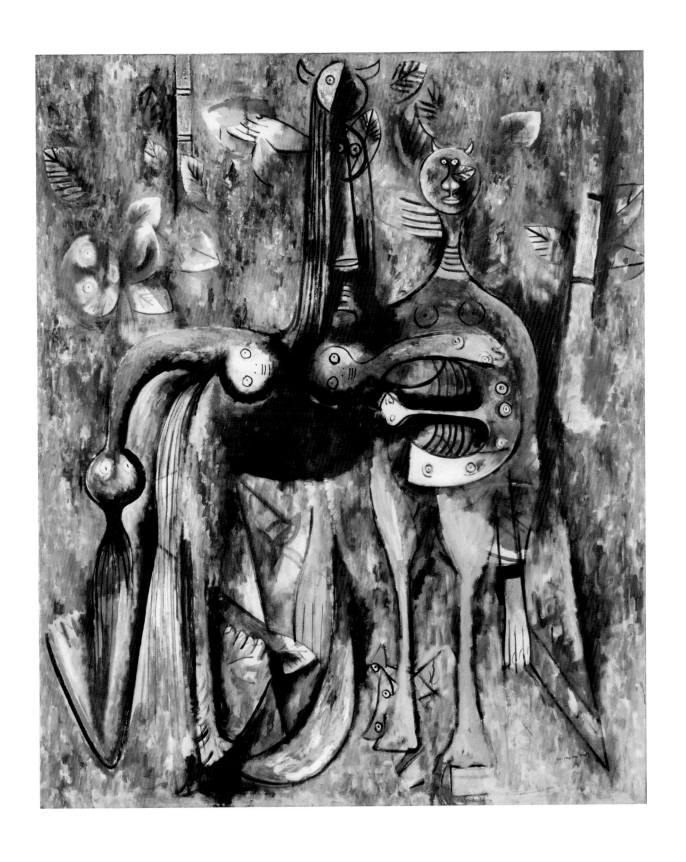

30. *Le Sombre Malembo, Dieu du carrefour,* **1943** [43.06]

Oil on canvas, 153 x 126.4 cm
Rudman Collection

31. *Untitled*, **c. 1944** [44.17]

Oil on paper, 106 x 84 cm
Private collection

32. *L'Annonciation*, 1944 [44.31]

Oil on canvas, 154.3 x 127.6 cm
Museum of Contemporary Art, Chicago, Gift of Mr. and Mrs. E. A. Bergman, 1977.28

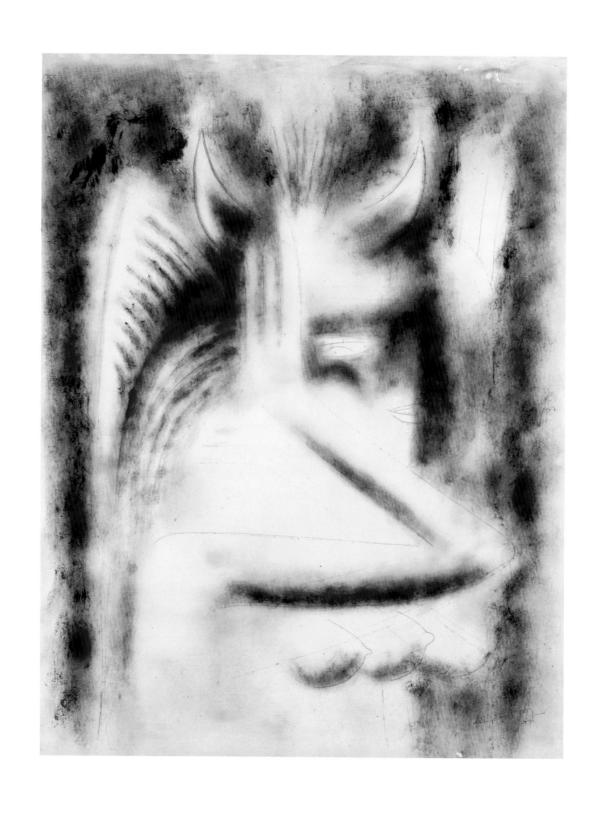

33. *Chant de pollens*, 1944 [44.66]

Oil on paper, 81.3 x 63.5 cm
Rudman Collection

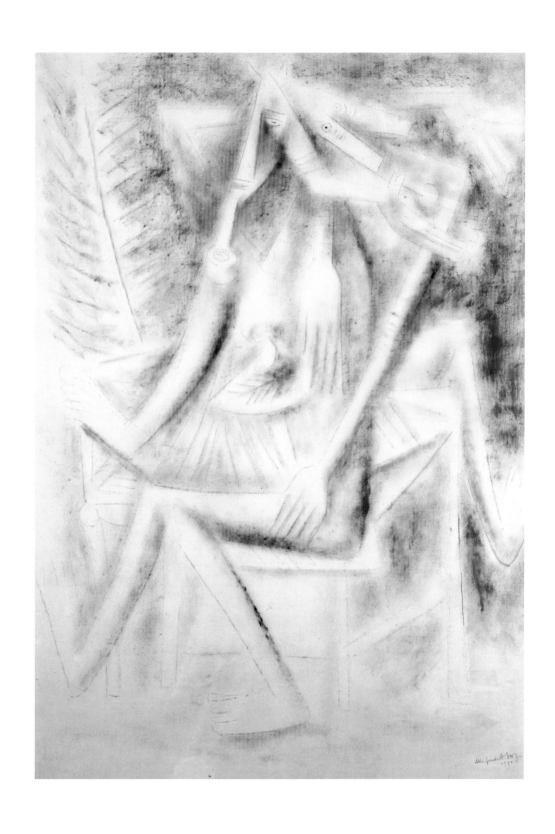

34. *Les Jumeaux,* **1944** [44.68]

Oil on paper mounted on canvas, 112.5 x 80.5 cm
Private collection

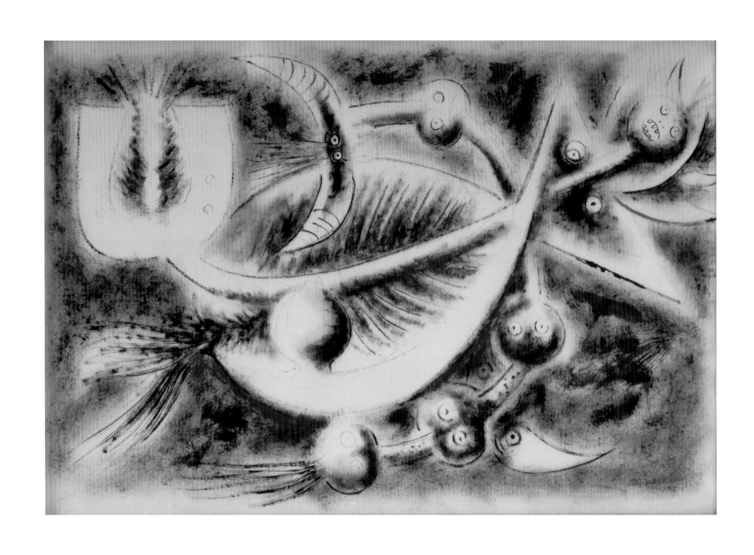

35. *Grand Capricorne*, 1944 [44.78]

Oil on paper mounted on canvas, 63.5 x 97 cm
Ella Fontanals-Cisneros Collection

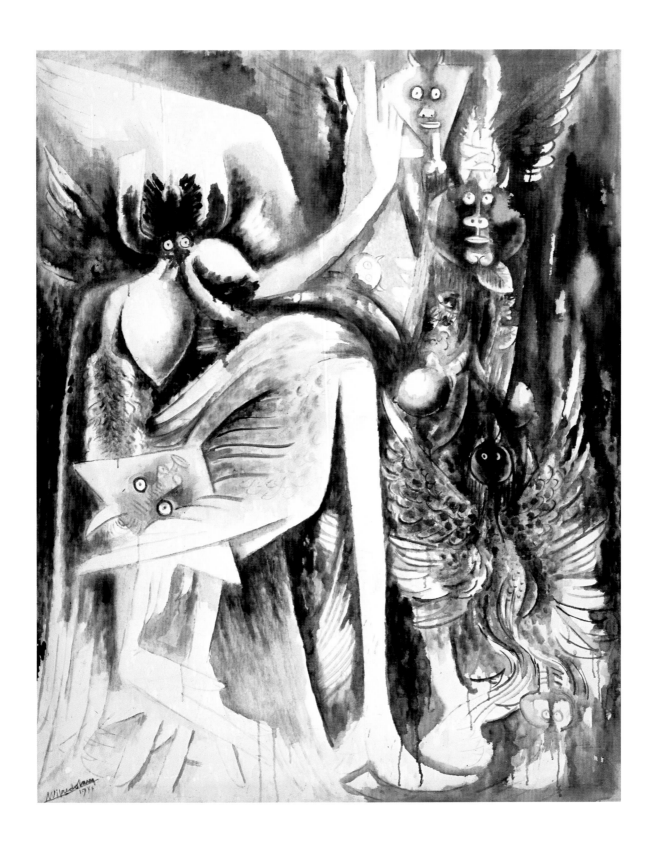

36. Oya *[Divinité de l'air et de la mort]* *[Idolos]*, **1944** [44.88]

Oil on canvas, 160 x 127 cm
María Graciela and Luis Alfonso Oberto Collection

37. *Au défaut du jour*, **1945** [45.06]

Oil on canvas, 160 x 127 cm
Ramón and Nercys Cernuda Collection

38. *Les Oiseaux voilés,* **1945** [45.28]

Oil on canvas, 111.2 x 126.3 cm
María Graciela and Luis Alfonso Oberto Collection

39. *Untitled*, c. **1945** [D-45.25]

Gouache and ink on paper, 61 x 80 cm
Private collection

40. *L'Action*, 1946 [46.04]

Oil and charcoal on paper, 61.2 x 53.5 cm
Silverman Family Collection

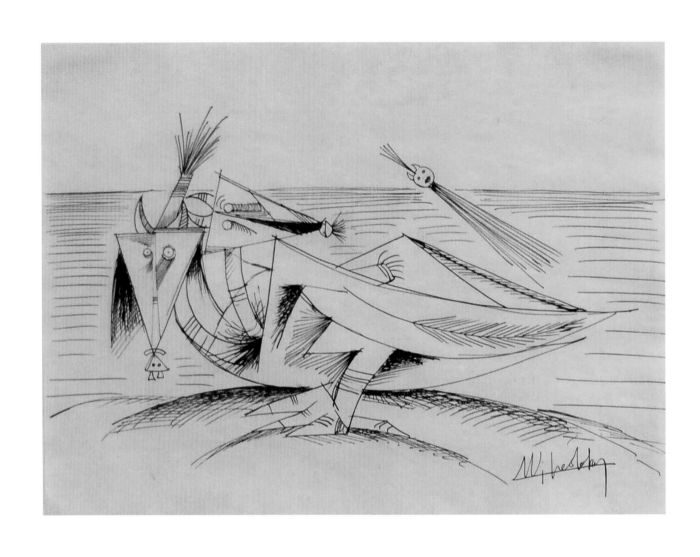

41. *Untitled*, 1946 [D-46.21]

Ink on paper, 27 x 36.5 cm
Private collection

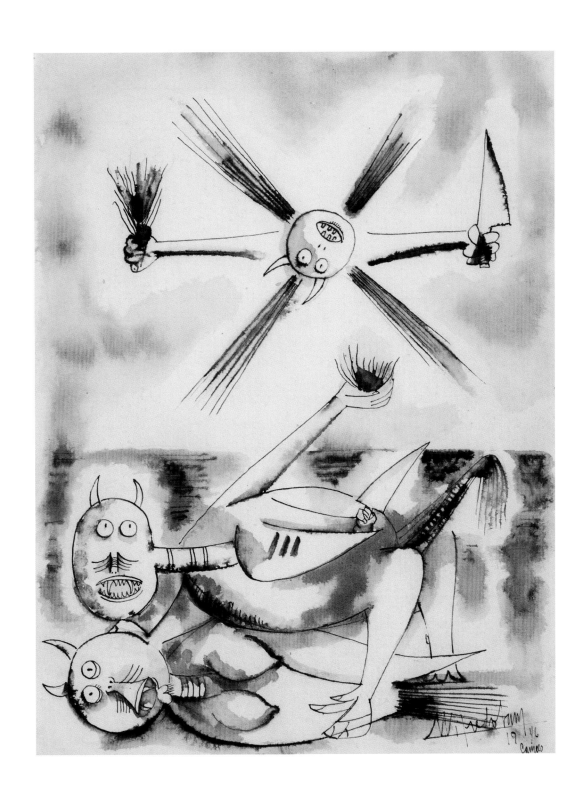

42. *[Yoruba Ritual]*, 1946 [D-46.28]

Ink on paper, 31.8 x 24.1 cm
Ann and Douglas Logan Collection, courtesy of Forma Fine Arts

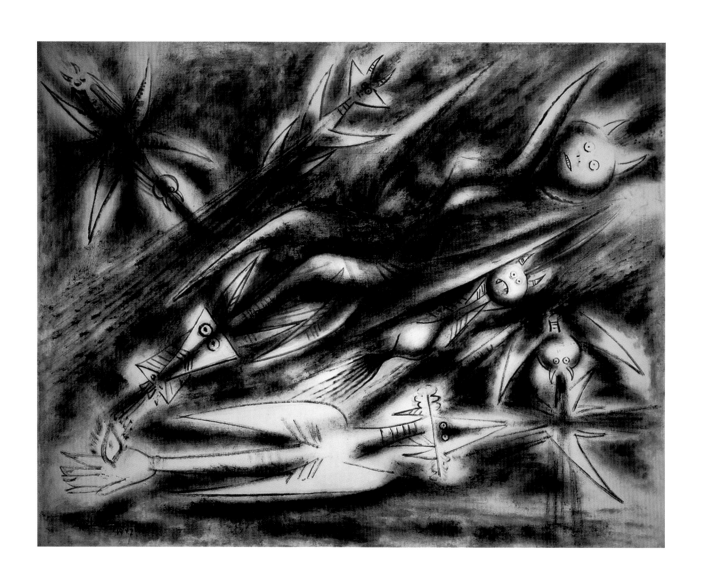

43. *L'Ascension*, 1947 [47.25]

Oil on canvas, 84 x 107 cm
Private collection, courtesy of Martha Richardson Fine Art, Boston

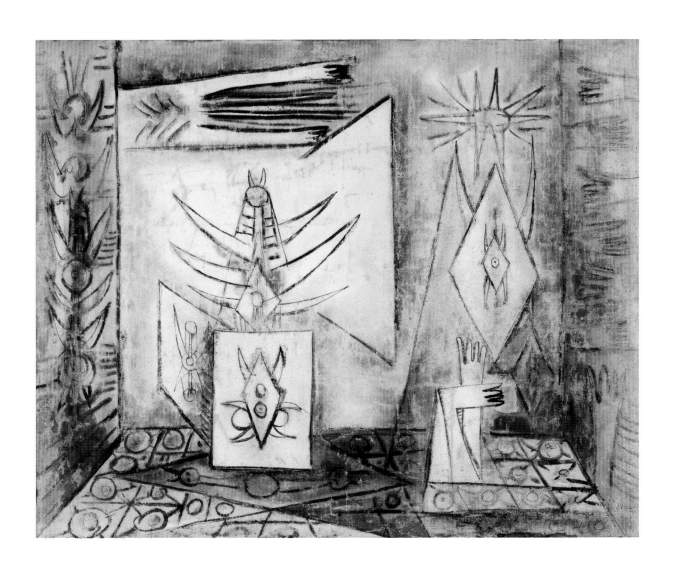

44. *L'Atelier [Cuarto Famba]*, 1947 [47.46]

Oil on canvas, 67.3 x 81.3 cm
Private collection

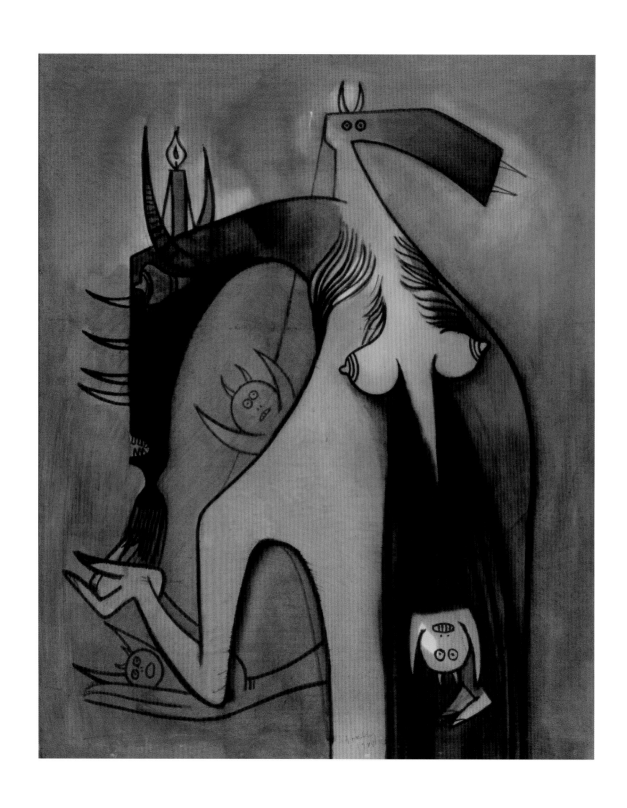

45. *Femme-Cheval*, 1948 [48.02]

Oil on canvas, 102 x 82 cm
Private collection

46. *Untitled*, 1949 [D-49.09]

Ink on paper, 22.2 x 15.2 cm
Private collection

47. *Femme-Oiseau*, 1950 [50.24]

Gouache on paper, 93 x 72.5 cm
Museum of Fine Arts, Houston, Brillembourg Capriles Collection of Latin American Art,
TR:809-2010

48. *Fresque*, 1951 [51.05]

Oil and mixed media on mortar, 205.1 x 177.2 cm
Private collection

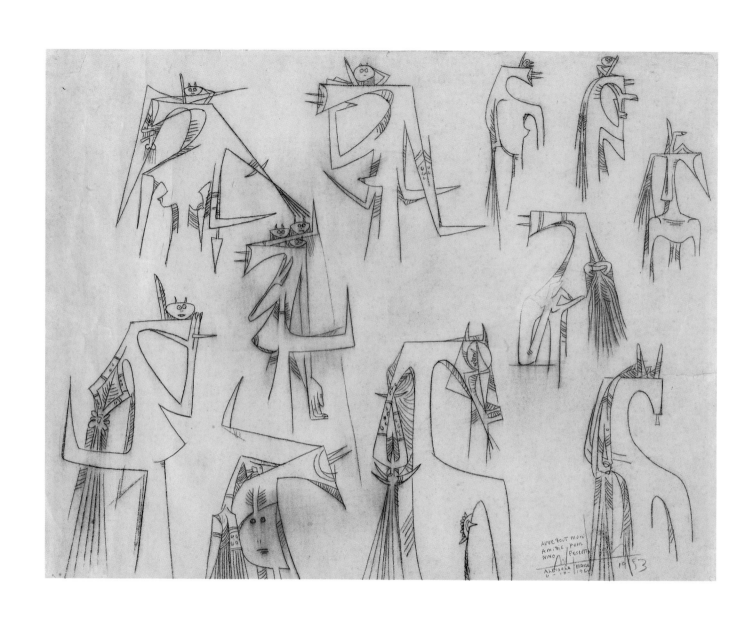

49. *Femmes-Cheval*, 1953 [D-53.01]

Chalk on paper, 48.9 x 64.1 cm
Museum of Fine Arts, Houston, Brillembourg Capriles Collection of Latin American Art,
TR:813-2010

50. *La Plume verte [Nature morte]*, **1955** [55.41]

Oil on burlap, 45.5 x 101.5 cm
Emilio M. and Silvia M. Ortiz Collection

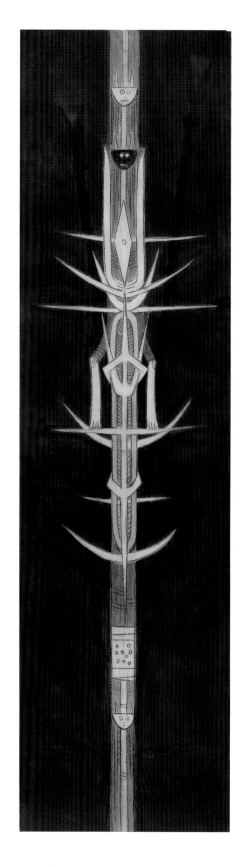

51. *Reflets d'eau,* **1957** [57.02]

Oil on canvas, 225 x 68 cm
Museum of Fine Arts, Houston, Brillembourg Capriles Collection of Latin American Art,
TR:851-2010

52. *Untitled*, **1958** [58.09]

Mixed media on paper mounted on canvas, 180 x 353 cm
Private collection

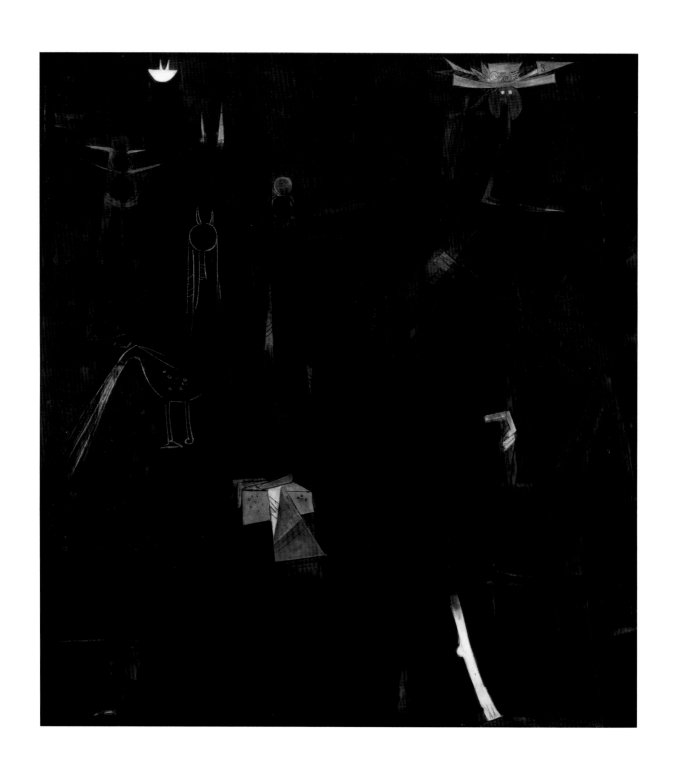

53. *Près des Îles Vierges*, 1959 [59.33]

Oil on canvas, 210 x 192 cm
Museum of Art, Rhode Island School of Design, Providence, Nancy Sayles Day Collection of
Modern Latin American Art, 69.054

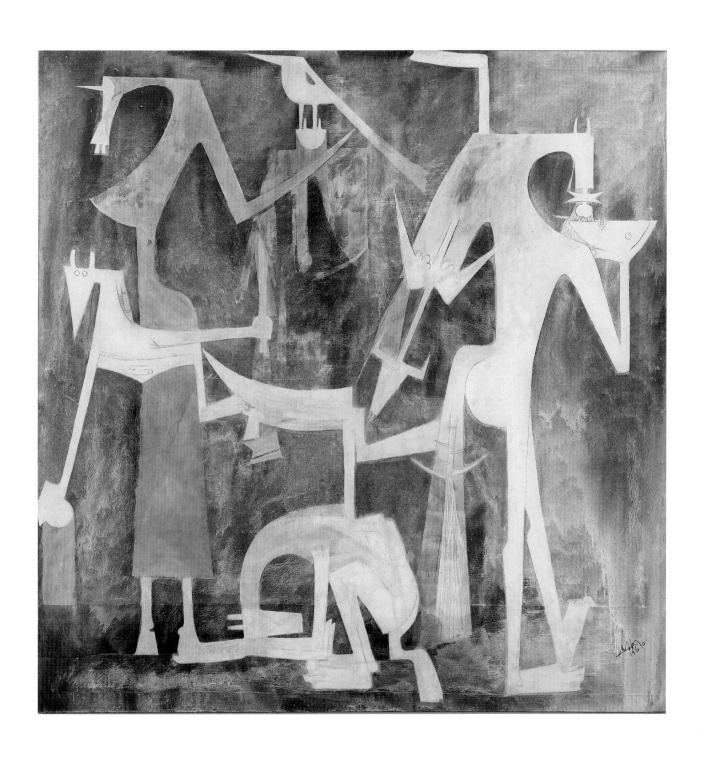

54. *Grande Composition*, 1960 [60.06]

Oil on canvas, 213 x 208 cm
Private collection

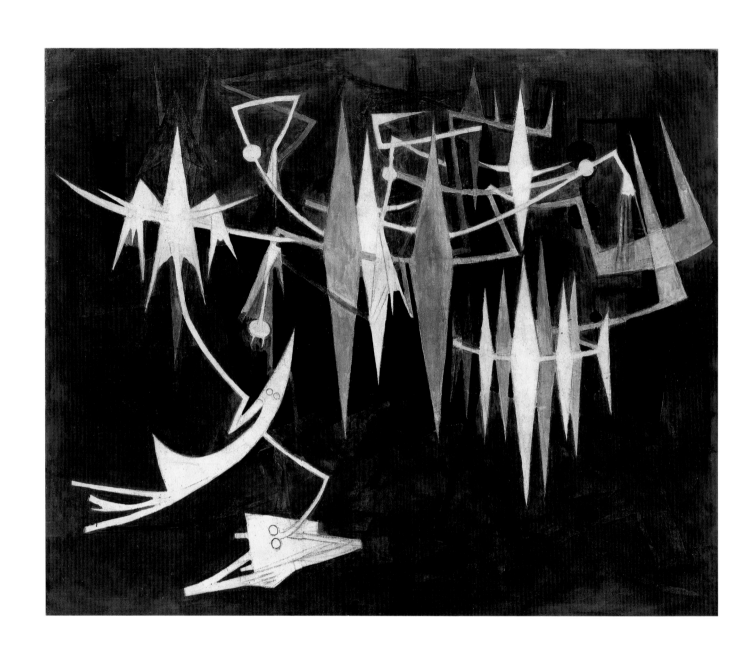

55. À la fin de la nuit [Le Lever du jour], 1969 [69.10]

Oil on canvas, 175 x 215 cm
Private collection

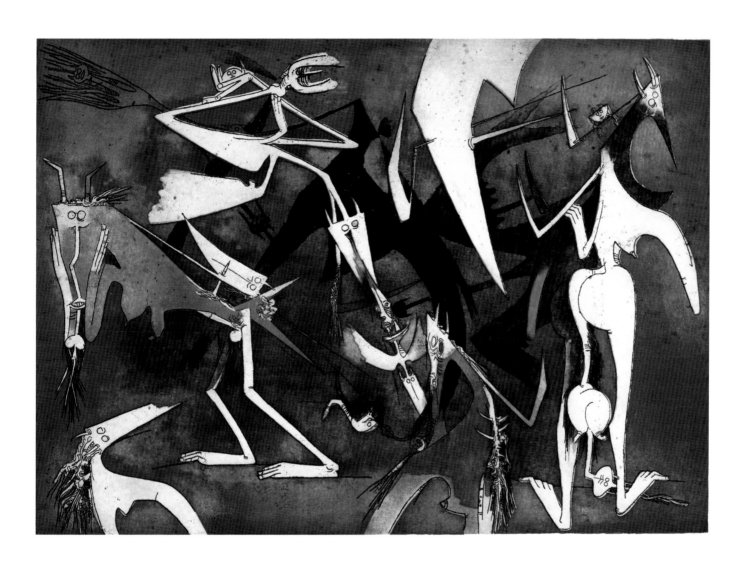

56. *Wifredo Lam...*, **1969** [221/NE6902]

Etching and aquatint in colors, 49 x 69 cm
Private collection

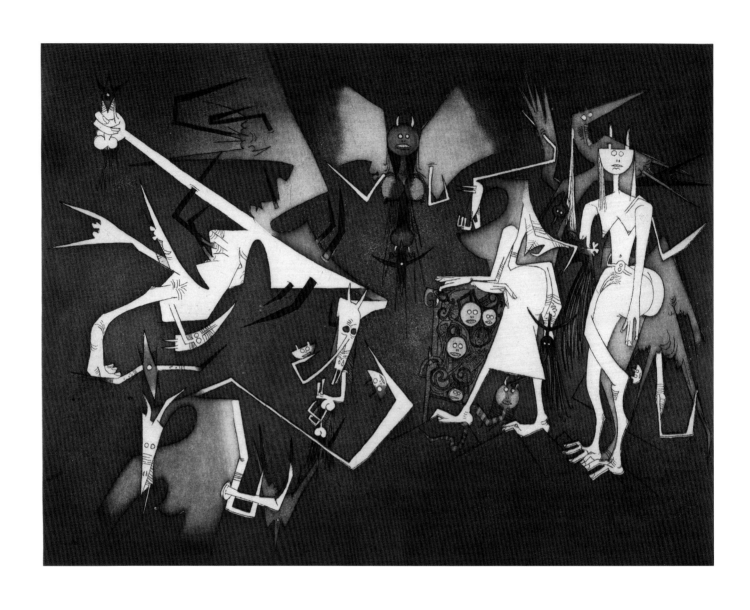

57. _connaître, dit-il,_ 1969 [223/6908]

Etching and aquatint in colors, 49 x 65 cm
Private collection

148

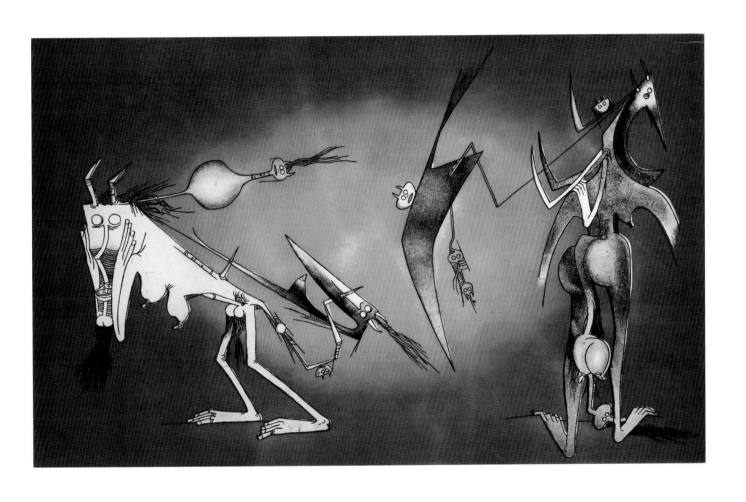

58. *genèse* *pour Wifredo,* **1969** [222/NE6903]

Etching and aquatint in colors, 50 x 80.5 cm
Private collection

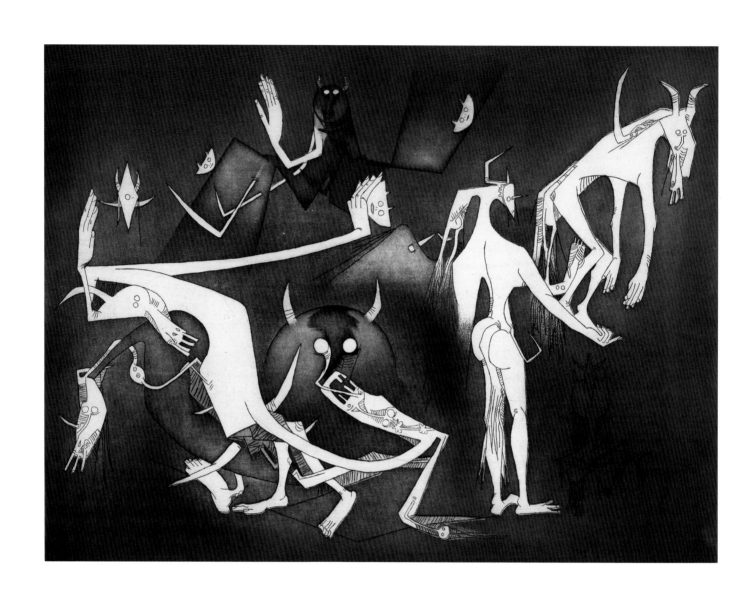

59. *façon langagière*, 1969 [224/6903]

Etching and aquatint in colors, 49 x 65 cm
Private collection

150

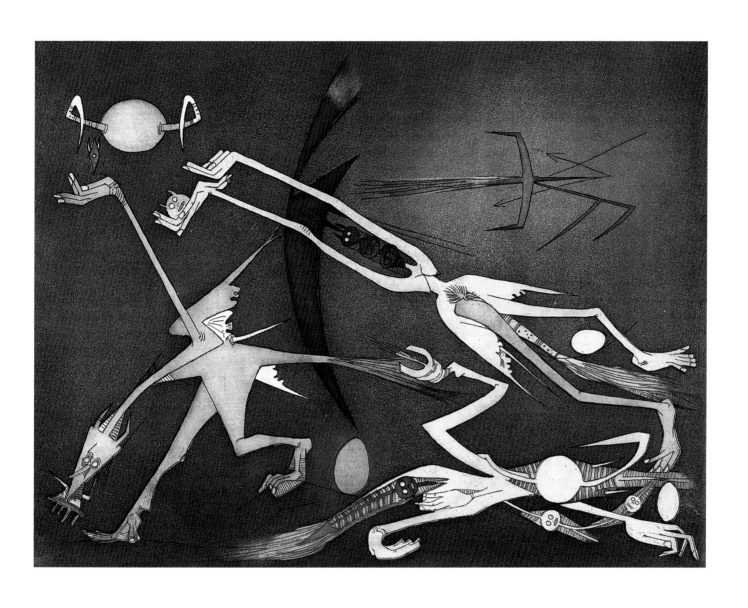

60. *passages,* **1969** [225/6907]

Etching and aquatint in colors, 49 x 65 cm
Private collection

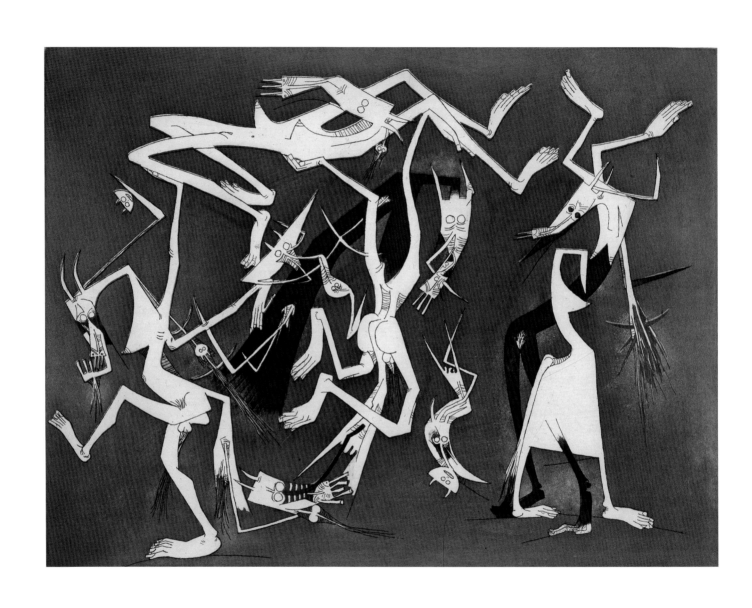

61. *rabordaille,* **1969** [226/6906]

Etching and aquatint in colors, 49 x 65 cm
Private collection

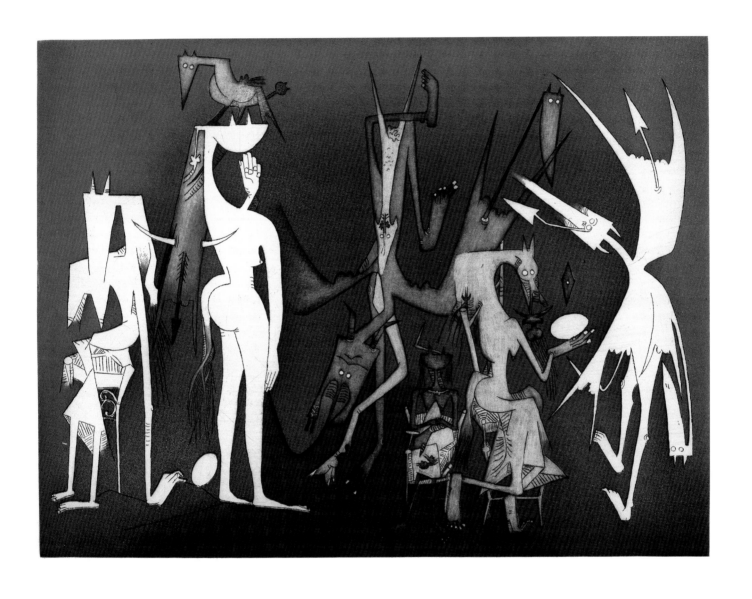

62. *que l'on présente son coeur au soleil,* **1969** [227/6905]

Etching and aquatint in colors, 49 x 65 cm
Private collection

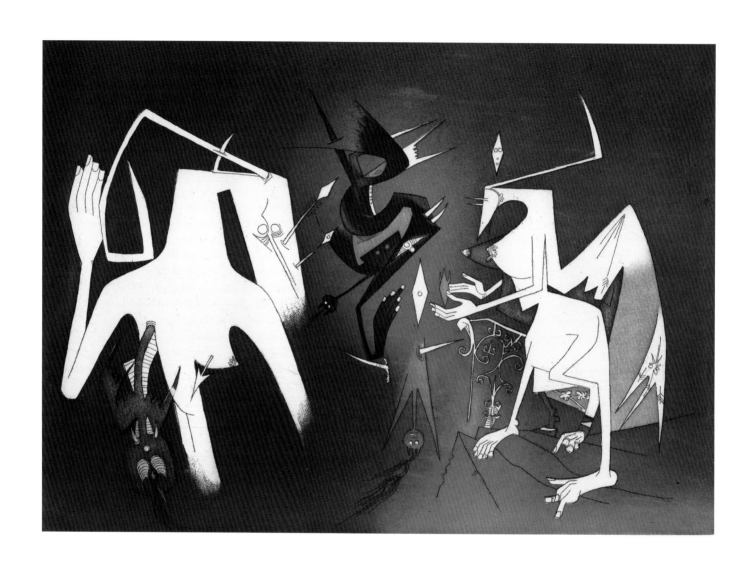

63. *insolites bâtisseurs,* **1969** [228/6902]

Etching and aquatint in colors, 49 x 65 cm
Private collection

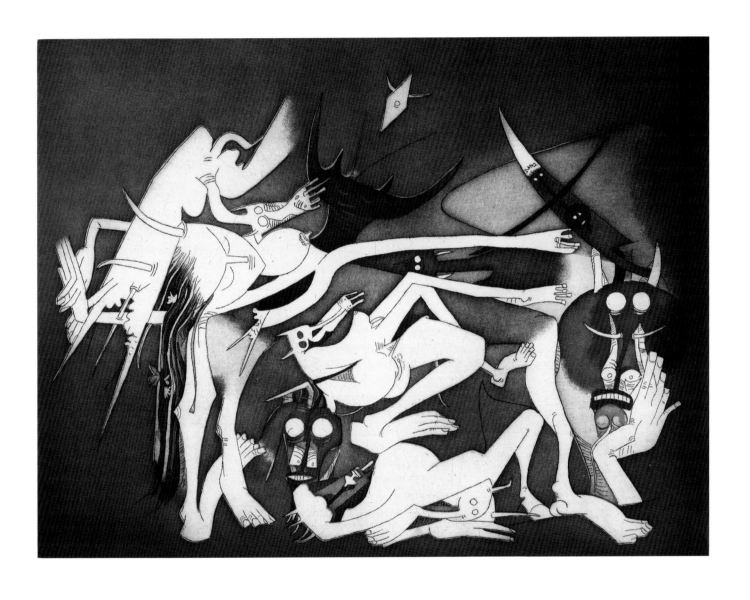

64. *nouvelle bonté*, **1969** [229/6904]

Etching and aquatint in colors, 49 x 65 cm
Private collection

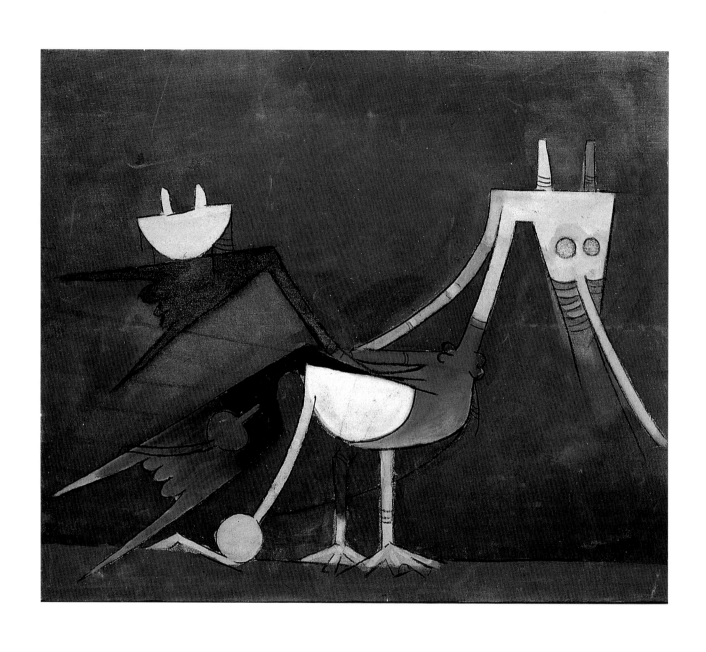

65. *Coq Caraïbe, IV*, 1970 [70.05]

Oil on canvas, 46 x 55 cm
Private collection

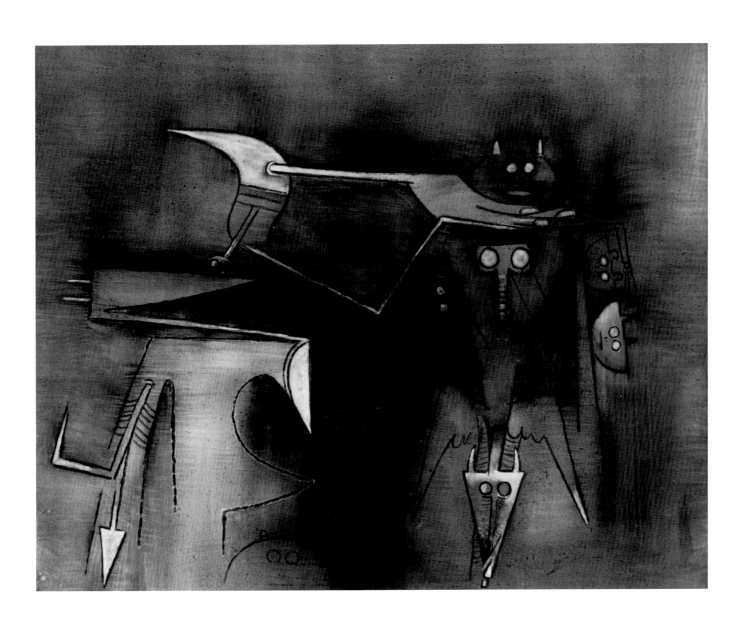

66. *Composition*, 1970 [70.12]

Oil on canvas, 80 x 100 cm
Private collection

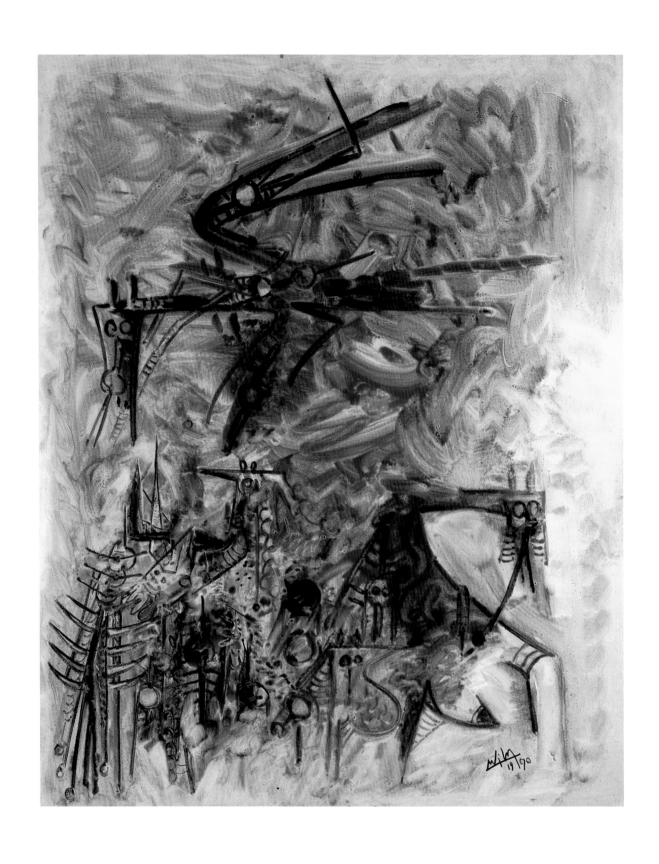

67. *Untitled*, 1970 [70.34]

Oil on canvas, 160 x 130 cm
Ramón and Nercys Cernuda Collection

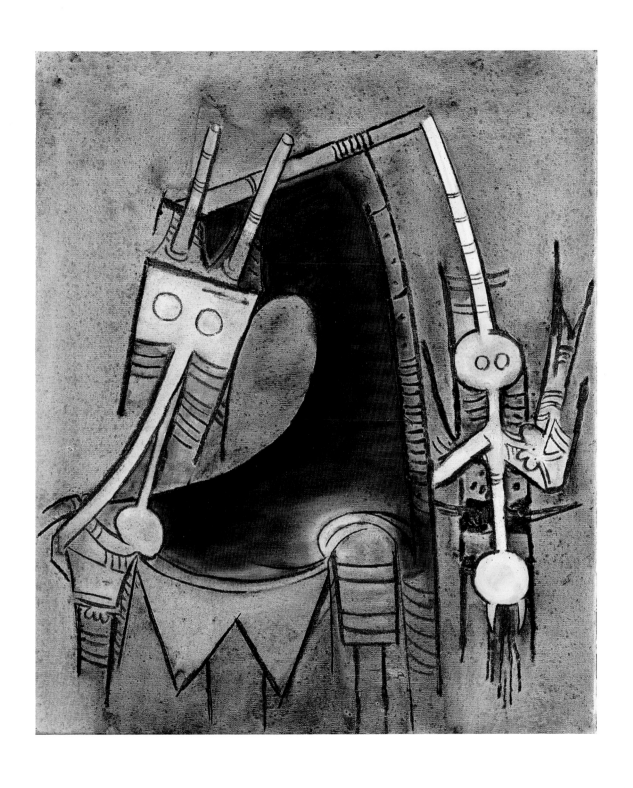

68. *Personnage 4/24, 1970* [70.64]

Oil on canvas, 59 x 50 cm
Private collection